Assault on the Impossible
Dutch Collective Imagination in the Sixties and Seventies

Marjolijn van Riemsdijk

translated and expanded from the
Dutch edition with Jordan Zinovich

Without Peter van de Westeringh and Adele Haft
this book would never have seen the light.
They complete us; motivation flows through them.

Translation Copyright © Marjolijn van Riemsdijk and Jordan Zinovich, 2013
ISBN: 978-1-57027-271-4

Unless otherwise designated, copyright for all contributed materials belongs to the contributors.

Book Design: Antumbra Design | Antumbradesign.org

Published by
Autonomedia
PO Box 568, Williamsburg Station,
Brooklyn, NY 11211-0568, USA
Email: info@autonomedia.org
Website: www.autonomedia.org

This publication is made possible in part with public funds from the New York State Council on the Arts, a state agency.

contents

Acknowledgments	i
Key to Magic Center Amsterdam	ii
Foreword by *Jordan Zinovich*	iii
Preface	ix
Progressive Art Policy in the Netherlands	1
Discontent with the Stedelijk Museum	5
Creative Activism—The New Players	9
The Assault on the Impossible	31
Power to the Imagination	41
The Expertologistic Laboratory	53
The Ending of an Era	79
Appendix 1: Robert Jasper Grootveld: Proclaiming Amsterdam Magic Centre of the World, White Bicycles and Provos, by *Eric Duivenvoorden*	93
Appendix 2: Theo Kley: Pataphysicist— Fragments from the Pataphysical Record, by *Matthijs van Boxsel*	100
Appendix 3: Simon Vinkenoog: "Damn War, Animate Peace!" (a short biographical sketch) by *Derrick Bergman*	105
Appendix 4: Cor Jaring: Photographer of Amsterdam, Magic Centre of the World by *Marjolijn van Riemsdijk*	118
Appendix 5: Ruigoord Cultural Free Zone, a Timeline to the Millennium, compiled by *Aja Waalwijk* and *Ted Doorgeest*	120
Appendix 6: An Amsterdam Balloon Company Manifesto	127
Appendix 7: Burning the Anti-Smoke Temple and the Birth of the Amsterdam Balloon Company, an interview with Gerben Hellinga	132
Appendix 8: Kees Hoekert: Recipe for One Kilo of Hashish	139
An Annotated General Bibliography	143

acknowledgments

Peter Boom (de Jong), who advocated for an English-language edition of this book and initiated the first stabs at its translation, deserves heartfelt thanks. Theo Kley gave of himself and his archive for both the Dutch and English editions of this project—they wouldn't have appeared without his help. Hans Plomp is an anchor (in a deep dark pool); his collaboration on this and other projects kept them from drifting. Derrick Bergman, Eric Duivenvoorden, Gerben Hellinga, Matthijs van Boxsel, and Aja Waalwijk expanded the compass of the text and contributed to completing it; we are grateful. Enno Wiersma appeared during the last months of work, when a particularly intractable problem threatened to hold us up—his assistance helped solve it. We were fortunate that Ab Pruis's photo archives, Theo Kley, Wim Ruigrok, Igno Cuijpers, Hans Bruggeman, and Coen Tasman provided us with photos and graphics to use as illustrations; sincere thanks to those sources. Thanks also to Peter Stansill and David Mairowitz for the use of their translation of the Provos' initial statement of intent. The Autonomedia collective remained supportive throughout the work. Adele Haft and Ben Meyers passed their clear eyes over the near-final text—thank you. Morgan Buck and Josh MacPhee designed the book: kudos to you both. Overall this was a collective effort, and we extend sincere thanks and apologies to anyone we inadvertently neglected to acknowledge.

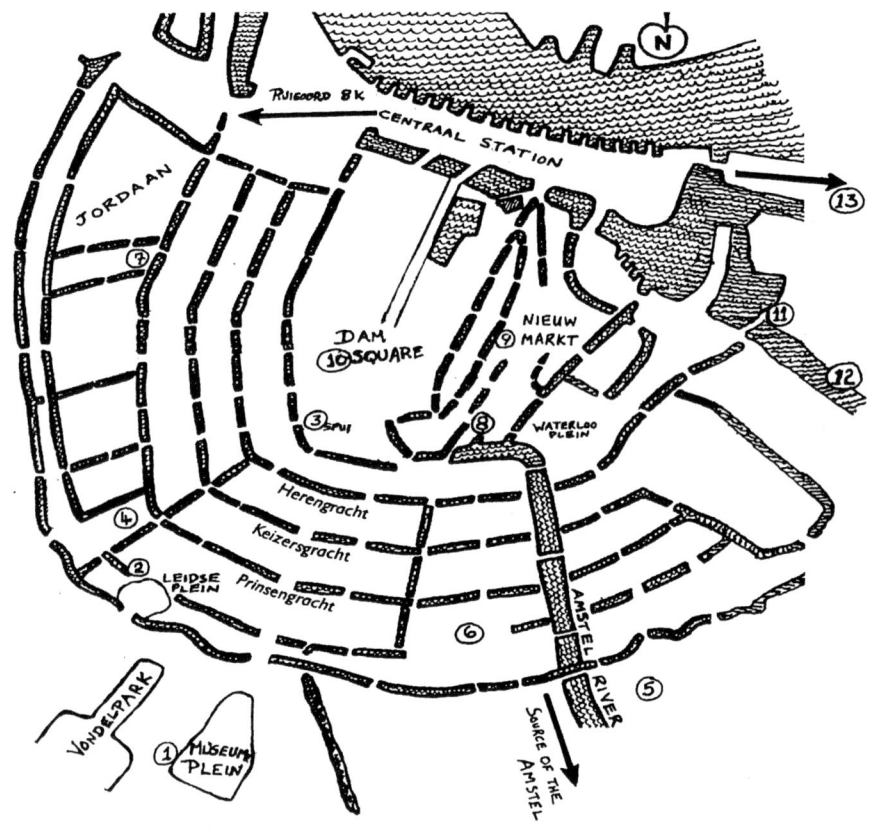

KEY TO MAGIC CENTER AMSTERDAM

1. **Stedlijk Museum**, Museumplein 10
2. **Anti-Smoke Temple**, Korte Leidsedwarsstraat 29
3. **Het Lieverdje**, in front of Spui 14
4. **Social Religious Discussion Center**, Raamstraat 16A
5. **Theo Kley's house**, Ruyschstraat — birthplace of the Exotic Kitsch Conservatory
6. **Dutch Central Bank**, Fredriksplein — Immune Blue intervention
7. **Open the Grave Happening**, Prinsengracht 146
8. **Amsterdam Sigma Center**, Kloveniersburgwal 87
9. **Theo Kley's rooftop studio and garden**, Oudezijds Achterburgwal 81 — birthplace of the Amsterdam Balloon Company
10. **The last GNOT**, cut into the southeast corner of the Royal Palace at chest height
11. **Scheepvaartmuseum**, Kattenburgerplein 1 — death of the raft Frya
12. **Lowland Weed Company**, Wittenburgergracht
13. **International Institute for Social History**, Cruquiusweg 31 — Jasper Grootveld's rafts

foreword

Assault on the Impossible is the second Autonomedia title to concentrate on the Provo period in the Netherlands. The Provo movement is unique in the modern era for having radically reshaped the political foundations of an important Western nation virtually without violence. Aside from the death by heart-attack of socialist Jan Weggelaar during an early confrontation with police, and the near-fatal shooting by police of the precariat laborer Floris Schaper, who was trying to leave a riot zone during the height of the action, remarkably few injuries or arrests resulted from the three-day "Battle for Amsterdam," as the pivotal riots were called. Yet the Dutch body-politic has yet to recover from the blow struck to it. The political aftermath of the Battle sparked a progressive social experiment that even today remains the envy of other would-be Western revolutionaries. (By way of comparison, a real case can be made that the immeasurably more doctrinaire "Situationist revolution of Paris '68" left behind little more than theoretical wet-dream traces.) Provo's influence both changed socio-political consciousness and provided continuing cultural access to conscious-changing substances, ideas, and impulses. This Dutch revolutionary moment stands as exactly the kind of case study that anarchists have been searching for since Kropotkin and Woodcock first started exploring our historical antecedents.

Political change is often tumultuous, but never takes place in cultural isolation. Actuating the impulse to change requires activating large groups of people, generating what might be called new "group minds," minds capable of reimagining the realities they inhabit. It requires a kind of visionary emotional adventurism able to gaze with a clear heart at impossibility. Viewing the "historical nature" of revolutions through exclusively ideological lenses tends to miss the fact that they blaze forth from wider cultural fields, frequently ignited by the eccentric (often aesthetic) insights of a few profound aliens. That was certainly the case for Provo, yet there's so little available in English on the period that until now it's been difficult to even begin analyzing its background. Our first book, Richard Kempton's *Provo: Amsterdam's Anarchist Revolt*, focuses on a detailed narrative of the birth, florescence, and decline of the Provo political trajectory between 1961 and 1967. Marjolijn van Riemsdijk's *Assault on the Impossible* widens the field, investigating the aesthetic attitudes and ludic interventions that generated the group mind behind the events, and surveying the politico-aesthetic evolution of a few of the offshoot manifestations the cultural changes wrought.

Van Riemsdijk's book directly addresses certain questions that arose following our work on Kempton's book. Was Robert Jasper Grootveld the only "out-

sider" artist shaping Amsterdam's visionary aesthetics? Was there an emerging pre-Provo group mind that opened a public space for revolutionary consciousness to inhabit? Who were the emotional adventurers, the eccentrics who fired the impulse to question and reject the restrictive parameters of pre-Provo social reality? Her subtitle, *Dutch Collective Imagination in the Sixties and Seventies*, highlights her clear sense that before, during, and after the Provo moment there was indeed an emergent group mind, a "collective imagination" as she calls it. And the text she labored with us to translate and shape is a unique contribution to the period-based library that Autonomedia is working to establish. This edition of *Assault on the Impossible* isn't simply an English-language version of her original Dutch book, *De Bestorming Van Het Onmogelijke* (2001). It is a new group of texts, translated and original, specifically intended to expand the period information available in English.

In a very real sense, both Richard Kempton's and Marjolijn van Riemsdijk's books are small libraries in themselves. Both employ a primary narrative to focus the timeline, and a group of accompanying appendices that provides background and expansive documentation. Kempton charted the specific historical boundaries that supported his view of Provo's history, then briefly scanned the visionary utopianism (Appendix 1: New Babylon), the bickering over legitimacy (Appendix 2: Provo and the Situationists), the dada underpinnings (Appendix 3: Dada Influences), the local anarchist history (Appendix 4: Anarchist Antecedents in Amsterdam), Provo's territorial spread (Appendix 5: Provos in Belgium and the Provinces), and the movement's successors (Appendix 6: the Kabouters). He finished by offering a theoretical stance that he believes will help future insurrections sustain their energy (Appendix 7: Sarte's Concept of the Fused Group), and by analyzing a recent Dutch critique of the Provo mindset (Appendix 8).

Marjolijn van Riemsdijk allows herself more flexibility than Kempton did. Art activists and politicos pursue different ends, with politicos attempting to motivate co-ordinated groups to overturn inadequate social structures, while artists struggle to nudge individuals toward expanding awareness, experimentation, and collective appreciation. Though van Riemsdijk *is* examining the evolution of a community, hers isn't resisting a political status quo as much as it's challenging an ongoing epistemological stasis. Most attempts at grouping artists are best compared to herding cats. There are theoretical and rhetorical ways of attempting it, but in practice each artist remains fiercely alone. Van Riemsdijk's narrative strategy, therefore, combines an initial critical analysis of the historical timeline with biographical explorations of individuals and their stages and strategies of collaboration. Since one of her fundamental interests lies in the viability of the playfulness engendered by combining idiosyncratic aesthetic lifeways, the structure of her presentation naturally differs from Kempton's.

Cultural historians and theoreticians who focus on play (and playfulness)

often open their analyses by referencing Johan Huizinga's landmark study, *Homo Ludens: A Study of the Play Element in Culture* (first published in the Netherlands in 1938). Huizinga assesses the importance of playfulness to culture and society. His term *Play Theory* defines the conceptual space in which play can occur, and his basic conclusions view play as a primary and necessary (though not sufficient) condition of cultural generation. However, there is a stark difference between establishing a theoretical position and transforming theory into practice. Action requires facilitators, activists prepared to take real risks. When Provo politics became playful, the movement's provocatively violent tendencies were transformed. The imaginative insights underpinning that transformation were based on an artistic practice that had removed itself from elitist aspirations and tendered itself to activists on the street. *Assault on the Impossible* investigates the Dutch artists and practices that opened the potentialized cultural space and galvanized the adventurous audience primed to respond to Provo's lead.

Earlier, in regard to the unanswered questions Kempton's book seemed to pose, I referred to Robert Jasper Grootveld as an "outsider" artist, a designation that begs elucidation. Since Grootveld is a benchmark figure who assisted at the birth of Provo and helped edge Dutch art from the museums to the streets, it's necessary to clarify what I mean. Art critic Roger Cardinal coined the term *outsider artist* in 1972 as an English synonym for *art brut* ("raw art" or "rough art") — French artist Jean Dubuffet's term for art that ignores the boundaries of "official" culture. To paraphrase Dubuffet (Dubuffet, p. 36):

> Art brut emerges from solitude and pure, authentic creative impulses — where notions of competition and status are immaterial — and is, therefore, more authentic than the work of commercialy oriented artists. Such "flourishings of an exalted feverishness, lived so fully and so intensely by their authors," make "professional" art seem little more than the fallacious game of a futile society. Mainstream culture attempts to assimilate new developments in art, bleeding off their creative power, asphyxiating all genuine expression. Only art brut (outsider art) is immune to the mainstream, immune to being absorbed, because the artists themselves are incapable of being assimilated.

Though Dubuffet's term seems formally specific, "outsider art" is now almost always applied more broadly: those labeled outsider artists, typically have little or no contact with mainstream institutions; in many instances their work evinces extreme mental states, unconventional ideas, and/or elaborate fantasy worlds. Nevertheless, Dubuffet himself associated closely with the *Collège de 'Pataphysique*. He was friendly with Antonin Artaud, admired and supported Louis-Ferdinand Céline, and embraced the artistic circle around the surrealist André Masson. And, even more directly germane to our concerns here, in the early Sixties he experimented with sound and made several recordings with the Danish painter Asger Jorn, a founding member of the CoBrA movement. Since the fairly recent

interest in "outsider" practices may be seen as part of a larger emphasis on the rejection of the established values of modernism, and since the Dada, Surrealist, CoBrA, and other avant-garde movements generally involve a rejection of outdated cultural forms, I choose to apply the term *outsider* as if it were simply a logical extension of Dubuffet's *raw* artist.

Grootveld becomes my focus here only because, aside from the great Dutch poet Simon Vinkenoog, in the English-speaking world he is the best known of the figures on whom *Assault on the Impossible* concentrates. That is not to say that the book presents him as any more important than his collaborators. Rather that, despite the fact that Eric Duivenvoorden's comprehensive biography *Magier van een nieuwe tijd: Het leven van Robert Jasper Grootveld* remains unavailable to us, there is plenty that a reader of English can find written about him. By suggesting that he and his closest collaborators—Theo Kley, Lawrrence Nutton, Max Reneman, Aat Veldhoen, and Vinkenoog—resemble Dubuffet-style "outsider artists" I don't intend to marginalize them, but to valorize the purity of their intent. (In truth, only Grootveld fits my outsider definition, though there is no denying the *brut* purity of his collaborators' intentions.)

As the Autonomedia collective wrote in our foreword to Richard Kempton's book:

> Provo's playful combination of theory and street-level practice helped generate the creative and flexible engagement that has become an essential part of our most effective [current] interventions into the increasingly militarized and regulated spaces of our daily lives. It [Provo] is part of a hidden history of fleeting moments, outbursts, and insurgencies that connect to form a revolutionary history, one that often remains secret even to those who make it. Many people involved in Provo likely were not aware of the ways in which previous revolutionary traditions informed them, and likewise, Provo has "invisibly" informed current practices of creative resistance.

Though the politically-oriented Provos, many of whom were very young, may not have known much about their historical antecedents, Holland's art activists certainly did. They can be seen as an older, more experienced resistant group sprouting from preceding generation. And because they were older, better trained, and had direct contact with the avant-gardist sensibilities of such internationally-active creators as the purged-Situationist Constant, they readily grasped the implications of their actions. Max Reneman instantly recognized both the originality of Jasper Grootveld's vision and the deep wells of creative precedence that Theo Kley drew from. And Simon Vinkenoog brought a wider awareness to Amsterdam's outsider scenes. (See Appendix 3) Following seven years lived in Paris, where he befriended luminaries like Alexander Trocchi (another spirit deemed insufficiently doctrinaire by commissar Debord), and a momentous meeting with Allen Ginsberg in 1957, Vinkenoog had helped shape the

Vijftiger movement (Writers of the Fifties) that changed Dutch poetry. Whenever Reneman or Vinkenoog initiated a group event, they read it forward and back. When Grootveld and Kley sensed a threshold, they fearlessly crossed it. All of them battled resolutely against any status quo that dared to stifle their creative impulses, affirming a common "performative understanding of culture" set to construct new realities. And therein lay the pulsing heart of Amsterdam's emergent collective imagination.

The impulse that elevated the Netherlands' political transformation above a purely national event also drew from art activism. The artistic antecedents of the countercultural institutions that took shape seem obvious. Vinkenoog, inveterate networker that he was, constantly communicated with his friends. In 1962, his friend Alexander Trocchi published "A Revolutionary Proposal: Invisible Insurrection of a Million Minds" in the Scottish publication *New Saltire Review*, a piece that reimagined the internationalist project and functioned as a claxon for nascent notions of counterculture: "We are concerned not with the *coup d'état* (seizure of the state) . . . but with the *coup du monde* (seizure of the world), a transition of necessity more complex, more diffuse than the other . . . Political revolt is and must be ineffectual precisely because it must come to grips at the prevailing level of political process. . . . The *coup du monde* must be in the broad sense cultural." An "Invisible Insurrection" "must seize the grids of expression and the powerhouses of the mind." Trocchi followed his "Revolutionary Proposal" with a manifesto titled: "sigma: A Tactical Blueprint," also in *New Saltire Review* and also in 1962. The similarity between his proposals and the notions that Provo explored in its 1966 White Plans suggests that, through Vinkenoog, Trocchi's influence was seminal. (Appendix 1 offers new insight into the origin of the famous White Bicycle Plan; and Appendix 3 offers more on Vinkenoog.) Hijacking the nation's cultural mind was more important than merely reshaping its established institutions.

Vinkenoog's aesthetic adventurism and Reneman's and Kley's 'pataphysical comportments were enticingly playful (ludic), but in uniting politicos, art activists, and radicalized youngsters into a Provo group mind, Grootveld's fearless charisma (the outsider tension inherent in his street events as offset by his insistence on non-violent engagement) was probably the only kind of authentic risk-taking that *could* have drawn in Amsterdam's disaffected delinquents, the *nozems*. His uniquely eccentric status and his ability to defuse and channel the nozems' wild energies into strategic playful engagement were the inspirational force behind Provo's initial cultural toehold. And Provo's unique implementation of Grootveld's creative ferocity fertilized Amsterdam's larger group mind, infusing radicalized notions and artistic tendencies into the Netherlands' moribund labor movement. The historical confluence of these elements and others made the Battle for Amsterdam possible and enabled the countercultural flowering that followed it.

Marjolijn van Riemsdijk has structured *Assault on the Impossible* to account for her subjects' eccentric status without specifically defining it, suggesting that their practice arises naturally from the de-professionalizing ethos of the time. Her core narrative sets an open-ended trajectory for the events, timelines, and personalities she examines. The package of appendices delves more deeply into the specifics of the contemporary aesthetic mind than anything previously gathered in English. Yet neither this small book, nor Richard Kempton's, pretends to be magisterial. They are simply the beginnings of a useful library. There is much yet to be done before any comprehensive coverage of the period nears completion. Missing from *Assault on the Impossible*, as it was from *Provo: Amsterdam's Anarchist Revolt*, is any attempt to explore the impact of women's contributions on the overall experiment. And the wider effects of psychedelics on the group mind remain only tantalizingly alluded to. However, by investigating such hitherto obscure countercultural forces as the Amsterdam Balloon Company, the Insect Sect, Kees Hoekert and the Lowland Weed Company, Theo Kley, Max Reneman, Hans Rooduin, the Ruigoord Cultural Free Zone, Johnny the Selfkicker, and Leo van der Zalm, and by increasing the available information on Simon Vinkenoog and Robert Jasper Grootveld, *Assault on the Impossible* adds contour to the Dutch culturescape. Provo no longer rests, *sui generis*, towering over a flat cultural plain, arising and propagating in isolation. A larger context begins to emerge. Environmental awareness makes better sense, and the landmark manifestations and events of the time take on clearer texture and form. Autonomedia is pleased to add it to our expanding list of publications on the Provo-era transformation of the Netherlands.

As was the case for Richard Kempton's book, *Assault on the Impossible* was a collective effort. Sustained input from my long-time Dutch collaborators (Eric Duivenvoorden, Lou Heldens, Gerben Hellinga, Montje Joling, Theo Kley, Lawrence Nutton, Hans Plomp, Rudolph Stokvis, Jinny Thielsch, and Aja Waalwijk), from the Autonomedia collective, and from Morgan Buck and Josh MacPhee, helped bring it to print. The deep truth of the value of Mutual Aid sustains and nurtures every evolutionary project. Without their support networks, the fittest don't remain fit for long. Regardless of what any reactionary cretins may say, the science certainly isn't out on that!

Jordan Zinovich
02/22/2013

preface

 Everything was in motion. The mantras of the Sixties and Seventies advanced notions of Change: "The old structures are broken; Authority is obsolete." Companies, schools, and universities were being democratized, communes and housing groups became fashionable, women agitated against fixed gender roles, and people experimented with ways to raise their consciousness. "Anti-authority" and "democratization" were the slogans powering campaigns against politicians, university boards, the army, male dominance, the existing theatre system, art ideas. Even the formal rigidity of spelling came under attack: words were written as they sounded, and in extreme cases the use of capital letters was abolished in order to avoid any suggestion of hierarchy. In the Netherlands, agitation against social institutions was often approached playfully, with political groups like the Provo movement (by way of provocation) handing out raisins to the police and staging weekly happenings around the statue of an Amsterdam ragamuffin, and the *Dolle Mina's* (Crazy Mina's) staging the theatrical pro-abortion actions *Baas in Eigen Buik* (Boss of My Own Belly).

In the arts an international cultural revolution was taking place. Composers wrote operas about current political events, writers and poets recorded the language they heard on the streets, and in the theatre actors left the stage to perform with the audience. Artists strove to reduce the distance between daily reality and art and to involve the public directly in their work. They experimented at combining images, materials, and sounds—whatever was available on the spot. They produced sculptures and paintings that embraced daily life and works of art composed of scrap materials. For many artists, the Zen-philosophical ideas of John Cage on the inseparability of life and art, rejecting a recognizable hierarchy between art and life (*why should producing a painting be more important than picking a bunch of flowers?*) became sources of inspiration. And as artists expanded their spheres of activity, the arts assumed social functions: raising awareness of social injustice or improving poor living conditions, for example. In order to achieve their aims, art activists asserted that everybody must have the opportunity to develop their own creativity, an opportunity they felt was vanishing due to society's ongoing technologization. German artist Joseph Beuys foresaw a better world where everyone would be an artist and *intuition* (a kind of shamanic approach) and *ratio* (culturally conditioned rationality) would merge harmoniously. The arts would no longer remain the exclusive domain of museums, commercial galleries, concert halls, or theatres, but would take to the streets to reach more people and encourage greater participation.

This utopian vision seems quaintly historical now, when there's nothing much to be seen on the streets except passing cars and people hurrying to work, when Art as a recognized profession has again retreated into the studios and is again dominated by museums and commercial galleries. Yet valiant attempts were made to realize it, and remembrance of a time when play was taken seriously and imagination was power is both inspiring and illuminating.

Exemplary of the implementation of the new ideas was a group of Dutch artists in Amsterdam that drew people from the streets to the museum and carried art from the museum to the streets. At its core were three artists who, though they had emerged from different backgrounds, shared similar ideas and complemented one another perfectly—inventive and practical Max Reneman, visionary and magical Robert Jasper Grootveld, and creative and original Theo Kley. Together they conjured up beautiful, playful projects that encouraged participation, and events—mixtures of street theatre, Happenings, and performance—that defied the conventional descriptions of that time. They committed themselves absolutely to the emerging views on the importance of creativity and the value of an indiscriminate combination of daily life and art. Their inventive individual and collaborative projects were amusing and delightful to view, as well as being cleverly conceived and implemented very precisely to address issues of environmental pollution, wasteful consumerism, and the essential place of *homo ludens* (playful man) in life. And because their art was serious fun, the news media paid attention to it. Who they were, what they did and why and how they have been appreciated—these are the subjects of this book.

progressive art policy in the netherlands

By the 1950s, Amsterdam's Stedelijk (Municipal) Museum had become world famous for its progressive art policy. As soon as Willem Sandberg (1897–1984) became director in 1945, he began acquiring the kinds of art that he believed demonstrated a break with the old, a desire for renewal, an expression of creativity and experimentation. He championed CoBrA, a group of young painters from Copenhagen, Brussels, and Amsterdam that fashioned a new kind of art: colorful, expressionistic, and childlike in its spontaneity. Among these experimentalist painters were Karel Appel (1921–2006), Corneille (van Beverloo) (1922–2010), Constant (Nieuwenhuijs) (1920–2005), and Asger Jorn (1914–1973), to name only the most well-known. In their manifestos the CoBrA group proclaimed that the old order had ended, and that out of the resultant chaos a new order, a new society would emerge. For them the new artistic experiment meant both using materials in experimental ways and casting away all the old standards and rules that governed art. As Willemijn Stokvis noted in *CoBrA, de weg naar spontaniteit* (*CoBrA, the Road to Spontaneity*) (2001):

> It was like groping to start again, an attempt to express themselves in a completely spontaneous way like children, like primitives, like the mentally ill. For those who approached creative expression in this manner, it was almost inevitable that the experiment would also affect the establishment, yes, the whole of life.

Some of the CoBrA artists—including Jorn, Constant, and the Belgian painter Dotrement—held Marxist views on art's position in the future society, aiming to achieve a new people's art and to educate the general public toward better aesthetic taste. In 1949, the first CoBrA exposition in the Stedelijk resulted in an uproar. The sleekly spacious white rooms designed by architect Aldo van Eyck (1918–1998) did justice to the hefty expressionistic paintings of the experimentalists, as the CoBrA artists called themselves. And the publicity surrounding the rebellious and provocative pamphlets they circulated attracted throngs of people to the opening. But outrage ensued when Dotremont, accompanied by a recording of African drumming, read a French text that regularly repeated the word *soviétique*. Several members of the audience stormed out of the room. (Stokvis, p. 244)

Sandberg's institutional model was the Museum of Modern Art (MoMA) in New York, which in the early Fifties was backing American Abstract Expressionist Painting—described by influential art critic Harold Rosenberg in 1952 as an

"all-out revolt against tradition that represented nothing but the artist's existential, even moral struggle to discover and re-create his authentic self." (*Art News* 51/8, Dec. 1952) Sandberg intended to transform the Stedelijk from a parochial, Dutch-oriented institution into a truly innovative international museum of modern art, and his credo was "the future starts today, come along!" By the end of the Fifties he had succeeded in developing the Stedelijk into one of Europe's most important centers of modern art, celebrated not only for its curatorial take on painting and sculpture, but also for its explorations in the fields of graphics, design, and photography.

In the Netherlands, Sandberg was both highly praised and harshly criticized. The art-critics most antagonistic to his views called him an "art-Bolshevist," a "barbarian," a "dictator," and a "half-formed follower of fashion who frittered away the people's tax money and gave the museum to the dogs." (Van Galen and Schreurs, p. 143) Since the museum's founding in 1895, Amsterdam's local artists' societies had been accorded the right to exhibit there. But after Sandberg took charge, he moved to curb that right—in his opinion the locals were merely following the well-trodden paths of figurative realism. During his tenure, contemporary Dutch artists, especially those who had grown accustomed to holding regular exhibitions in the Stedelijk, became particularly embittered. After introducing the CoBrA group, which he saw as a mirror and motor for social change that had left the beaten track and was renewing art, he doubled his effort to banish the local groups impeding his focus on experiment and innovation. In his view he was laboring to strengthen the Stedelijk's ties with foreign countries by internationalizing its exhibitions, and he needed more space for that effort. He ordered the artists' societies to move their exhibitions to the Fodor Museum on the Keizersgracht. They protested, insisting that it was absurd that only experimental foreign artists and their Dutch imitators were exhibited, "while hundreds of serious, honest workers were being cast on the streets and neglected." (Van Galen and Schreurs, p. 138) In the end, despite Sandberg's best efforts, an influential member of the City Council named De Roos supported the artists' societies' right to continue their Stedelijk exhibitions.

One of the societies that had protested most vigorously against Sandberg was a group known as *de Keerkring* (the Turning Cycle), so called because they organized annual programs of Stedelijk exhibitions. The *Keerkring* had introduced themselves to the public in 1949 with an exhibition proclaiming that overcoming the political and religious differences in the Netherlands was an essential national cultural goal. It was an ideal widely shared by progressive Dutch politicians, activists, intellectuals, and artists; a constituency that, after having suffered the trauma of World War

II, felt it was time to abolish all previous divisions between political and religious convictions. Before the war, Dutch politics had broadly distinguished between Catholic, Protestant, and Socialist (including Communist) parties, with subdivisions of those groups contending amongst themselves with their own newspapers, radio stations, and schools. The three divisions had regarded each other with open hostility. But during the conflict the Dutch people had worked together regardless of their party or religious affiliation, and even the Communists had come to be highly appreciated. After the war, as the country began rebuilding, most progressive thinkers advocated continuing the working relationship, avoiding a return to the prewar compartmentalization.

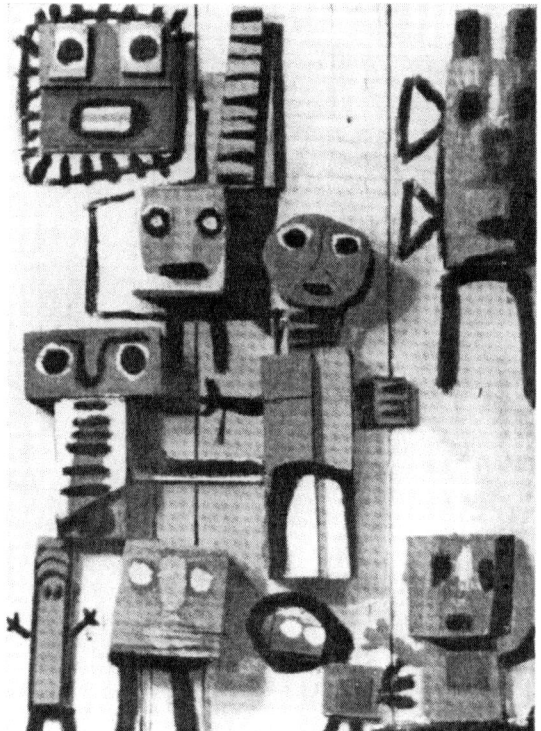

Karel Appel, *Questioning Children* (P. H. ten Hoopen Archive)

The catalog of the first Keerkring exhibition illustrates how the group imagined that a broad coalition of Dutch artists—regardless of their differing aesthetic motivations and sensibilities—might reinvigorate the nation's culture. The CoBrA artists were represented: Karel Appel submitted two primitivistic scrap-wood panels entitled *Questioning Children*; Constant presented the childlike, naïve painting *Sunday School*; the *Visages* paintings by Corneille (Guillaume Cornelis van Beverloo)

Assault on the Impossible ▬ 3

were done in the same style; and Ger Lataster offered an almost-abstract work entitled *Two Women*. (That same year, Appel painted a mural—also entitled *Questioning Children*—in the canteen of the old city hall on the Oude Zijds Voorburgwal, which, after complaints from the civil servants that it spoiled their appetite, was painted over. When the structure became Hotel The Grand, the mural was restored. Today it can be seen at the entrance of the hotel restaurant.) Beside CoBrA's disquieting experimental images, the Keerkring curators placed figurative-realist paintings, carefully giving equal weight to both modernist and traditional work. A year later, in 1950, Keerkringers Rudy Bierman (1921–1972), Cor Basart (1915–1991), Arie Kater (1922–1977), Rik van der Mey (1920–1982), Jan Sierhuis (b. 1928), and Dick Zwier (1915–1993) presented a much less-inclusive vision at the Stedelijk. This small group formed a hard core that would eventually move the Keerkring back from experimentalism toward figurative-realism, the style most Dutch artists favored at the time. Yet, even as the hard-core figurative realists made a public case for their aesthetic, the society itself remained open to all kinds of other styles and impulses.

This tendency toward inclusion was not shared by another influential group, the Realists, which jeered openly at the CoBrA experimentalists in their exhibition catalog *De Realisten*. The Realists accused Sandberg and the Stedelijk of knowingly perverting the development of authentically Dutch art forms and artists. Responding to the Realists' categorical rejection of experimentation in a Keerkring exhibition catalog of 1953, the Keerkring figurative-realists added simply that they saw themselves as painters "who wanted to be connected with reality" and viewed the CoBrA group as too dogmatically experimental.

In 1954, intending to rouse the public's curiosity and lure it in for a closer look, Sandberg incorporated huge glass outer walls into the New Wing of the Stedelijk so passers-by on the street could view the art exhibited inside. For its 1955 exhibition in the New Wing, the Keerkring invited painter Peter Alma to present his stylized, communist-oriented representations of working farmers and laborers and accepted some charming portraits and still lifes from a group of female painters known as the *Amsterdamse Joffers*. The work of another guest artist, Gerrit Benner (1897–1981), consisted of large, colorful, almost-abstract surfaces. And, despite the previous criticism of the CoBrA program, Corneille was again invited to exhibit. The 1955 exhibition presented an amalgam of styles that further illustrated the Keerkring's devotion to inclusiveness. Their 1957 exhibition catalogue stressed the fact that all they really wanted to do was paint—without a lot of talking or "publishing of manifestoes." In his review of that exhibition, the influential art critic Marius van Beek called the Keerkring "a group of sympathetic painters who regarded nature as the source for their creative deeds" (*De Tijd*, 12/17/1957).

discontent with the stedelijk museum

 Towards the end of the Fifties, public discontent with the art policy at the Stedelijk grew more vocal. One of Sandberg's major opponents was Vincent Prange, an influential art editor for the popular daily newspaper *Het Parool* (*The Password*), so named because as an underground newspaper during the war it had to be delivered in secret. According to Prange, by showing only the work of "bunglers" like Picasso and the "boundlessly overrated" like Braque, Sandberg had completely demolished the Stedelijk as an institution. Prange's 1957 pamphlet *The God Haj Haj and Rhubarb, with the Chopping-Knife through the Jungle of Modern Art* was a raving tirade against experimentalism and a passionate plea for "beauty in art," which he insisted was threatened and abused.

The A-Dynamic exhibition, Fodor Museum, 1961 (Stedelijk Museum Archive)

Frustration with the Stedelijk's policies was also growing among a newer generation of Dutch artists. In 1961, Ger van Elk (b. 1941) and Wim T. Schippers (b. 1942)—multi-disciplinary artists who had studied together at Amsterdam's Rietveld Art School—published a series of A-Dynamic Group manifestos denouncing the pathos and violence of the abstract-expressionist painters, whose enormous and overpowering canvases seemed to obsess the Stedelijk curators. As a parody of Jackson Pollock's Action Painting and other serious, but in their opinion meaningless, American art, they also curated an A-Dynamic exhibition at the Fodor Museum that consisted of two rooms, one filled with glass shards, another containing salt and a fountain, set off by scattered formless sculptures and meaningless drawings.

The A-Dynamic Group's ideas and use of ordinary materials in a museum setting accorded with the ideas of George Maciunas. Inspired by the works of Marcel Duchamp and the Dadaists, Maciunas, a New Yorker of Lithuanian extraction, had founded the international art movement Fluxus. (The literal meaning of Fluxus is diarrhea, purification, or flow.) Fluxus exhibitions combined multiple art forms—including music, visual art, poetry, and film—and advocated purging commercialization from professional art. Maciunas accepted the A-Dynamic Group as the European phalanx of the Fluxus movement. As Dutch members of the Fluxus cadre, Schippers and his collaborators organized festivals, Happenings, manifestations, and exhibitions in Amsterdam galleries. Together with Willem de Ridder (b. 1939), founder of the Fluxus Postorder Company, they established institutions like AfSRiNMoR (Association for Scientific Research in New Methods of Recreation), the Institute for Advanced Studies, and the SEO (Society for Exhibition Organizing). It was serious fun, employing humor as an instrument to open new horizons and to kick against the authorities. Most of the Dutch participants were in their twenties and wanted to do away with old institutions. And since the Fluxus art forms were based on public participation, the A-Dynamic Group emphasized the idea that there is no hierarchical relationship between artists and their public. As a fundamental tenet of the counter-cultural revolution sweeping the Western world, this notion of the non-commercial became the main art trend during the Sixties and most of the Seventies.

At the same time as the A-Dynamic artists became more active, the Keerkring continued its fight against the Stedelijk policies—rejecting the notion that "the authorities" were best positioned to decide what belonged to the realm of art. The Keerkring artists published their own manifestos arguing against locating art in specific categories, meaning that the fact that they painted figurative work did not mean they were against non-figurative painting. As Max Reneman (1923–1978), the chairman of the Keerkring since 1960, put it, "just because I am right-handed does not mean that I hold anything against my left hand." (Wingen, 11/07/1964) The Keerkring artists prided themselves on refusing to take sides in

any battle of fads, proclaiming themselves against all officially-designated styles. On the occasion of its fifteenth anniversary, in 1964, the Keerkring published a booklet in which Reneman declared:

> It isn't the category of an artwork that counts, but the passion artists bring to their creative process. The Keerkring, which is a bunch of individualists, chooses the What. We take the liberty of painting what we want. Grandpa and grandma, house, tree, beast, flower and nude, the devil and his mother—it doesn't matter how beautiful or ugly, tasty or boring, as long as it gets on the canvas . . . preferably complete with the hallucination or vision that generated it. And this is the yardstick to measure it by: visual reality as revelation. Figurative-Realism is a slogan as futile as all the others, at best a starting-point. But visionary realism is a revelation, a vision, a deed, an event for those who see it.

Caption: Keekring exhibition invitation, 1967
(Ed Dukkers litho, P. H. ten Hoopen Archive)

Assault on the Impossible ▬ 7

Sandberg's immediate successor was Edy de Wilde (1919–2005), who directed the Stedelijk from 1963 to 1985. Though he, too, was annoyed by the artists' societies, his only response to them was to place signs in four languages reading "Not the responsibility of the Museum" on the door accessing their exhibitions in the New Wing. In response, Max Reneman wrote an open letter to the City Council in which he proposed removing the name *Stedelijk* from the museum because the adjective "municipal" did not accurately describe the many international exhibitions presented there. Reneman suggested it should be renamed the "Recreational Center for Visual Manifestations," with the name posted on the building in four languages, because in his view the Stedelijk had developed into nothing more than a branch annex of the international art market with an acquisition policy aimed at importing foreign leftovers and minimizing the impact of Dutch artists on the foreign market. And so the sniping between the artists' societies and the Stedelijk continued.

In 1969, the Federation of Visual Artists occupied the Stedelijk on several occasions. They declared de Wilde's policy a "symptom of authoritarian social structure," and characterized the Stedelijk exhibitions as "window displays for the art market." (Van Galen and Schreurs, p. 173) They also declared that many of the exhibitions advanced an American imperialist agenda by showing expensive, CIA-sponsored works of art. (This allegation was not mistaken, as research in the Eighties proved. As propaganda against Cold War communism, the CIA together with members of the Rockefeller family, who were on the board of the MoMA, supported European exhibitions of huge American abstract canvases meant to stand not only for experimental, autonomous avant-garde art, but also for freedom of individual expression in a free world. (See F. Frascina, *Pollock and After: The Critical Debate*, pp. 114–15, 125–33))

Though the protests did not change the curatorial policy at the Stedelijk, the artists' societies did defend their right to continue exhibiting there until 1985, when Wim Beeren became director and finally succeeded in pushing them out. However, in 1969 the Keerkrings' policies were radically transformed when Max Reneman encountered Robert Jasper Grootveld (1932–2009) and Theo Kley (b. 1936). Both Grootveld and Kley had long histories as activist artists of the streets, and through their influence on Reneman street art entered the museum. In fact, after 1969, the openings of the Keerkring exhibitions at the Stedelijk became almost extensions of the street. During many of them, hundreds of curious viewers invaded the distinguished halls of the museum to participate in strange processions, listen to performances by a "fruit organ" and the "Resistancy Orchestra," or engage with suggestively imaginative constructions.

creative activism
the new players

Who Was Max Reneman?

Max Fyko Reneman was both a painter and sculptor enrolled in the Department of Monumental Art at the *Rijksacademie* (State Academy) in Amsterdam and a dentist maintaining a small private dental practice and a half-time job at the National Health Service, where he specialized in prosthetic dentistry. He became a member of the Keerkring in 1957, and from 1960 until his premature death in 1978, he functioned as the society's most prominent chairman. He was a man of outspoken ideas, a particularly charismatic personality who pursued his ideas with perseverance and a peculiarly mocking kind of humor. For him there was little difference in the process of creating a dental prosthesis or a painting: "It is creating order in chaos." (*De Telegraaf*, 01/01/1962) He had a way of making things clear in unexpected and imaginative ways.

Reneman was born into a prosperous, intensely Catholic family. In Groningen, where he was raised, his father had a wholesale dental equipment business. As a young boy, he displayed a talent for drawing and announced that he wanted to become an artist; but since art was no way to make a secure living, his father insisted that he learn a trade. At his father's urging, Reneman first attended Canisius College, a rigorous Jesuit school in Nijmegen, after which he studied dentistry in Utrecht, graduating when he was twenty-two years old. In 1945, after finishing his dentistry studies, he embraced his own inclinations by enrolling at the Rijksacademie. There, under the guidance of Heinrich Campendonk (1889–1957), a German Expressionist who had connections with August Macke and Franz Marc of the *Blaue Reiter*, he applied himself to studying stained-glass construction, glass-in-concrete techniques, and concrete relief-stamp printing. He also studied drawing and painting under Jan Wiegers (1893–1959), a painter belonging to Groningen's Expressionist group *De Ploeg*.

Throughout his life, Reneman was active as both an artist and a dentist, with his expertise in dentistry receiving almost as much professional recognition as his artistic creativity did (in 1963 he was appointed to a teaching position in the dentistry faculty at the *Rijksuniversiteit* (State University) in Utrecht). But his work as an artist brought him his greatest public renown. Through the years he received numerous monumental commissions, including a glass-in-concrete wall and a relief pillar for the Roman Catholic Church on Kanaleneiland in Utrecht in 1960, and a large sculpture, *Monument for Fallen Butterflies*, in Eindhoven

Max Reneman self-portrait (Ole Eshuis photo, Ike Cialona Collection)

in 1968. He claimed that his fondness for monumental work in glass resulted from his strict Catholic upbringing. In his youth he had been confronted with the churches of Pierre Cuypers (1827–1921), an architect responsible for the designs of at least a hundred Dutch Catholic churches (as well as the Rijksmuseum and Central Station in Amsterdam), and it was while sitting in those churches that he began dreaming of making stained glass windows himself. (Illés, 01/09/1976)

Reneman gave himself passionately to his commitments. When he was appointed Keerkring chairman, he tirelessly visited the studios of young Amsterdam artists he considered suitable for inclusion in Keerkring exhibitions. In addition to reaching out to younger artists, he also began publishing critical articles in the weekly *De Nieuwe Linie* and the glossy monthly magazine *Avenue*, mostly about upcoming and controversial young artists and trends. In a later interview he mentioned that he had never quite understood how he had time to do it all. "Perhaps it was because he never watched TV?" (Ibid.)

He wasn't particularly interested in actual political movements like Provo, but he was fascinated by the creativity and originality of the people involved in them.

Who Was Robert Jasper Grootveld?

On March 19, 1962, *Het Parool* published the following news:

> Robert Jasper Grootveld, the 29-year-old former window cleaner from Amsterdam who conducts his own anti-smoking campaign, has again caught the attention of the city police. This time policemen did not undertake action because of the fact he defaced cigarette ads with a large capital K [signifying] *kanker* (cancer), but because they feared a public disturbance by this R. J. Grootveld. The man had announced that he had installed a K-temple in a former carpenter shop in the Korte Leidsedwarsstraat 29 (near the Leidseplein), property of Nicolaas Kroese, and that he would hold a public anti-smoking meeting there. But the meeting took place without incident. Two policemen observed the meeting and noted that Mr. Grootveld spoke dressed in a remarkable costume with some sort of hat with a built-in pipe. The policemen reported to their chief that their estimate of the number of interested people listening to him varied between four and five. At eleven thirty, the meeting, which had passed very quietly, was over and everyone went home quietly. Mr. R. Grootveld included.

Reading between the lines it seems clear that neither the reporter nor the police had expected Grootveld's anti-smoking event to pass so "quietly"; and also, because they considered him dangerous, that they viewed the small turnout to be laughable.

Since 1961, the authorities had monitored Grootveld as he left slogans like "A CONTENTED SMOKER IS NOT A TURMOIL-STOKER" (*een tevreden roker is geen onruststoker*), "STILL SMOKING? CANCER," and the added letter "K" to cigarette advertisements on billboards and kiosks owned by the Publex Company. They were uncertain how to respond. Was his anti-smoking campaign dangerous? Were his actions

directed against civil authority? Would they result in riots? Introducing himself as the "Fruitboy of Tiel" (the well-known icon of a jam company), Grootveld himself made a point of informing Publex whenever he modified its ads. One night he was caught working on a Publex kiosk and arrested. After a brief court hearing on March 14, 1962, during which he refused to pay the court-imposed fine of one thousand guilders for each vandalized advertisement, he was sentenced to sixty days in jail.

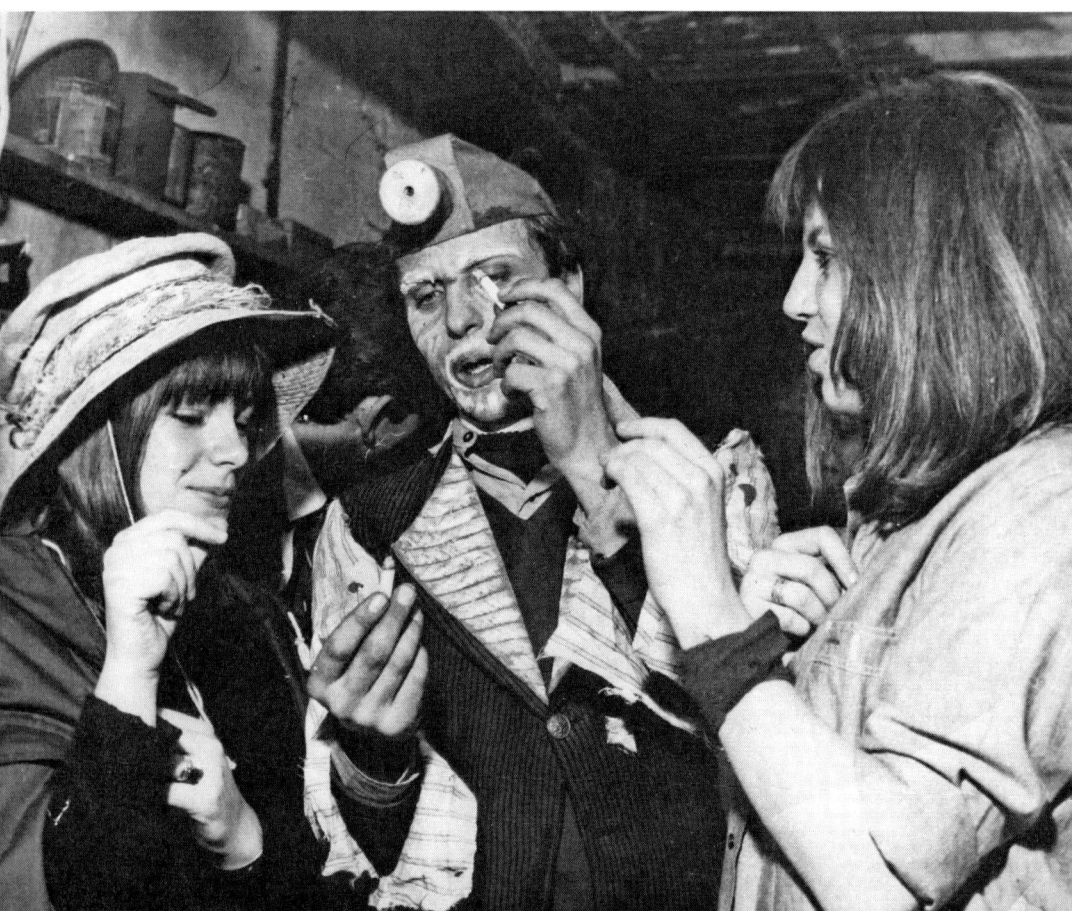

Robert Jasper Grootveld in his Anti-Smoke Temple (Ab Pruis Archive)

The ironically dismissive tone of the story in *Het Parool* proved premature. Following Grootveld's release, his anti-smoking campaign quickly grew to include anti-materialist, anti-consumerist aspects and began to garner significant public attention and support.

Even before Grootveld manifested himself as the "Anti-Smoke Magician," he was a well-known figure in Amsterdam. As a young man he'd had dozens of jobs: as ice cream vendor, assistant in a photographic reproduction shop, publicity assistant, demonstrator of gadgets for the Hema department store, store assistant, and window cleaner for the Hirsch building on the Leidseplein. And whenever he wasn't working, he took to floating on a raft through the canals of Amsterdam cross-dressed in women's clothing, often stopping in front of the sophisticated Excelsior Hotel to fry an egg. At one point, in drag, he spent several months peddling a *bakfiets* (carrier-cycle) to Paris, which brought him significant public notoriety. (See Kempton, p. 24) On his return to Amsterdam he was offered a job as assistant to documentary film-maker Jan Vrijman (1925–1997), who in 1961 was filming *The Reality of Karel Appel*, which recorded the CoBrA painter at work slapping paint on a huge canvas. (During the course of the film, Appel famously declaims: "I paint like a barbarian in a barbaric time.") But Grootveld's time with Vrijman did not last long.

**Jasper Grootveld cross dressing
(Eric Duivenvoorden Archive).**

Assault on the Impossible ▬ 13

His life changed dramatically in 1961, after he voyaged to South Africa as a cabin boy on the ship *De Johan van Oldebarneveldt*. In an obscure Durban shop he discovered a mysterious case containing the magical implements of a medicine man who had been murdered. The Africans appeared to be frightened of it, but the discovery led Grootveld to view himself as a magician, or shaman. He intuited that people in the so-called "developed" Western countries were every bit as subject to powerful uncontrollable forces as were the so-called "primitive" Africans. However, while the lives of African people were governed by occult and magical forces, westerners were governed by a consumerist compulsion—with the west's enslavement to cigarettes being one of the compulsion's excrescences. Addicted smokers were victims of their smoking and served as smoke sacrifices in a primitive worship cult, and the contents of the case he had discovered empowered him to organize rituals to banish the malign consumerist spirits that had taken control of them. (For an image of the fetish case see http://harryartist.wordpress.com/2011/08/30/het-lievertje/; see also Van Reeuwijk, p. 11.)

The force of Grootveld's African insight powered the anti-smoking campaign he initiated. To break the enchantment of the cigarette companies' advertising jingles, he composed incantations—*warnings*, as he called the slogans he marked on the cigarette ads. For his battle he invented a special language that repeated such unusual conceptions as the "Sickening Class of Shopkeepers," "God John Public" (*Jan Publiek*) the ordinary man in the street, and the "Dopesyndicats," which to him meant the tobacco companies. He became convinced that psychological discoveries were being misused by the Dopesyndicats to oppress the masses. He proclaimed: "The clever publicity boys, the witch doctors of our Western Asphalt Jungle, are projecting their images on the public subconscious, and God John the Almighty Consumer kneels." He himself never bought cigarettes, instead smoking those that were offered to him as a gestural form of public service intended to help people rid themselves of their cigarettes: the more *he* smoked, the less someone else did. (Van Reeuwijk, pp. 17–20)

Grootveld continued his ritual events at his Anti-Smoke Temple at Korte Leidsedwarsstraat 29 until the early summer of 1964, when it accidentally caught fire. By June of 1964, when he moved his magic-inspired performances and Happenings to a small square on the Spui centered on the sculpture known as *het Lieverdje* (the little darling), his audience had swollen from "four or five interested listeners" to scores—sometimes hundreds—of riotous young Amsterdamers. In an attempt to control the Happenings on the Spui, the police began cracking down. Searching their records they discovered that Grootveld still had twelve days to serve on his kiosk-modification sentence. In August 1964, the increasingly violent police response to the Lieverdje Happenings combined with actions by Grootveld's politically-minded friends brought him a second jail sentence.

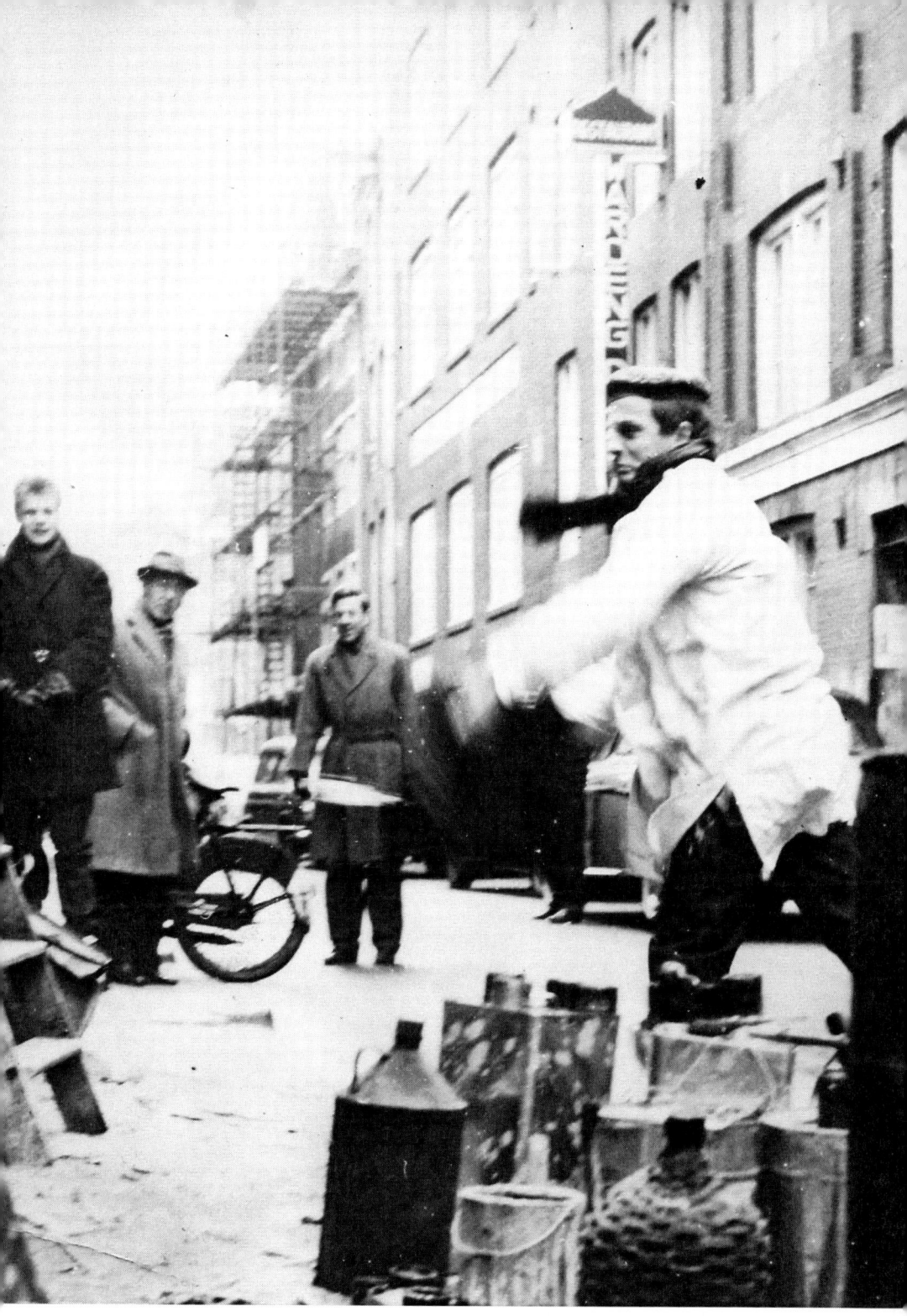

Jasper Grootveld painting the front of his Anti-Smoke Temple (Ab Pruis Archive)

After serving his second jail term, Grootveld began a series of speeches at the Social Religious Discussion Center, located at 16A Raamstraat. Every Friday night a group of well-known academics, philosophers, and world reformers assembled there to speak and debate. Among the regular visitors were actor Otto Sterman (1913–1997), who in 1952 had become the first colored stage actor in the Netherlands; Dr. Meinsma, director of the Office of Cancer-registration and anti-smoking campaigns; and Lou de Palingboer (1898–1968), who at that time had a large group of followers and was nicknamed "the Eel Farmer" because he had once been a fish vendor. Palingboer was eloquent and charismatic and presented himself as the new immortal Messiah. Another frequent visitor to the Center was Nicolaas Kroese (1906–1971), preacher of the New World Mathematics and owner of the Five Flies restaurant in the Spuistraat, which was favored mainly by American tourists. Kroese was convinced that he had discovered in the Jewish Kabbalah the number representing world peace, and he sent telegrams to prominent people all around the globe specifying exactly when and how world peace would manifest itself.

Kroese also owned the small handyman's shed off the Leidseplein that had become the Anti-Smoke Temple. In March 1962, when Grootveld first began holding his ritual services in the shop, they were mostly attended by a small group of well-known actors and writers belonging to the Leidseplein "scene." These artists comprised the only truly avant-garde arts scene in Amsterdam and were intensely interested in any innovative artistic manifestation. They met at venues on or near the Leidseplein like the artist club *De Kring*, *Café Reijnders* and *Café Eylders*, the American Hotel, the Dancing Lucky Star, or in a small nearby coffee shop called *De Groene Kalebas* (the Green Gourd) and *De Poffertjeskraam*, a kind of pancake house. Among the attendees at Grootveld's rituals were singer/songwriter Ramses Shaffy

The GNOT symbol

16 — Marjolijn van Riemsdijk

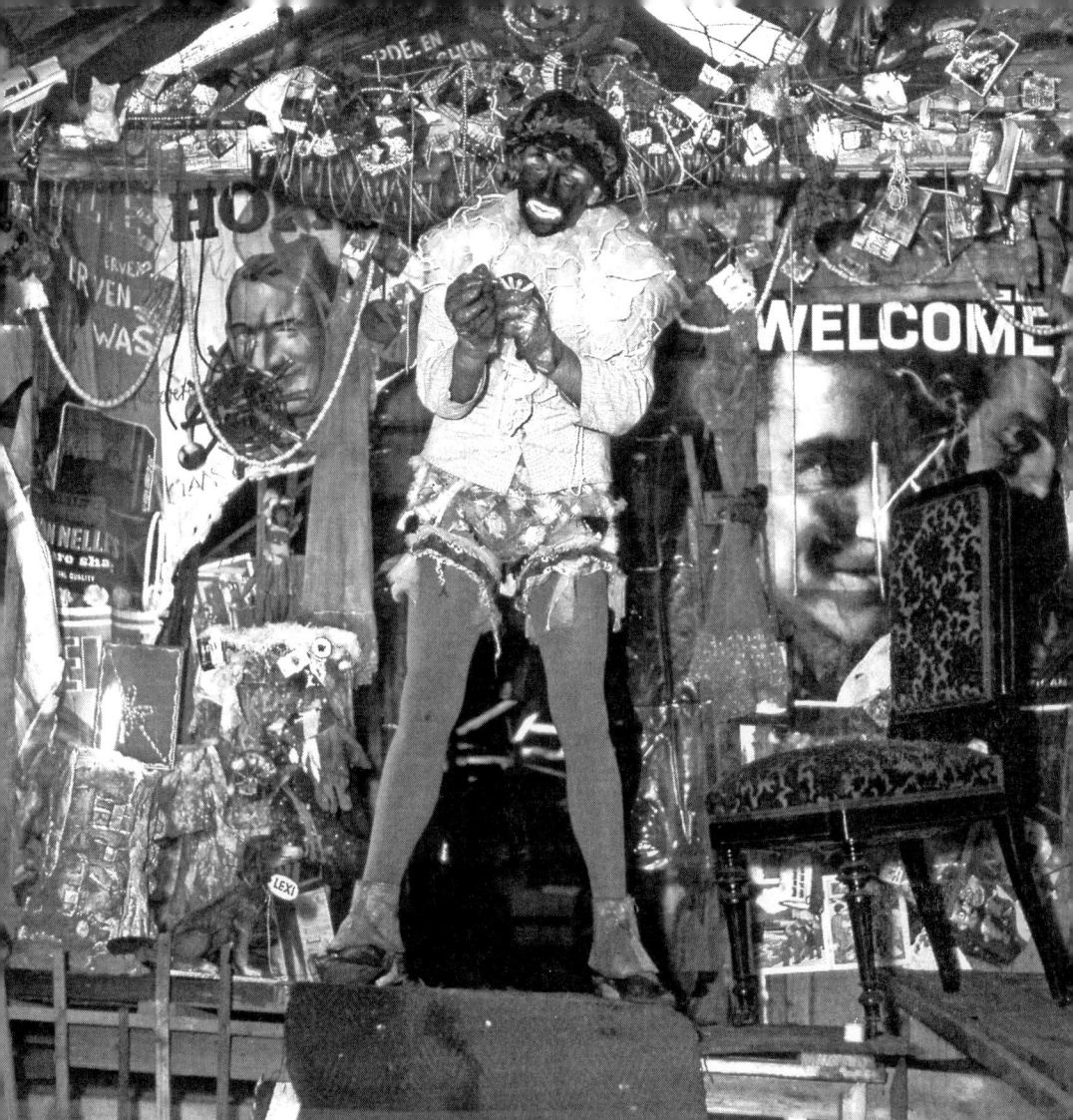

Jasper in the Anti-Smoke Temple (courtesy of Igno Cuijpers)

(1933–2009), writer Harry Mulisch (1927–2010), and the prominent poet/writer Simon Vinkenoog (1928–2009). (See Appendix 3 for more on Vinkenoog.) Members of the group called themselves "conscious nicotinists," which meant that they were conscious of tobacco's addictive effects. Besides tobacco, which they didn't really enjoy, the nicotinists also inhaled conscious-raising drugs like marijuana, which they did. Medical intern Bart Huges became medical advisor to Grootveld's anti-smoking campaign, advancing the informed medical opinion that smoking conscious-raising drugs was not addictive. (In 1965, Huges trepanned a third eye into his forehead, which he claimed brought him a permanent state of euphoria.) This group of more-or-less renowned artists "launched" Grootveld's artistic career,

Assault on the Impossible ▬ 17

recognizing in his ritual performances an early manifestation of the emerging avant-garde performance events known as "Happenings." (See Chapter 5 for a description of how the Happening art form came to the Netherlands.)

For an audience already open to the prophecies of Lou de Palingboer and Nicolaas Kroese, Jasper Grootveld's Afro-magical theorizing was not particularly exceptional. What was clear to them was that he possessed the gift of gab. Though his puns can only be fully appreciated in Dutch, he was a master of word play and games of all sorts. The conscious nicotinists advocated the increased use of marijuana and, since the police had recently started arresting people for possession of it, Grootveld designed a Marihuette game patterned after Russian Roulette. He defined "marihu" as anything that smoked—including straw, wood shavings, weeds, *and marijuana*—but that wasn't tobacco, and the rules for the game appeared as a manifesto titled "Marihu #2." He called his manifesto a magic chain letter and asked people to copy it five times and circulate it among their friends. "Marihu #2" is the document that first identifies the city of Amsterdam as "The Magic Center." (Kempton, p. 26; see also Appendix 1)

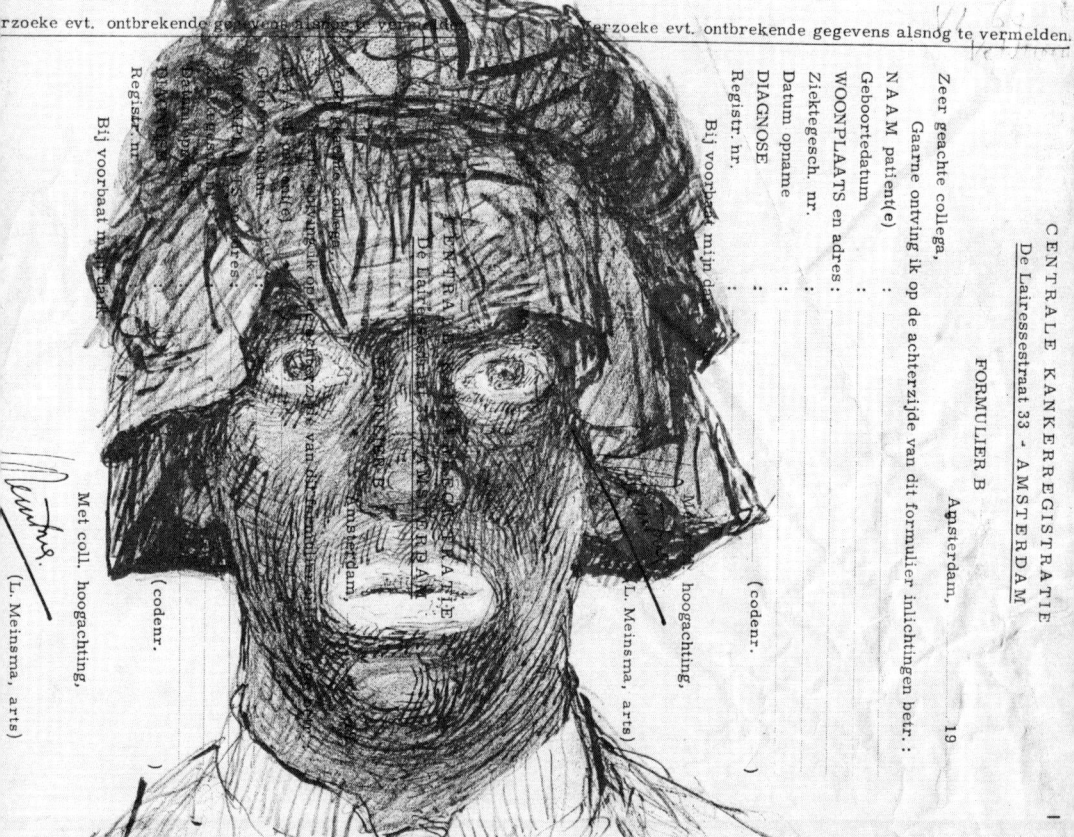

Jasper as Zwarte Piet, drawing by Aat Veldhoen (Theo Kley Archive)

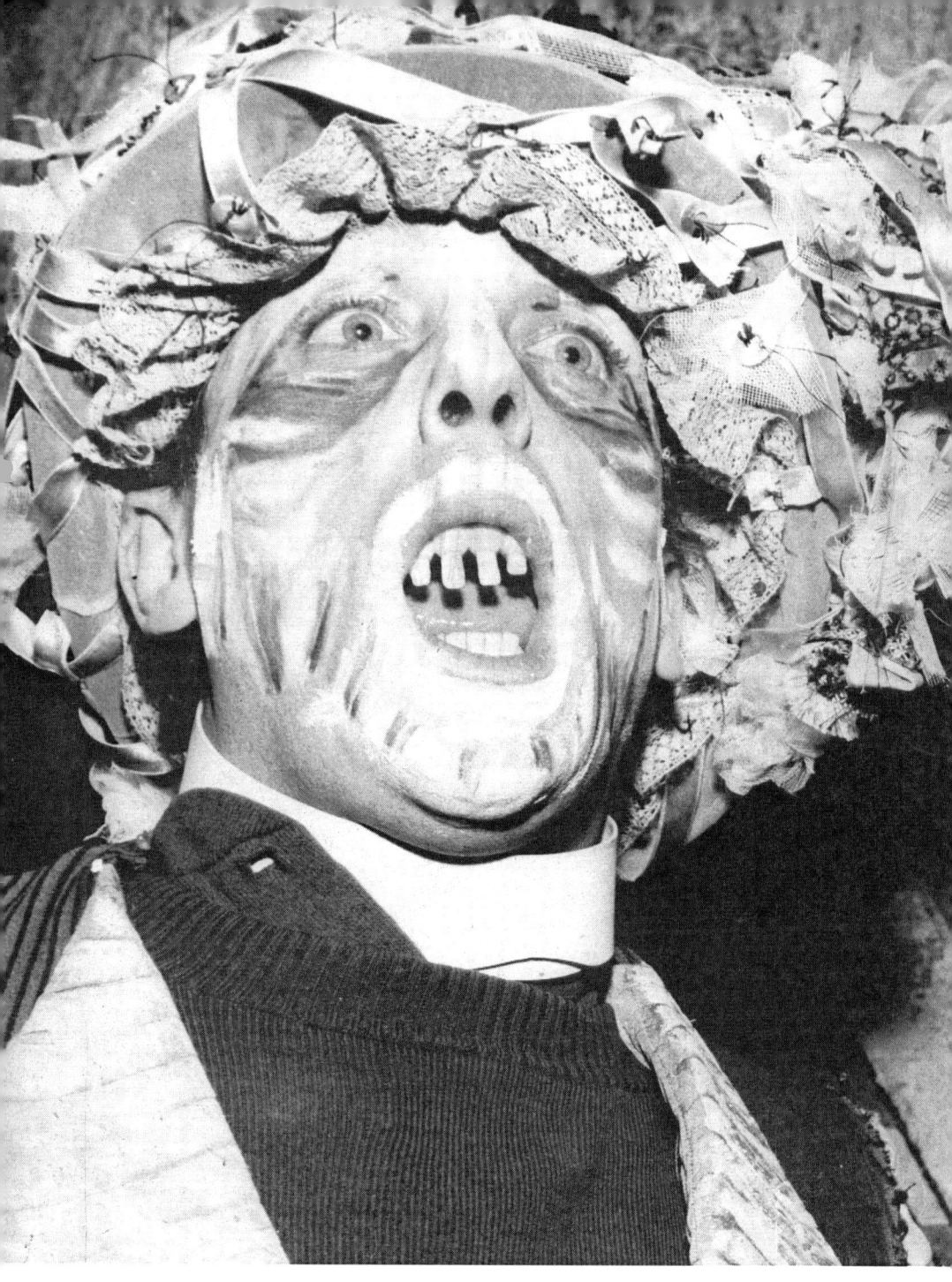

Jasper in full rant mode (Ab Pruis Archive)

An essential aspect of every ritual service in the Anti-Smoke Temple had involved invoking "Klaas" (associated with "Sinterklaas," the Dutch Santa Claus and patron saint of Amsterdam) as a symbol and prophet of Amsterdam as the Magic Centre. Grootveld was an accomplished symbolist and everywhere you looked in the Anti-Smoke Temple you saw the apple sign he invented to stand for GNOT—the word is an abbreviation of God and *Genot* (hedonistic Lust)—the force that powers release from consumption-enslaved existence. At his rituals he predicted that the world's other prophets would also soon appear in Amsterdam. His term for the arriving prophets was also *Klaas*, and he foresaw a coming Council of *Klaasen* that would resolve the confusions and corruption of modern civilization. This prophetic vision led to a new campaign. In addition to chalking up K for cancer, he now took to marking walls and advertisements with the slogan "Klaas kom!" "Klaas is coming," he preached. "Klaas must come. Klaas will come!" (Kempton, p. 30)

The Happenings on the Spui

In 1964, during one of Grootveld's scorching speeches, the Anti-Smoke Temple caught fire. He and his audience emerged unhurt, but the Temple was gutted. (See Appendix 7 for Gerben Hellinga's eyewitness account.) Grootveld then moved his ritual performances to the Spui square centered on the sculpture known as *"het Lieverdje,"* which had been created by Carel Kneulman (1915–2008). Het Lieverdje depicted a cocky street urchin. In 1960, the Hunter cigarette company had presented the bronze statue to the people of Amsterdam, and because of Hunter's involvement Grootveld deemed it to be a symbol of "the future enslaved consumer" and organized his anti-smoking events around it.

The first "Happening" on the Spui was an initiative of the Art of Living Inc., an organization founded by Simon Vinkenoog and Oliver Boelen to integrate every form of creativity into society—Grootveld, cineast Louis van Gasteren (b. 1922), and Bart Huges were members of the group. The event took place on the evening of June 13, 1964, when Grootveld, dressed as "Zwarte Piet" (Black Pete, Sinterklaas's assistant), lit a paper band and placed it around the shoulders of the Lieverdje. The action was meant as a flaming protest against tobacco industry advertising. After that first event, every Saturday night was "bingo!" with as many as two hundred bystanders forming a ring around the sculpture chanting "Publicity! Publicity! More Publicity!" and hacking out the coughing song, "Uche Uche." During one early Happening, pianist Enrico Neckheim played on a burning organ and American poet Pete Stevens recited poems with candles burning on his shoulders. At another, Grootveld distributed paper-mâché masks of his hands and feet and graphic artist Aat Veldhoen (b. 1934) distributed two hundred prints of a couple having sex. (As a counterbalance to the inflated prices

charged by gallery art dealers, the performers emphasized that Veldhoen's prints cost only a few guilders. Shortly after the event Grootveld and Veldhoen were summoned to court on the charge of dispersing licentious images.)

Initially, the police reacted pompously to the events at the Spui, but didn't actually intervene. "[T]hey only want publicity. When it looks like it's getting out of hand we say 'boys, stop it,'" a policeman explained to a reporter of *Trouw* on August 10, 1964. But after the Provos joined the Happenings in 1965, the increasingly confrontational aspects of the events provoked rows and fights with the police. (One of Provo's core ideas was to employ acts of provocation to force authority to tear off its benign mask.)

Provo

In 1963, a young anarchist named Roel Van Duyn (b. 1943) had moved to Amsterdam. In early 1965, he teamed up with Rob Stolk (b. 1946), a charismatic nineteen-year-old pacifist from Zaandam, north of Amsterdam. Stolk and Van Duyn began aligning their activist politics so as to attract the attention of an anti-social youth cohort that social theorist Wouter Buikhuisen had labeled the *nozems*—Dutch working-class juvenile delinquents who in many ways resembled the English Teddy Boys. Because the nozems were bored, unemployable, and deliberately provocative, Buikhuisen called them *provos*.

Van Duyn's background involved a combination of journalism and activism. In early 1965, he published a small anarchist broadsheet called *Horzel* (*Gadfly*), which was intended to annoy the political authorities. It ran only a few issues. After he and Stolk joined forces, they published *Barst* (*Burst*), which ran only one issue, April 1965, but included an open letter from "pre-Provo" Garmt Kroeze to the B. V. D. (the Dutch FBI) proclaiming that they, the Anarchists/Provos, would "burst the smooth façade of a society that debases human beings by turning them into machines of conspicuous consumption." Bursting the façade would bring on the collapse of middle-class society.

Stolk and Van Duyn adopted Buikhuisen's term *Provo* as the title for both a political movement they hoped to establish and a new journal that they proposed publishing. Though anarchists could no longer hope for true social revolution in the Netherlands, the Provos insisted that they could and should provoke the authorities and the State. Provo formally announced itself in a stenciled leaflet dated May 25th, 1965:

> Dear Comrades,
>
> The anti-Bomb movement, which seemed to be the only dynamic element on the Left in Holland, has disappeared up a back alley. The ban-the-bomb groups have given up their work.

The "November 29 Committee" hardly functions anymore and just acts occasionally without any real conviction.

The Peace Committee and the People's Committee do not seem to be able to attract many more supporters and are becoming isolated.

The annual march through Amsterdam, performed with the painful regularity and senselessness of a ritual, only just manages to keep the flame burning.

The Dutch Left will have to find new ways of achieving real results before it loses its attraction altogether. We believe that non-violent dissidence is only incidentally appropriate to our ends because it is not happening on a large scale.

When slogans and gestures fail we have to turn to action and attack. We believe that only a revolutionary Left movement can bring about change!

This preference for direct action leads us to anarchist concepts. Anarchism propagates the most direct rebellion against all authority, whether it be democratic or communist.

The Dutch anarchist movement has been languishing since the war. We want to renew anarchism and spread the word, especially among the younger generation.

How? Through *PROVO*, which will appear monthly starting July 1965.

PROVO is a new magazine—as if there weren't enough already. However, it's the only one radically opposed to this society. Why?

> — Because this capitalist society is poisoning itself with a morbid thirst for money. Its members are being brought up to worship Having and despise Being.
> — Because this bureaucratic society is choking itself with officialdom and suppressing any form of spontaneity. Its members can only become creative, individual people through anti-social conduct.
> — Because this militaristic society is digging its own grave by a paranoid arms build-up. Its members now have nothing to look forward to but certain death by atomic radiation.

PROVO feels it must make a choice: desperate revolt or cowering defeat. *PROVO* encourages rebellion wherever it can. *PROVO* knows it must be the loser in the end, but it cannot miss the chance to thoroughly provoke this society once more.

PROVO sees anarchism as a well of inspiration for the revolt. *PROVO* wants to renew anarchism and bring it to the young.

Our issues will contain material which is varied, up-to-the-minute, and provoca-

tive to the ruling class, and we'll also regularly publish issues devoted to special subjects. On the agenda we have:

— What is anarchism?

— de Sade

— Dada

— Militarism and the Dutch army

— Prostitution

— Revolt and conditions in the Jordaan

— Etc.

PROVO will take the initiative in all kinds of direct action. *PROVO* wants to gather around it a core of anarchist youth. *PROVO* is eager to co-operate with all other anarchist groups.

In addition, *PROVO* will regularly issue pamphlets entitled *PROVOkaties* No. 1, 2, 3, etc.

GIVE US A CHANCE!

None of this will be realized without your help. We desperately need several hundred guilders to set up *PROVO*. For us penniless students the cost of printing the first issue, plus postage, advertising, manifestos, etc., is far too much.

So we ask you kindly but PROVOcatively: send a large sum of money without delay to our administrative address, Karthuizerstraat 14, Amsterdam C.

<div style="text-align: right;">
The Editorial Board

5 May, 1965

(Translation from Stansill and Mairowitz)
</div>

Van Duyn knew of Grootveld's Saturday night rituals at the Lieverdje and considered them "uniquely creative," completely different from anything else going on in Amsterdam at that time. Because the nozems were one of the strongest contingents participating in the events, he and Stolk believed that Grootveld was helping prepare Amsterdam's youth for the emergence of Provo—introducing the idea of street happenings and supplying much of the new vocabulary and symbolism that Provo would adopt. In late May of 1965, at one of the Lieverdje happenings, Stolk and Van Duyn passed out the leaflets announcing their forthcoming anarchist periodical, *Provo*.

Grootveld was intrigued by the idea of the new magazine. After the event he invited Stolk and Van Duyn to his apartment, where he told them that his fa-

ther had been an anarchist and explained that Amsterdam was the Magic Center from which the Klaazen would launch their mission. He sympathized with their anarchist ideals, welcomed their participation in the Lieverdje Happenings, and proposed a collaboration. He even briefly allowed them to place his name on their list of candidates for the city-council elections. But by August he had decided that their actions were too aggressively political. He retired from the election list and, on August 28, 1965, organized his last Happening at the Lieverdje, after which the Provos took over.

The Klaas Chair

At the events organized by the Provos, violent confrontations between police and participants grew fiercer. During the marriage procession in Amsterdam on March 10, 1966, celebrating the nuptials between Crown Princess Beatrix and Claus Von Amsberg, somebody threw a smoke bomb at the royal carriage. At the age of 17, Von Amsberg had served with other German boys that Hitler conscripted at the end of the war, and because of his origins most Dutch were against the wedding. Yet his given name, Claus was eerily similar to the Klaas prophecies Grooteveld had been trumpeting. (In Dutch, "Klaas" and German "Claus" are homophones.) Klaas had indeed come, and after the carriage incident the battles between the police and Amsterdam's political radicals ceased being even remotely playful. Grootveld had nothing to do with the violence, but fearing that he would be accused of complicity, he thought it better to leave Holland for a time.

He visited Sicily for a few months, where he began fabricating a chair out of willow branches, a pair of cow horns, and pieces of rope. The chair grew larger and larger, becoming a seat for the great unknown Klaas who still occupied Grootveld's thoughts. After reading an account of Prince Claus sinking through his seat while on a state visit to Suriname, it also became the chair for "Claus the Klaas," and Grootveld decided to return to Amsterdam. With the Klaas/Claus Chair attached to the roof of his Citroën Deux Chevaux, he detoured to Rome, where he drove around the Vatican three times to charge the chair with the magic forces there. Then he made his way to Paris, where he placed his creation in front of the Louvre to make absolutely clear that it truly was a work of art.

In August 1968, two years after its creation, the Klaas Chair sat on display in the window of the Galerie Mokum on the Amstel River, and it was there that Max Reneman saw it and began seeking information about its creator. On August 31, in the weekly magazine *De Nieuwe Linie*, Reneman wrote: "This crazy dysfunctional object, the Clauschair [sic], belongs to the realm of art with a capital A." The article and Reneman's active outreach initiated a long-term collaboration and friendship between him and Grootveld. Soon they were meeting practically every day, beginning an escalating reciprocity that included Grootveld cleaning Rene-

Klaas Chair, alternate form (Theo Kley Archive)

Assault on the Impossible—25

Jasper and the original Klaas Chair in Paris (Arthur Monkau photo)

26 — Marjolijn van Riemsdijk

man's house and helping him move, and Reneman manufacturing Grootveld a new set of dentures.

Who Is Theo Kley?

Grootveld and Theo Kley first met in 1966 in Amsterdam shortly after Kley returned from Africa, where he had lived and travelled extensively. They viewed their concepts and creative impulses as complimentary—Grootveld acting as the visionary force and Kley the creative one—and teamed up to concretize their wildest ideas.

Kley's artistic career began early: as a young boy he assisted as a window dresser in his mother's shop. Later he studied industrial design and illustration at the Academy St.-Joost in Breda, and painting at the Jan van Eyckacademie in Maastricht, before apprenticing with stained-glass artist Charles Eyck (1897–1983), who was known for his expressionistic style. Until the mid-Sixties, Kley concentrated mainly on painting. Traveling for extended periods with his wife, the sculptress Josephine Bergh, he visited Yugoslavia, Greece, Bulgaria, and Turkey, then Kenya, Tanzania, Zambia, and Rhodesia (now Zimbabwe). His paintings and reliefs from that period are full of colorful intricate forms clearly inspired by African colors and motifs.

Like many other young Dutch artists, writers, and performers of the time, Kley grew interested in more performative forms of art upon his return from Africa. Happenings, performances, and all kinds of improvised public art were "the things to do"—commented on in newspapers and on television, frowned upon by conservative art critics and applauded by (mostly younger) progressives. These new art forms seemed to Kley to correspond closely to his experience of the vital musically and visually charged cultures of Africa. Furthermore, John Cage's ideas were in the air. After several meetings with Grootveld to discuss the situation, Kley decided to abandon his painting career in pursuit of other creative avenues. He had come to the opinion that anyone could be creative with everyday materials, like drumming on barstools or slapping wet washing on a line. These kinds of creativity, he still insists, are no less important than the conventional doings of professional artists: everybody can engage in Happenings, employing self-made instruments and self-made music to explore their own creativity. (Kley, personal communication with the author; see also Appendix 2)

As a first exercise of this new creative impulse, at his house on the Ruyschstraat in Amsterdam Kley organized what he called the Exotic Kitsch Conservatory (*Eksooties Kietsj Konservaatooriejum*, EKK—the Dutch spelling reflects the simplified orthography used by advocates of democratized language). The EKK functioned both as a musical ensemble and as a vagabond performance troupe. The book *Moeder wat is er mis... met deze planeet?* (*Mother, what is wrong... with this Planet?*)

Theo Kley performing (Dick Kok photo, Theo Kley Archive)

(1969) contains a summary description of instruments the EKK created for their performances. Among the most interesting is the Klaashonker played by poet Leo van der Zalm, which consisted of a toy flute, several meters of garden hose, an old-fashioned car hooter, and painted funnels. But piano wires attached to mattress springs, a child's barrel-organ, and plastic balls also became instruments. During one early performance the ensemble's flute player, Hans Verburg, varied eastern melodies with vigorous gusts into a vacuum cleaner hose, raising the ensemble's noise levels with alarming foghorn sounds. Ernst Vijlbrief played *diversen* (diverse instruments) and Kley's young daughter accompanied the group's marimba on her toy xylophone and an African drum.

Initially, the EKK performed exclusively in Amsterdam, but before long the

ensemble was traveling to any event that caught Kley's attention. Daily newspapers like *de Volkskrant*, *Het Parool*, and *De Telegraaf* began regularly covering their performances. As is plain in the story of their presentation of the *Sycle Woeps* (Cycle Whoops) to Stedelijk director Edy de Wilde in front of the museum, there was always plenty to see and hear when the EKK appeared, often unexpectedly, bringing their colorful, noisy, lively spectacle. On March 5, 1968, in its regular column "Day in Day out" (*Dag in Dag uit*), *de Volkskrant* reported:

> Thanks to Theo Kley, the only person in the Netherlands who celebrates Carnival all year long, it looks like Amsterdam is again becoming the Magic Centre. . . . Yesterday afternoon he and his interesting company paraded from the Leidseplein to the Stedelijk to offer the museum a Family Bike, a ***Sycle Woeps***. This Family Bike consists of three bikes cleverly welded to each other, colorfully painted, and sprayed with foam that has dried into weird appendages. . . . Very handy for expanding families, when another baby is born you can attach another small bicycle to either side. The procession to the Stedelijk was accompanied by rhythmic drumming and carnivalesque honking, with a second bicycle construction riding along. A four-year-old child in Arabic dress (Theo Kley's daughter) walked in front. De Wilde gladly accepted the bike constructions. They now stand in the garden of the Stedelijk Museum, where children immediately made creative use of them.

Everybody appreciated Kley's lively manifestations, including the city council. In 1968, they asked him to come up with something special for the festivities accompanying the opening of the new tunnel under the IJ. He responded by distributing four thousand plastic recorders to school children and passers-by. On opening day, crowds of school children blowing their new recorders marched through the city. Accompanied by the shrill sound of recorders resounding off the tunnel walls, the Queen officially opened it to traffic.

On other occasions the EKK appeared without invitation, as was the case at the opening of the Nederlandse Bank (Dutch Central Bank) on the Frederiksplein. To construct this "tower of power," a cast-iron gallery containing artists' ateliers and shops which had been a popular location for meetings and festivities was destroyed. On the occasion of the Bank's opening, the EKK introduced the public to the indeterminate color Immune Blue by scattering small bags of laundry "bluing" into the new fountain. Kley considered Immune Blue to be the color of the universe, enormity, and immateriality, and the bright blue water that soon streamed from the fountain danced in poetical contrast to the static awkward concrete colossus of the Nederlandse Bank.

Audiences at EKK performances quickly became participants, which was exactly what the performers intended: They played for their own pleasure, but they were also activating the larger project of unleashing the hidden creativity in their audiences.

Plans for the Motherdoll (Theo Kley Archive)

30 ▬ Marjolijn van Riemsdijk

the assault on the ▬▬▬ impossible

As an artist's book, *Mother, what is wrong... with this Planet?* is a typical product of the Sixties, with simplified spelling, strip and collage images, a chaotic layout, texts that finish abruptly, and unnumbered pages. It explores many of the projects Theo Kley was conceptualizing at the time, and provides extensive descriptions for some that were realized and others that were not. There is no shortage of imaginative vision, and many were collaborative. One of the more fantastic of the unrealized projects was the Motherdoll, an eleven-meter-high polyester figure of a naked, kneeling "mother surrogate" designed in collaboration with psychiatrist Joost Mathijsen. Inserting coins in a mechanism noiselessly opened the huge pink belly. A viewer could then enter the womb by way of a ladder and dive from a small board into a pool of amniotic fluid made up of water, lemonade syrup, stewed pears, tutti frutti, currants, and alcohol.

Together with Jasper Grootveld, Kley founded the Throwaway Automobile Industry. A research survey they consulted had indicated that Dutch car owners clearly preferred coziness. Bearing that in mind, they equipped a prototype car with leaded gothic-style windows and a homey interior that included comfy rattan chairs instead of car seats. The survey also specified that Dutch owners preferred economical vehicles. So Grootveld and Kley offered an economical, environmentally-friendly "powder" motor that required only one packet of washing-powder fuel to travel 73 kilometers—the exhaust produced soap bubbles that added a festive atmosphere to driving. Their final design innovation ensured that the car folded quickly to fit into an ordinary suitcase, making it very convenient for use in the city. No more searching for a parking space; no worries about car theft.

Other projects included a Self-Service Automat for hungry homeless animals; a Relaxation Cell where overwhelmed people could retire to recompose themselves; the Demonstration Project, which provided cardboard cut-outs to the home bound (the "demonstrations" Kley had in mind were anti-Vietnam-style political street actions); and the remarkable What-is-Holland-Worth? project, which advocated selling The Netherlands and restarting Dutch culture from scratch. (See Appendix 2 for more on the Demonstration Project and What-Is-Holland-Worth?)

Together with filmmaker Louis van Gasteren and photographer Cor Jaring (b. 1936), Kley proposed a festival of world records in the Vondelpark, where participants could break a world record in the field of their choice. Van Gasteren pre-

Theo Kley with his disposable car (Theo Kley Archive)

dicted that people would soon live 120 years or more, and when that transpired the current Olympic Records would become unbreakable. The collaborators believed it was time to develop a new kind of Olympics. They proposed celebrating events like Snapping Wooden Matches, One Hundred Meters of Fretwork (creating ornate fretted wooden patterns), Standing on One Leg, Reading One's Own Work. On August 17, 1968, Kley and van Gasteren appeared on Willem Duys's popular AVRO TV program to plead for assistance in establishing their New World Record Foundation. Despite the positive attention the proposal was getting, the city of Amsterdam declined to support the festival.

All of Kley's projects garnered widespread attention. Simon Carmiggelt (1913–1987), Holland's most popular newspaper columnist at that time, wrote in *Het Parool* (02/28/1968):

> Because he does not get lost in the wordy, tedious fuss that realization of these projects would necessitate—just think of all the official agencies he would have to satisfy!—but daringly pushes open windows with a view on a better world, I find his conceptions very inspiring. In any case, to his credit, he has started the assault on the impossible.

The Insect Sect

Kley and Grootveld both felt that something had to be done to highlight Holland's increasingly toxic environmental pollution. To bring the public's attention to the disappearance of insect species occurring as a result of an elaborate, nationwide agricultural-pesticide spraying program, they founded the Insect Sect. They claimed that the so-called harmful species—like the Peeper, Toady, Swarming Mite, Nosebeetle, Butterprick, Concreteworm, and the Diablebug (all insects they themselves had invented)—had already been eradicated, and that Holland's remaining insects had to be protected. In order to clean and purify the water and air, they proposed using Immune Blue Powder on a huge scale and exploding Green Bombs, delayed-action seed-filled bombs, on sites where nature had already been destroyed. They had Insect Sect members costumed as June Bug, Leaf Insect, Firefly, Bumble Bee, and Grasshopper perform at sites where poison had been sprayed, and suggested the voluntary transfer of farmers and market gardeners to re-education camps where they could spray plastic trees and plants with as much pesticide as they liked.

The Insect Sect's performances were accompanied by a musical group called the Resistancy Orchestra, which included Huub Mathijsen, a violinist in the Royal Concertgebouw Orchestra and brother of Motherdoll-collaborator Joost Mathijsen. The name, Resistancy Orchestra, highlighted the musicians' resistance to insecticides and punned on Holland's officially-designated "Residence Orchestra," which is based in Den Haag. Mathijsen played the *violophoon*, or *horngeige*, a

Lost Insect species (Theo Kley Archive)

Deze insectensoorten zijn reeds met succes uitgeroeid!

violin that generated horn-like sounds. Years later, in the daily *NRC Handelsblad* (01/23/1998), journalist Henk Hofland remembered the sounds as conveying "unfathomable melancholy, like the burst sounds of a past peacefulness." Pianist/recitationist Chaim Levano and cellist/dramaturge Carel Alphenaar were other prominent members of the Resistancy Orchestra.

Butterfly Monument

The Insect Sect had only recently begun performing when Jasper Grootveld learned that Max Reneman was unveiling a butterfly monument for the Dia-

Music for "Mother, Where have the Butterflies Gone?"

konessen Hospital in Eindhoven. Grootveld and Kley immediately traveled to Eindhoven, where Kley met Reneman for the first time. Reneman's original conception for the sculpture had been based on the image of a spinal column, but during the creation process it had come to look more like a pole with butterflies clinging to it, so when it was finished he called it *Monument for fallen Butterflies*.

Concert Program for The Butterfly Opera

The Butterfly Monument, as it was popularly known, became a tremendous success and was featured on the cover of the July 1968 issue of the trendy magazine *Avenue*. A 60-centimeter-tall model of it was offered to the magazine's readers for the price of one guilder. At the unveiling, Grootveld, Kley, and Reneman publicly advocated prioritizing the effort to save the nations butterflies because they were

Max Reneman's Monument for Fallen Butterflies (Ole Eshuis photo, Chiara Reneman Archive)

among the species most endangered by industrial and chemical waste.

To draw attention to the impending environmental catastrophe, the three collaborators began preparations for a *Butterfly Opera* to be performed in the spring, when farmers sprayed their crops. Kley and Grootveld traveled to the Ardennes to undertake a butterfly survey and mosquito hunt, because in their ironic opinion mosquitoes were also nearly extinct. The evolving butterfly project captured the public's imagination. The Dutch chapter of the World Nature Fund invited the Insect Sect to suggest an appropriate environmental action for children to do in the context of their lives. Kley and his colleagues proposed creating large blue flags centered on a golden-yellow butterfly (symbol of fantasy and metamorphosis) that would fly at half-mast whenever an environmental disaster took place, like the vast fish die-offs that were resulting from waste matter run-off. The Nature Fund responded enthusiastically, offering to publish a cut-out of the flag in its children's magazine, *The Ranger Club*. The children's TV program *Stuif es in (Come on Over)* joined the project, offering to teach youngsters how to fabricate the flags, with the magazine notifying them to fly the homemade banners whenever an environmental disaster loomed. But on March 13, 1969, when Kley suggested in *de Volkskrant* that the flags appear every time Prince Bernhard, father of Queen Beatrix and chairman of the World Nature Fund, visited Africa on an elephant hunt, the Nature Fund withdrew its support.

John Lennon and Yoko Ono were on their honeymoon in the Amsterdam Hilton Hotel at the time, conducting one of their two Bed-Ins for Peace. Reneman, Kley, and Huub Mathijsen visited to offer them honorary memberships in the Insect Sect. The couple accepted, and in a short, impressive ceremony they were presented with a butterfly flag of their own.

In June of 1969 a group of biology students from Amsterdam University asked the Insect Sect, in its role as an environmental action group, to participate in a student action against pollution. The two groups collaborated by curating an exhibition in *Galerie De Tor* (The Beetle Gallery) where visitors kneeled before a *prie-dieu* chair designed by Max Reneman that stood in the Blue Chapel of the Insect Friends. There, in an attitude of prayer, they listened to a recording of Grootveld reciting "Song of the Immune Blue."

The Butterfly Opera

Preparations for the *Butterfly Opera* were soon in full swing. Huub Mathijsen and Chaim Levano composed the music, with the lyrics of the deeply-sentimental opera highlight "Mother, Where have the Butterflies Gone?" written by writer/painter Alain Teister (1932–1979). Reneman and Kley designed the costumes. Immune Blue, a color that the Insect Sect considered a potent weapon against toxins, would be liberally sprayed in the venues during the performances. Cigarettes with

immune blue filters, which guarded against lung cancer, would be available. Kley would perform as the Fantastic Alarmist and Improver of the World; Reneman as the Immune Expertologist; and Joost Mathijsen would be featured as the Addicted Agrarian, Psychiatrist, Choir Boy, and Immune Blue Bird, assisted by a Black Nightbird, a Dragonfly, and a nurse from a detox camp. Photographer Cor Jaring and poet/biologist Dick Hillenius (1927–1987) were included in the cast, with The Resistancy Orchestra performing the music and the Great Alarmist Choir providing the singers. Anyone else who wanted to participate was welcome, providing they costumed themselves as an insect—a butterfly, ladybug, dragonfly—or a bird.

Promoted as a "beastly work," the *Butterfly Opera* debuted in Warder, a small village in northern Holland, with the local brass band taking part. The second performance was at Pietersberg near the Belgian village of Eben Emael, against the fantastic background of the Eben Haezer Tower. Stone mason Robert Garcet (1912–2001) had constructed the Eben Haezer Tower by hand, with all its proportions having a numerological significance based on his philosophical study of ancient codes and the Revelations of St. John. Garcet intended the tower to be a peace monument and a protest against war, and it had become an international gathering place for pacifists and Esperantists. The Eben Haezer Tower performance was recorded on film by Roelof Kiers for the Dutch TV channel VPRO. It was broadcast on Sunday, June 8, 1969, after which "Mother, Where have the Butterflies Gone?" became a top hit performed by all kinds of choirs and groups on all kinds of occasions. The Insect Sect, Resistancy Orchestra, and Expertologistic Laboratory (newly founded by Kley, Reneman, and Grootveld) eventually produced their own recording of it together with other *Butterfly Opera* songs, including "Soulology," "Thinking of Holland," and "Environment Boredom."

The events of that time—the Happenings, theatre, art manifestations, and various street events and performances—inevitably attracted throngs of "non-artists" who wanted to participate. One activity produced another, and so began a general and continuous public outburst of creativity. Art was bypassing the official venues to become active on all fronts.

power to the imagination

Except for sculptures appropriately located in officially-designated places like parks and public squares, the generally accepted view in the Netherlands at the time was that "art" was properly viewed in museums and galleries. There, in complete silence, one admired paintings on a wall and sculptures on a floor. This sacred silence could only be legitimately broken during exhibition openings, when official invitees busily networked with one another.

In the United States, the museum and gallery experience had become more tumultuous. In the words of essayist Susan Sontag, as a result of the activities of the artists Allan Kaprow, Robert Rauschenberg, and Claes Oldenburg, "the paintings came off the wall." (Sontag, pp. 264–69) Inspired by the concepts of composer John Cage, who made use in his compositions of unusual material and unexpected events, Kaprow, Rauschenberg, and Oldenburg experimented with unusual theatre-like combinations of images, material, movements, texts, and sounds that had no connection with each other, materialized on the spot, and depended on what chance and the moment made available. This often generated a kind of synesthesia, meaning an amalgamation of the senses, and sometimes even Rimbauds' *dérèglement de tous les sens* (total deregulation of the senses), which had been the basis of all absurdist, dadaist, and surrealist activities. Such performances came to be called *Happenings*, meaning events that arose spontaneously.

At first these Happenings were carefully scripted and took place in officially recognized art venues, but gradually they moved to unsanctioned spaces and out onto the streets. This kind of art required few accoutrements: it could be performed with little or no preparation and required no special professional competence. It was art that rendered concrete occurrences from daily life recognizable, and in which everybody could participate. It corresponded closely to the ideas of democratization that held international sway during the Sixties.

In 1959, in the magazine *The Anthologist*, American artist Allan Kaprow (1927–2006) published the principles governing a Happening in the text "Something to take place: A Happening":

> [T]he work is over before habits begin to set in. . . . An artist who makes a Happening is living out the purest melodrama. His activity embodies the myth of Non-Success, for Happenings cannot be sold and taken home; they can only be supported. And by their intimate and fleeting nature, only a few people can experience them. They remain isolated and proud. The creator of such events is

Poster for the Open Het Graf Happening (Simon Vinkenoog Archive)

42 — Marjolijn van Riemsdijk

an adventurer too, because much of what he does is unforeseen. He stacks the deck that way.

European artists first encountered the new art form in New York City. In 1961, French artist Jean-Jacques Lebel participated in Happenings at Claes Oldenburg's studio/anti-gallery/shop, The Store. Lebel described the events as being among the most important experiences in his life, because, as he later wrote in his essay *Le Happening* (1966), "we do not show people something to look at, but we give them something to do. Something they can take part in and something they can create themselves. We give them a language for their hallucinations, their longings and myths."

Open the Grave

Back in Paris, Lebel organized his own Happenings. And after he introduced Dutch poet Simon Vinkenoog to the new art phenomenon in Ibiza in 1962, Vinkenoog returned to Amsterdam to organize *Open the Grave* (*Open Het Graf*) in painter Rik van Bentums' studio at Prinsengracht 146. Participants in that first Dutch Happening included Vinkenoog, van Bentum, Lebel, poet Cornelius

Performers at the Open Het Graf Happening, left to right: Simon Vinkenoog, Jasper Grootveld, Johnny the Selfkicker; front: Danielle
(Ed van der Elsken photo, Simon Vinkenoog Archive)

Bastiaan Vaandrager, actor Melvin Clay of New York's Living Theatre, painter/writer Jan Cremer, Robert Jasper Grootveld, writer Johnny van Doorn (alias The Selfkicker), and Bart Huges. The others present were mostly actors, writers, photographers, and visual artists from the Leidseplein scene. The event was recorded by filmmaker Jan Vrijman.

Based on the film footage, it is possible to summarize parts of the performance. Vinkenoog, solemnly dressed in tails, welcomes the public by saying: "Here every word trembles with acrophobia. Every word becomes an event. Each name, each reaction on an action evokes a situation." Then Lebel appears wearing a box-cutout TV on his head and carrying signs bearing images symbolizing a penis and a vagina in his hands. *Nigger* is written on his face, with a third eye painted on his forehead and his right eye blackened, and he wears buttons that announce "I like sex." Some of the participants smash tables and chairs. From the remains, the "mobile art group" builds a construction that they paint red. Then Johnny van Doorn, as The Selfkicker, is bound to a chair and thrown on the stage. Ranting and raging he tears himself loose, almost tumbling out a window. He recites a speech by Goebbels and some of his own poems, and together with Vinkenoog performs a "shadow fight against life and death." Vinkenoog does a flamenco dance. Van Doorn throws raw entrails, bones, and black powder into the audience, then slides semi-conscious to the floor. Dressed as Zwarte Piet (Black Pete), Grootveld declares that he has had a vision of Sinterklaas and has become his servant. He lights a cigarette containing a firecracker, the *Mariebam*. He distributes *marihu* shouting "Publicity!" and "Cancer!" Meanwhile, Vinkenoog sells programs and writes an ongoing account of the Happening on a typewriter. From time to time he reads aloud what he has just typed. It ends with all the collaborators, standing with their backs turned to the public, shouting "Honor the dead, an ode to the living!"

Fluxus

Under the Fluxus aegis, the beginning of the Sixties also introduced Europeans to other Happening-like performances. The Fluxus *events*, as the group called them, were first organized in Germany by New York gallery owner George Maciunas, and were "concerts" where enactors and their audiences made use of ordinary objects and spontaneous occurrences. The underlying thought, based on Cage's ideas, was that practicing such art forms would dispel the separation between performers and audiences and so achieve an interaction between art and daily life. Thus, no one kind of art would be considered higher than another, and art and life would not be seen as separate from each other. That attitude made all of daily life's events and moments available to the practices of art, with a baby's cries being as much a part of an event as any artist's activities. It was

Poster for a 1964 Fluxus event (Simon Vinkenoog Archive)

about the reproduction of life in simple acts like "drinking a glass of water," or "putting down a vase of flowers." Not only was the *reproduction* of ordinary life significant, but also the idea that public participation in the actions facilitated the optimal interaction between art and life. The Fluxus artists believed that art must offer distraction and entertainment as a counterweight to formal museum and concert culture.

As the Fluxus movement expanded to France, Denmark, Lithuania, and the Netherlands, it found many supporters among artists. In 1962, in Scheveningen, performer/storyteller Willem de Ridder and sculptor/performer/multimedia-artist Wim T. Schippers enacted a "composition" during which the performers entered the stage wearing laughing masks and simply stood for a while. Then

Assault on the Impossible ▬ 45

they bowed and left the stage. At the same time, outside on the street, others performed inconspicuous events—like picking up a piece of paper or asking for directions—for occasional passers-by. Performers at the Scheveningen "Fluxus concert" included free-form pianist Misha Mengelberg (b. 1935) and Simon Vinkenoog, who played two mouth organs. Another Fluxus event was the "March through Amsterdam for six gentlemen, from the Central Station via the Martelaarsgracht, Nieuwendijk, Dam, Kalverstraat, Muntplein, Regulierbreestraat to the Rembrandtplein in seventeen minutes." On December 29, 1963, when the Dutch TV program *Signalement* broadcast footage of Schippers emptying a bottle of lemonade into the sea at Petten, few of the viewers could have realized that the event was part of an important international art current.

In addition to the work influenced by the ideas underpinning Happenings and the Fluxus theories, the Netherlands was producing home-grown spontaneous artists. In 1960, Stanley Brouwn (b. 1935), who created what he called "concrete art," asked arbitrary passers-by to sketch routes, which he then stamped: This Way, Brouwn. He also laid down sheets of white drawing paper at several places in the city, which he gathered up twenty-four hours later after "the life of the city had descended on them." And Pieter Engels (b. 1938) developed a Fluxus-like performance where he sold his personality as art. On demand, for a fee of 25 guilders, he damaged cars. When he was paid, he tore up the paper currency.

sigma

In London, at the beginning of the Sixties, the sigma center was established as an international spontaneous academy for the development of creativity. Sigma's founder, Scottish writer and Situationist Alexander Trocchi (1925–1984), based his work on the principle that unless all people had the opportunity to develop and express it, creativity would be lost due to the ongoing technologization of society and the interrelated process of "massification." At venues like sigma, trained artists were designated to help uncover the latent creativity of the untrained participants.

In imitation of the London sigma center, in 1966 Oliver Boelen and Simon Vinkenoog founded a sigma center in Doelen Hall, at Kloveniersburgwal 87, in Amsterdam. The Amsterdam sigma center obtained a grant from the city council. Film producer Matthijs van Heyningen (who later called his production company sigma films) was appointed director, with visual artist Tjebbe van Tijen as coordinator. Van Tijen declared that the creative activities in and around the center would no longer be subsumed under the rubrics "theatre," "visual art," "music," "dance," or "amusement," or tagged with the euphemism "Happenings." To establish a connection with everyday life, sigma would support artists who wanted to practice outside the regular artistic venues in the city.

The Amsterdam sigma center accommodated two theatres, a cinema, an es-

presso bar, two rehearsal studios, a film studio that supported workshops, and the *Steim*—a sound studio specially designed for electro-instrumental music. Under the *Steim* name, composers Louis Andriessen (b. 1939), Conrad Boehmer (b. 1941), Reinbert de Leeuw (b. 1938), Peter Schat (1935–2003), Jan van Vlijmen (1935–2009), and pianist Misha Mengelberg developed a new sort of musical toolbox and soon became well-known composers of Dutch experimental music. The center also regularly hosted performances by jazz groups and theatre troupes like the Living Theatre. And it provided space to activist groups like the *Bond Van Beeldende Kunstenaars* (BBK; Union of Visual Artists), and, for a while, the Provos. At the opening, the Living Theatre presented a transvestite production of *The Maids* by Jean Genet.

One outside project that the sigma center supported was the *Ongoing Drawing*, which had started in 1966 in the sewers of London. The chalk drawing consisted of two autonomous but interacting lines that branched off and reconnected on streets, objects, and people. Participant artists worked simultaneously on different parts of it. By 1967, it was ready to visit Holland, traveling across seats and passengers by airplane to Amsterdam. At Schiphol the police held up traffic so it could get on the bus to the Central Station, whence it journeyed by taxi to the Stedelijk Museum. In the Paulus Potterstraat the drawing flowed over the street, climbed up the Stedelijk façade by way of a crane belonging to the local electricity company, spread down the stairs, through the main hall, across the floors, the restaurant, the terrace, the visitors, and over the sculptures in the garden. It then continued on to Rotterdam and, via a partially finished metro station and the Lijnbaan, arrived at the Schouwburgplein. There, in a huge, transparent, inflated, smoke-filled polyethylene dome called the Corpocinema, which offered free public entrance, parts of it were projected onto the dome so that the *Ongoing Drawing* literally went up in smoke.

Joseph Beuys

All these ideas and expressions of the amalgamation of art and life, the participation of the public in art expressions and the promotion of everybody's creativity, were also nourished by the work of German artist Joseph Beuys (1921–1986). In his lectures at the art institute of Düsseldorf, Beuys prophesied a better world, where *intuition* (shamanic living) and *ratio* (culturally conditioned rationality) would harmoniously blend together, where each person would be an artist because he gave shape to his thoughts, formed his thoughts to words, and created the world around him. All people's acts and thoughts together formed a "social sculpture," a work of art from and for everybody. His statement "*Jeder Mensch ist ein Künstler*" ("every person is an artist") became a widely-voiced slogan. Famous also were his "lessons" outside the academy, like the one he performed in 1965 with a dead hare, during which he insisted that even a dead animal possessed more intuitive force

than people pursuing dogged rationality, and that people do not realize that rationalism is tearing their souls from their bodies. During the action/performance, Beuys sat with a dead hare in his arms, his head smeared with honey. The honey was meant as an allusion to the anthroposophical ideas of Rudolf Steiner, who depicted the society of the bees as an example for humanity to emulate.

Homo Ludens

Within the Netherlands the urge towards the fusion of art and life dovetailed nicely with an emerging political movement. The ideology of the Provos recognized the necessity of man developing his creativity and capacity for playfulness, because without those impulses boredom and massification loomed. According to the Provo theorists, Happenings were one means of achieving collective creativity, which was an important reason that they participated in Grootveld's Lieverdje Happenings. But their larger vision also embraced the ideas of former CoBrA painter Constant that centered on plans for a new city.

In the Fifties, Constant had joined the Situationist International, founded by Guy Debord (1931–1994) to propagate an environment where living and life's surroundings matched seamlessly. Between 1956 and 1969, Constant worked on a series of architectural models presenting an idealized future city that he called *New Babylon*. In New Babylon, as a result of technocratic automation, tomorrow's human being, *homo ludens* (playful man), could enjoy endless free time and play without care. Winning this revolutionary freedom would require both a revolutionary society and a revolutionary architecture. Constant's architectural designs for New Babylon as an adventurous labyrinth were intended to help generate an endless ludic creativity.

Provo set about implementing the utopian ideals of their new city and new society very pragmatically, proposing concrete changes to Amsterdam that included a car-free city center so the streets would become fit for play and recreation, free publicly-available bicycles as outlined in a "White Bicycle Plan" (*witte fietsenplan*), and the creation of anti-authoritarian nurseries where the creative and social faculties of children could develop in the best possible way. (See Appendix 1 for more on the White Bicycle Plan.)

For a short while, even the art in the Stedelijk Museum seemed to be moving with the time. In 1961, during the Stedelijk's *Bewogen Beweging* (*Moving Movement*) exhibition, the public was allowed not only to touch the artworks, but also to put them in motion. On exhibit were Jean Tinguely's kinetic, rotating, pounding, grinding, creaking engines, composed of used metal and other waste

Constant's New Babylon, 1966 (pencil on paper, Stedelijk Museum Collection)

material—playful machines that commented on our over-automated society. By telegraph from New York City, Marcel Duchamp played a game of chess with youngsters in Amsterdam that museum-goers could follow in the main hall of the Stedelijk. The *Dylaby* (*Dynamic Labyrinth*) exhibition in 1962 was compiled by Daniel Spoerri, Jean Tinguely, Niki de Saint-Phalle, and Robert Rauschenberg, artists who actively chose to work with waste material and found objects. They furnished seven museum spaces with an eccentric agglomeration of things, including rubbish from the Amsterdam flea market at Waterlooplein. In one work reminiscent of a sideshow or carnival contest, visitors could shoot at the prehistoric monsters that Niki de Saint-Phalle had created, "wounding" them with real bullets. Afterwards, the whole exhibition went to the garbage dump.

It was typically Dutch and typical of Amsterdam that so many of these events, interventions, and exhibitions were essentially humorous. In 1965, Wim T. Schip-

pers, in the context of his "sculptures for disembellishment and hindering traffic" placed a disproportionately large purple chair in the Vondelpark, which effectively tainted the park's natural surroundings to his satisfaction. That same year, together with Willem de Ridder and Stanley Brouwn, he founded AfSRiNMoR: the Association for Scientific Research in New Methods of Recreation, an organization intended to put a definitive end to seriousness in art. In 1967, visual artists Lucassen (b. 1939), Ger van Elk, and Jan Dibbets (b. 1941) mocked institutionalized art by founding their Institute for the Retraining of Artists, which featured courses like "How do I become a hip gallerist or 'A Respected Collector of Modern Art?'" Based on their common sensitivity to aesthetic bad taste, they opened the exhibition *His Whole World Is Full of His Magnificence* in Amsterdam's Galerie Espace, which consisted of just three works: *On Land*, *On Sea*, and *On Air*.

Power to the Imagination

All these Happenings, events, and occurrences caught the attention of the public and the press, though the response was not always positive. As a reaction to Simon Vinkenoog's descriptions of Happenings in the literary magazine *Randstad*, J. van Doorne, well-known critic for the Protestant daily paper *Trouw*, wrote virulently (*Trouw*, 06/11/1967):

> This is a summary of insane activities that propagate madness. . . . I believe that this madness springs from an emptiness of mind. In a world where there is still a lot that needs to be done, one does not do mindless, ugly, and nonsensical things just to do something no one else does. . . . One of the most beautiful properties that characterizes mankind, fantasy, is being used to advance unreasonable, often dirty, and always ugly actions or suggestions.

Van Doorne was certainly not the only one to hold this opinion, but the general public looked on with a benign eye.

One event sprang from another. There were huge numbers of young people in their twenties—the baby boom that occurred right after the war—seeking new challenges, happy to participate in any interesting event or movement that crossed their path. Post-war economic prosperity supported a welfare state; more people than ever had money and time on their hands, and a generous grant system enabled more young people to study, giving them time and energy to spare. Many artists did not have to bother about selling their work because an official arrangement for visual artists, the *Contraprestatie*, obliged the government to acquire some of their work at set times, assuring them a regular, though not excessive, income. So they were free to engage in art forms that did not immediately generate money, forms that were often performed only once, provoked public participation, and moved beyond the limits set for institution-based traditional art.

Postage stamps from the Orange Free State (Coen Tasman Archive)

Everything seemed possible. Young people from other countries, especially the U.S.A., were drawn to the Magic Centre, where it all happened. (See Appendix 8 for one response to the influx.) In the Vondelpark, hippies and flower power kids came together to celebrate Love-Ins. They visited government-subsidized alternative youth centers like *Paradiso*, a former church on the Weteringschans; *Fantasio* (which later became the Kosmos) on the Prins Hendrikkade; and the *Melkweg* (Milky Way), a former dairy and cheese factory on the Lijnbaansgracht. These became the new temples of the Underground, where young people listened to their own music while reclining on Persian carpets and cushions and enjoying reefers.

For the more politically minded, there was the *Oranjevrijstaat* (Orange Free State—the name references both the surname of the royal family and a former Boer state in South Africa): "an imaginary state that would feed itself like fungus on the rotting trunk and sap of the old society until that old state deteriorated." (Plomp and Tasman, 1997) The Oranjevrijstaat was proclaimed active on February 5, 1970, by the Kabouter (Gnome) Party, which was founded in 1967 by Roel van Duyn after the Provos officially disbanded and buried their movement in the Vondelpark. On the Dam Square the Kabouters distributed home-made banknotes valued at two thousand guilders, and entered the municipal elections with the slogan: Choose only Kabouter! (a well-known advertisement for a brand of Dutch gin). They won seats on the city council, where they not only proposed ludic ideas like planting flower gardens on the roofs of the city trams, but also strove to create collective facilities and to advance the sale of organic food.

The overall emphasis continued to be on developing creativity, creating space for *homo ludens*. Time was ripe for transferring "Power to the Imagination." And in the realm of the Imagination, the projects and spectacles of Jasper Grootveld, Theo Kley, and Max Reneman would find particular resonance.

Kabouter demonstration, 1971 (Coen Tasman Archive)

the expertologistic laboratory

In 1969, Max Reneman included Jasper Grootveld's work in the Keerkring exhibition in the New Wing of the Stedelijk, as well as work by William Kuik, political cartoonist Willem (who had supported the Provo movement, and since 1968 had been working in France for *Libération* and *Le Canard Enchaîné*), and the lewd drawings of Roland Topor (1938–1997). Participation in a Stedelijk exhibition transformed Grootveld from a notorious local eccentric into an acknowledged artist, something he badly wanted. He showed his Klaas Chair, a plaster mask of Cor Jaring titled "The Color Photographer," and two paintings. On the strength of his association with the Insect Sect, well-known biologist/poet Dick Hillenius (brother of Keerkring painter Jaap Hillenius) was asked to open the exhibition.

Shortly after that exhibition closed, the Stedelijk opened another Keerkring exhibition dedicated to the *Butterfly Opera* and the activities of the Insect Sect. On the opening night the Stedelijk was packed with visitors wanting to hear the Resistancy Orchestra play "Happy Sounds, Concerto for an Unknown Master," and "The Better Genre Light Music." Henri Plaat screened his movies of accidental events and passers-by; Cor Jaring projected his color slides documenting the *Butterfly Opera* performances; Max Reneman's model of the *Butterfly Monument* was on exhibit; and Theo Kley showed his *Wuifkoets* (Waving Chariot—a reference to the "Golden Chariot" from which the Queen waves to her cheering subjects on her way to opening the new Dutch Parliamentary year). Kley's chariot was a light, two-wheeled construction with twelve attached hoses positioned to receive the latest news and a long fabric-wrapped pole topped with a glove that waved whenever the chariot moved. The whole construction was sprayed Immune Blue. (The exhibition also included fairly ordinary, serious work by other Keerkring members.)

When they were invited by the Rotterdam Art Society and the Rotterdam Booksellers Association to participate in the opening festivities for the Erasmus University, Kley and Reneman (as professor Maximiliaan Bleu), together with other members of the Insect Sect and the Wuifkoets, traveled to Rotterdam aboard the clipper *Irma*. At the helm stood Captain Bluebeard—the remarkable Dutch scholar/poet Leo van der Zalm (1942–2002), the boat's owner. An apocryphal account of the voyage claims that the captains of two passing vessels, mesmerized by the waving Wuifkoets, forgot to pay attention and collided. In Rotterdam, Mayor Thomassen met the *Irma*. And to protect the local soccer club,

Expertologistics, left to right: Huub Mathijsen, Theo Kley, Max Reneman (Wim Ruigrok photo)

Feyenoord, against all external dangers, the Insect Sect presented it with a pot of Immune Blue. At the Erasmus village the Resistancy Orchestra and the Insect Sect performed a lively program. Then Max Reneman, dressed for the occasion as Erasmus, read the pages that the "real" Erasmus (a nearby statue portraying the philosopher with an open book in his hands) had never turned. "We were boys," Leo van der Zalm said, recalling this trip, "but we gave a lot of pleasure to a lot of people." (Van der Zalm, 2001)

Expertologistics

The core group, which consisted of Kley, Grootveld, Huub Mathijsen, and Reneman, met at Kley's home on the Ruyschstraat to dream up all kinds of new projects and collaborated with whomever came forward. During their sessions they smoked large joints of Kley's backyard marijuana, which they claimed dramatically improved their creative process. They also held public meetings in pubs like Hoppe, Scheltema, de Pool, and Frascati, where fascinated visitors could lis-

ten to or actively participate in the imaginative process. Many of the ideas, no matter how strange or wild they seemed at the time of conception, were actually executed. When someone suggested sending a packet of Immune Blue to the moon, for instance, Reneman immediately sent a packet of the stuff to Cape Canaveral with the request that the astronauts take it with them on their next visit. During one of these public sessions, probably in café Scheltema, the Expertologistic (*Deskundologisch*) Laboratory was founded.

The Expertologists connected to the laboratory determined that they would undertake research into perfectly simple matters, and explain in clear language the simplest activities—which would be approached "emblematically" instead of "problematically," and would proceed from the ontological foundation that "knowledge is nothing, attentiveness and love all." Reneman defined *expertologistology* as: "Science that people can experience with their wooden shoes and that does not extend beyond their caps." The Expertologistic Laboratory conducted investigations into subjects like the effect of the bicycle on the human body and boredom, the chicken and the egg, general applications for Immune Blue, and the extent to which the Netherlands could be said to be finished. Its members undertook archeological excavations and organized an expedition to the sources of the Amstel River. The outcomes of these investigations, excavations, and expeditions were soon seen in Keerkring exhibitions. *Expertologistic Magazine* and various books on expertologistology described all expertologistic hypotheses, tests, ideas, and advice. The term *expertologist* became current and was defined in the "Great Dictionary of the Dutch Language," the *Dikke van Dale*.

The first issue of *Expertologistic Magazine* appeared in 1971 and treated the following subjects: "Building your own Fruit Organ," "Can Plants Eavesdrop?" "In Search of an Erotic Relief," "To What Extent Do You Get Bored?" The Fruit Organ article described experiments investigating the sounds made by different species of fruit in different circumstances that were undertaken by the internationally-renowned Professor Kistemaker in his nuclear physics laboratory on the Ringdijk in Amsterdam. (It is a remarkable fact that some of Holland's most prominent scientists and thinkers enjoyed the Expertologistic Laboratory's work enough to collaborate with the group, bringing it a gravity it could never otherwise have had.) Kistemaker's research supported the viability of an instrument designed to produce natural sounds. The so-called "mobile fruit organ" was believed capable of both generating a "Betuwe concert" (the Betuwe is a fruit producing region in the Netherlands) and stimulating a bulb field to produce "bulbmusic." Theo Kley actually invented and built a Fruit Organ of his own design, which he played in Amsterdam on several occasions.

The *Expertologistic Manual, Part I*, edited by art dealer Jan Juffermans, was issued in 1972. Besides work by Kley, Grootveld, and Reneman, it included a piece by the director of the Lowland Weed Company, Kees Hoekert, that outlined the

origin of the word *drug,* the role played by the former East India Company (VOC) in distributing drugs, and reported on the drug scene in Amsterdam. Riffing on the Grootveld slogan "A Bicycle Is Something, But almost Nothing!" (Appendix 1), which helped popularize the Provo White Bicycle Plan Reneman wrote an extensive article entitled "The Bicycle Is Something." In it he treated the history of the bicycle, the influence of the bicycle on the lives of the Dutch, and the boredom gland—which he located in the hollow behind the left knee. According to Reneman, boredom was an important source of inspiration. Visual artist Pieter Holstein (b. 1934) contributed a series of captioned photographs of ordinary people in daily situations, pictured in poetic fashion. One of his captions read:

> Art is everywhere where people live,
> no talent is too small to be ignored,
> who can weigh the violet
> against the stars?
> Accept the fate of your body,
> art is everywhere where people live,
> the entrance is called attention,
> which in fact is love.

In addition to his many artistic activities, Reneman had continued his dental practice. In the context of expertologistology, together with his colleague, professor of Dentistry Guus Flögel of the University of Utrecht, he created the Foundation for Public Prosthesis. Reneman and Flögel experimented with designs for sports prostheses, a prosthesis suitable for opera-goers, cow prostheses, and a crash helmet with a built-in prosthesis. Reneman also conceived the extraordinarily disgusting notion of designing and creating a "public prosthesis" that could be shared by people who couldn't afford dentures of their own.

Serious Art

Apart from this serious nonsense, Reneman also produced serious art. Together with the architects Saarberg and Van der Scheer, he designed the outside walls, stairs, landscaping, and color scheme for the new West Swimming Pool in Rotterdam. Architecture critic K. Wiekart wrote in *Vrij Nederland* (10/31/1970) that the colors Reneman used were purely architectonic, so harmonic that the pool looked as if it had materialized on its own. About Reneman's sculpture at the entrance, a flagpole with lurid metal plates turning in the wind, he wrote:

> For the Calvinistic Netherlands it is a miracle that such an unserious work had been accepted by the commissioners, because two holy matters are being made fun of: the Flag and Art. Kids will be very happy with it.

Wiekart's remark about the flagpole doubtless made Reneman very happy. The prestigious monthly magazine *Avenue* commissioned him to design a trophy for the winner of the yearly **World Press Photo** exhibition, for which he created the **Golden Eye**, a thirty-centimeter-high sculpture. The Golden Eye remains the trophy given to winners of the World Press Photo Exhibition, which takes place annually at the Oude Kerk in Amsterdam.

Max Reneman's Golden Eye trophy (Ole Eshuis photo, Chiara Reneman Archive)

René Nyssen, Live Dispatch, 1975, bronze

58—Marjolijn van Riemsdijk

More Keerkring Exhibitions

The opening of the 1971 Keerkring exhibition was a lively Happening. Singing Sister Klara of the Expertologistic Laboratory performed to the accompaniment of the Resistancy Orchestra. There was a demonstration of Expertologistic Laboratory instruments, lessons were provided in "Independent Drawing," and first aid was given to those suffering from environment boredom. The Choir of Nicely Disturbed Women, conducted by psychiatrist Joost Mathijsen, sang agreeable aphorisms from the *Success Agenda* (texts similar to those that appear in the *Farmers' Almanac*)—"greet every day with a smile," "a smile is the best medicine," "if you can't beat 'em, join 'em." And it was at that opening that the first issue of the *Expertologistic Magazine* was launched. No one in Amsterdam wanted to miss the spectacle, so the Stedelijk was overflowing with visitors.

About the 1972 exhibition, *de Volkskrant* wrote (02/22/1972):

> It was a great chaos, for which Robert Jasper Grootveld, Max Reneman, and Theo Kley are responsible, having during recent years performed a daily continuing commedia dell'arte along the Amsterdam canals. Holy solemnity disguised as nonsense, or the other way round? Now they have brought together rusty bicycles from garbage dumps all over the country and put them on show among the sensitive and marketable works of painters like Rudi Bierman and Fred Grote. One can only guess what the meaning of this bike shed is.

The decrepit bikes had indeed been gathered from dumps across the Netherlands during an expertologistic expedition—with some of them replicated in cast plaster by sculptor René Nyssen (1928–1991). But as a matter of fact, presenting waste material in an artistic context was not a new idea. In the early Sixties, the Nouveaux Réalistes, Arman, Christo, and Daniël Spoerri, among others, had also gathered neglected or discarded items, heaping them in showcases or preserving them cast in resin as valuable museum pieces. Daniël Spoerri had glued plates, glasses, filled ashtrays, hunks of bread, napkins, cigarette boxes, and lighters to a tabletop on which he had eaten a meal with friends. And when he hung the assemblage on a gallery wall it had been accepted as a work of art.

The 1972 exhibition included a series of Cor Jaring's photos of a Happening in the hamlet of Holysloot, on the meadow of farmer Hojing, where the black spots on pedigree Frisian cattle were painted Immune Blue. Also included were Jaring's photos of an expedition to garbage dumps with the expertologists in party dress. The events had been staged specifically as photo shoots for the magazine *Avenue*, with the photographs appearing in the July 1972 edition.

From the very beginning, most of the "expertologistic" events, or Happenings, or whatever they were called, generated publicity, which is one of the reasons they became so widely known. Newspapers and magazines were happy to fill their pages with such material, especially when it was illustrated by Jaring's poetic, atmospheric photographs. (See Appendix 4) The expertologists were good at public relations. But not all Keerkring members appreciated the Happening-like events during their exhibitions. They wondered aloud if such things were really art. More and more they complained about the expertologists "manifest[ing] themselves as the cuckoo in the Keerkring's nest," and the "Calvinistic Grootveld who thought he could frustrate meetings with muddled cries and ridiculous *ad absurdum* propositions no one seconded or endorsed." So wrote a group of Keerkringers in a letter to the board of the Keerkring on December 18, 1972, in which they proposed blocking the expertologists' participation and suggested that Reneman resign as chairman.

Nothing of the kind happened. During later exhibitions the expertologists participated and the fanfare surrounding the openings continued to draw crowds. (Only the exhibition of January 1973, which was a homage to recently deceased painter Rudi Bierman, was at all subdued.) Furthermore, thinking people increasingly recognized that the expertologists were producing "serious art," particularly following a Fodor Museum exhibition in 1972. After that exhibition, art critic Lambert Tegenbosch enthusiastically compared Theo Kley's work to Paul Klee's: "fairy tale, child play, joke, poem, and still serious." He proclaimed that, at that moment, no other existing works of contemporary art were as beautiful as Theo Kley's. (*de Volkskrant*, 04/15/1972)

A substantial exhibition at *Het Lijnbaancentrum* in Rotterdam, which ran from March 18 through April 24, 1973, was dedicated to expertologistology, and a critic at *De Rotterdammer* described the experience that awaited visitors (04/06/1973):

> [U]nimaginable sheer nonsense, but nonsense against a significant background, because the products of Grootveld, Kley, and Reneman could be considered a parody of the current expert-oriented society. In any case it was clear that the expertologists were working vigorously at undermining the certainties of a technological world that could use some doubt and laughter.

For the Rotterdam exhibition, some non-expertologists joined the society of expertologistics. On display were etchings by Pieter Holstein accompanied with short texts—he later called these works the representation of the "peculiarity of life with objects." (*NRC Handelsblad*, 04/11/1975) "They consist of scenes of

Jasper Grootveld and Provo founder Rob Stolk on the raft Frya

Assault on the Impossible—61

Jasper Grootveld on the Frya (Theo Kley Archive)

62—Marjolijn van Riemsdijk

small dramas, like the image *Does a Falling Chair Remain a Chair?* which depicts twelve chairs, one of which has fallen, its place taken by a stool." This exhibition also marked the first time that René Nyssen linked his work directly with that of the expertologists. He showed *Levende Zending* (Living Parcel) *voor Theo Kley*—a small box sculpted with a rabbit as a cover.

Huge photographs of the vessel *Frya*, constructed of waste material by Jasper Grootveld, were also on display. Art critic Dolf Welling of the *Rotterdams Nieuwsblad* viewed *Frya* more as a symbol than a vessel. About Grootveld he wrote (04/06/1973):

> He is the greatest living symbol-butterfly of our time. The time has come for him to be considered a genius. As Constant was the stringent prophet preceding Provo, now the expertologists are Provo's laughing children. On the dung heap, testifying for life—yours and mine.

Grootveld's Rafts

For more than a year Grootveld had been busy roping together flotsam from Amsterdam's canals, forming it into a gigantic package that he named the *Frya*, after an ancient Frisian goddess. He considered his creation a symbol of land made by its occupants (in much the same way that the Netherlands itself had been created). For the most part the vessel consisted of old automobile tires packed with the polystyrene foam that he found floating in abundant quantities; these practically-unsinkable floats were bound together with non-rotting nylon cords and nets. It was built on what Grootveld called the "stream-through" principle, meaning that it was porous and flexible and so buoyant that it could never fill with water and capsize. The upper structure was constructed of sturdy, readily available scrap wood, mostly ladders and bamboo. The sails, which resembled those of a Chinese junk, were made of feather-light nylon packing material, and the rigging consisted of bicycle tires and old nylon stockings that Grootveld gathered from the Waterlooplein flea market and knotted together. On top, where the vessel's three masts came together, he had fixed three huge rope loops so the *Frya* could be hoisted out of the water. With this strong rigging she could be lifted without being destroyed. A video team from the Lijnbaancentrum was sent to film the *Frya*'s voyage from her Lowlands Weed Company mooring to the Scheepsvart Museum Wharf, and continued filming while she was lifted out of the water.

In September of 1973, assuming it was a heap of junk, a city cleaning-department crew towed the *Frya* away. She was torn apart and thrown on the refuse heap, though when it became clear that a work of art had been taken, the shredded fragments were gathered up and returned with excuses and apologies. Roel van Duyn, who at that time held the Kabouter Party seat on the city council, demanded that

The Tand des tijds (Wear and Tear) sets sail (Eric Duivenvoorden Archive)

Amsterdam's mayor and aldermen publicly acknowledge that the cleaning department's action had damaged the city's environmental hygiene. Recycling waste matter the way Grootveld did with his sailboat should become an example to everyone, Van Duyn insisted, and such products must not be destroyed (*de Volkskrant*, 09/08/1973). Afterwards, since Grootveld no longer felt any attachment to his destroyed vessel, he offered it to Kees Hoekert of the Lowlands Weed Company for the symbolic amount of one guilder—an offer Hoekert accepted.

Grootveld continued building rafts of different sorts of waste material. Together with Max Reneman he built one entirely of polystyrene foam, the *Ouwerkerk*. In their opinion polystyrene foam was the first really indestructible material in the shipbuilding industry, particularly when compared to the wood and metal from which most rafts and boats were constructed. Grootveld said that he planned to build larger foam rafts in the future, structures that could carry patches of soil with grass and trees, even houses. He thought that eventually all Holland could occupy rafts of that kind. They would be much cheaper than draining the sea and keeping the water from the polders, and could help provide a solution to world famine: huge rafts bearing cultivated fields and hay would roam the ocean, sailing to rainy regions when it was dry and finding the sun when the "raft country" had sucked itself full of water. "And when the corn is yellow and the apples blush, the sails will be hoisted, or the tugboats will be fastened, and the

harvest will be brought ashore." (Grootveld on VARA TV, 07/18/1977)

Despite the Dutch public's ongoing fascination with Grootveld's work, in June of 1977 he again found his rafts threatened. The new mayor of Amsterdam, Wim Polak, announced that he was opting for a clean, safe, prosperous city. One month after Polak's announcement, Grootveld received a letter demanding that he dismantle his raft the *Tand des tijds* (Wear and Tear) or the municipality would take care of it, with police assistance if need be. Public pressure was immediately brought to bear on the city council from all sides, urging the councilmen and mayor to stop bothering the artist, but Mayor Polak held to his decision, saying

DE KEERKRING

STEDELIJK MUSEUM
28 jan. - 19 febr.

Keerkring logo, 1978

NEDERLAND IS BIJNA KLAAR

De ondergang van de Lowlands Weed Company
De Verschrikkelijke Sneeuwvrouw
Oefeningen met de Nieuwe Amsterdamse Vlag Kunst
Amsterdams Ballon Gezelschap
Comitee 2000
Deskundologie te land
 te water
 in de lucht
Nederlandse Vereniging voor Orale Hervorming
Condor
Stichting Openbaar Kunstgebit
Operatie VLOTwezen
Milieu Verveling

KLAAS KOMT O.W.

DE KEERKRING nodigt u uit de opening bij te wonen van de tentoonstelling in de nieuwe vleugel van het Stedelijk Museum op vrijdagavond 27 januari 1978 om 20.15 uur.

De opening zal geschieden door de Heer
EMILE MEIJER

Muziek:
Mister Slim and his Wonderland Steel Band
Palm Pop Band
Koor van Prettig Gestoorde Vrouwen
Nurks Mannenkoor

Films:
Arie Kater (van Dee)
Sad-Is-Faction (Alex Sadkowski)
Lost Rooms (Henri Plaat)
Grootveld op IJsselmeer (Vara)

Invitation to the Stedelijk Museum exhibition of The Netherlands Are Almost Done (28 January – 19 February, 1978)

(*Het Parool*, 07/19/1977):

> It is not a question whether your raft can be called a work of art or counted as an important scientific experiment, because this is not the point under discussion; the important thing is now to prevent the canals filling up with structures of all kinds.

This obviously-targeted assault provoked Grootveld and his wife Thea to flee the city. They navigated their threatened raft as far as the IJsselmeer, but during a storm that hit them near the Marken lighthouse the vessel was shipwrecked.

Because of the continuous commotion and negative publicity, the city council finally compromised with Grootveld. The raft builder was assigned working space on the Borneokade, in a building complex formerly belonging to the Nederlandsche Stoomvaart Maatschappij Oceaan (The Dutch Ocean Steamboat Society), where he had room enough to continue his experiments. In 1979, the police publicly acknowledged the value of his work when a police expert asked Grootveld to oversee a "raft-building project" for twelve police inspectors who had been studying at the Study Center for Higher Police Officials in Warnsveld. With Grootveld directing them, the policemen built an enormous polystyrene raft, the *Management I*, which they sailed down the Oude IJssel River. When crossing the IJsselmeer near the small religiously-focused village of Urk, the raft drifted to the lee shore and hit the basalt. The church paper, *Urkerland*, appreciated the humor of the situation in reporting: "When it stranded on the dyke the raft was not damaged, and that is because it is *soft-built*." (See Smits, *Vrij Nederland*, 09/11/1993)

The Netherlands Are Almost Done

In 1973, the manufacturer of Solex mopeds had asked members of the expertologistic society to assist with a publicity campaign by helping design an action especially for youngsters. The sales of Solex mopeds were declining because young people considered them more suitable for elderly people and favored sleeker models. The expertologists had been planning for some time to research the completeness of the Netherlands, a project that had spun off Max Reneman's idea that the Netherlands was a work of art, the only territorial nation in the world that had been constructed by its own inhabitants. England had existed before the English arrived there, Africa before the Africans, and China before the Chinese, but by draining and creating the polders, the Dutch had largely created the Netherlands. The expertologists thought it a good idea to mount their research expedition on mopeds. The Solex company agreed to the plan and pro-

Opposite: The Netherlands Are Almost Done (Wim Ruigrok photo)

vided them with fifty new Solexes.

In preparation for the expedition, the Expertologistic Laboratory placed an ad in *de Volkskrant* calling for young researchers willing to investigate the thesis "The Netherlands Are Almost Done" by soft modes of transport. Cor Jaring gathered a group of students from the AKI art school in Enschede, where he taught photography. At the end of June, a team consisting of expertologists, independent researchers, and AKI students started off accompanied by a reporter from *de Volkskrant* named Willem Ellenbroek. At the outset it was decided that Jaring's Polaroids of expedition activities would be delivered to the Atheneum News Centre on the Spui, behind the Lievertje, where interested viewers could follow the expedition's daily progress in the shop's window showcase.

The aim of the ten-day journey (the expertologists decided on ten days as an ironical commemorate on King Willem II's failed 1831 campaign against the Belgians, who defeated him with French support) was to register the state of the Netherlands emblematically, not problematically, in clear language and through clear images. This was necessary, declared Max Reneman (*de Volkskrant*, 06/30/1973):

> [B]ecause till now the Netherlands has been researched economically, morally, and ethicologically [sic] *ad nauseam* from oats to barley to threads. The remains have been buried in incomprehensible reports, unread libraries, nothing but problems, gloomy conclusions, solutions immersed in darkness.

The expedition began at the center of the Netherlands, near Lunteren. At night, by the light of the full moon in a sand pit in the Heart of the Netherlands, the researchers discovered the "Hole of the Netherlands." They painted the pole they found marking this navel of the country red, blue, and white (Holland's national colors), and camped for the night. Next morning the police arrived, demanding to speak to the expedition leader. In a patient tone Grootveld explained that there was no leader; that everyone decided on every aspect of the project. When the time came to leave, disagreement arose about the route they would take. After some manipulation by Grootveld ("sometimes you have to use demagoguery when you get tangled up in democratic fuss"), the group visited the Echo Well in Apeldoorn, where the researchers asked the oracle: "Are the Netherlands almost done?" In clear language the oracle echoed: "Done." After this, part of the group found itself by accident on the lawn of the royal palace, Het Loo, where they were removed by the Royal Gendarmes. En route to its next destination, the expedition decided to investigate the way farmers in different regions of the Netherlands greeted one another. In Kampen the researchers presented the mayor with a copy of the *Expertologistic Manual, Part I*, and the local swimming pool, which had been emptied for reasons of environmental health, was transformed into a herb garden that included hemp plants to heal the ailing environment.

An imminent confrontation with the local police quickly changed into a friendly photo session when Cor Jaring asked the policemen to pose for his camera. This they did willingly.

From Kampen, the expedition continued on to Lemmer. There a throng of people gathered around the researchers when two boys dressed in jump suits flanked a half-naked girl displaying her breasts, which were painted Holland's national colors. The expedition left Friesland by way of the Afsluitdijk to North-Holland. According to the expertologists, research to this point had indeed shown that the Netherlands were almost done; except for Friesland, which needed more forests—not little bushes like in Amsterdam, but real Frisian Woods. They noted that Friesland now consisted only of over-grazed plains, a completely *uitgemolken* (milked out) country.

In Bergen the researchers sheltered with the United Family, a sect from Korea that lived in a former holiday camp. The expedition received a hospitable welcome, but following a friendly request that they "live like the Family, like Brothers and Sisters, without sex," some of them chose to stay outside the camp boundaries.

At the end of the trip the expertologists announced that their research was not yet done. Only the Echo Well had offered them any true clarity about the current state of the Netherlands. (Ellenbroek, 06/30/1973)

The Amsterdam Balloon Company

It was Theo Kley's idea to focus on lighter-than-air issues. From his roof garden—with its fruit-bearing apple trees and pavilion with an open fireplace—at Oudezijds Achterburgwal 81 in Amsterdam, he sent a series of balloons trailing long tails of aluminum foil into the sky. When the aviation police viewed them on the Schiphol airport radar, they appeared to them to be "foreign objects." Buoyed by this success, Kley began collaborating with Rudolph Stokvis, an enthusiastic kite flyer and accomplished organizer, to plan kite parties during which every participant would send some kind of object skyward. Kley concentrated his initial efforts on Styrofoam forms, including a huge Styrofoam question mark he sent up in 1975 during the Nieuwmarkt riots against the construction of the Amsterdam subway.

The kite parties soon morphed to become the Amsterdam Balloon Company, which was founded to stimulate "Soft Aviation," with Kley, Stokvis, visual artist Guus Boissevain, and others as "hard core" members. The Balloon Company stood open to "everyone who favored balloons, kites, birds, and other soundless sky vehicles, like the sun, moon, stars, comets, etc." Membership cost nothing and there was no board of directors. One of the earliest members, writer Gerben Hellinga, considered kite flying the most democratic form of air traffic, some-

thing anybody could afford. Kley advanced the notion that everybody became taller with a kite in their hands: "In fact, it is a long prosthesis of your 'self.' Furthermore, kite flying is a subtle happening that responds to the elements, to the laws of nature." (*Het Parool*, 08/31/1974)

One of the first Balloon Company parties was a midsummer solstice gathering organized at Ruigoord, a small squatted village in the Houtrakpolder in the West Port area of Amsterdam. At that first party, most of the artist-inhabitants of Ruigoord and many of their friends and acquaintances from Amsterdam were present. Chiara Reneman, Max Reneman's daughter, remembers that when she camped with her father on the land near Ruigoord, everybody was busy crafting all kinds of homemade kites. Theo Kley made one he could sit in.

Every year after that first event, Ruigoord sponsored a midsummer feast, with the feasts becoming kite festivals that eventually attracted hundreds of enthusiasts from far and wide. The presence of the Zomerstraattheatre (Summer Street Theatre), the Dog Band (an outdoor performance troupe), and musical performances by saxophonists Hans Dulfer and Herman de Wit enhanced the events.

Ruigoord

The artists who had squatted Ruigoord in 1973 were enthusiastic supporters of Grootveld's idea of Amsterdam as the Magic Center and incorporated magical thinking into their daily lives. According to one story, their presence in Ruigoord was a direct extension of Amsterdam's potency: a magical coincidence had led to the discovery of the village—like in fairy tales, where signs show the way. Hans Plomp, who discovered the place, had been one of the nozems participating in the Lieverdje Happenings and had gone on to join the Provo movement. In 1972, he was traveling in the mountains of Morocco when he came upon a young French woman stricken with a malady that left her delirious. She had been abandoned by her traveling companions in a small village with no medical facilities. Plomp had a vehicle, and when he realized how ill the woman was, he drove without stopping until he got her out of the mountains and into a hospital that could properly diagnose and treat her. He stayed with her until the worst of her illness had passed, then continued on with his travel plans, not giving his good deed much thought.

By the time he returned to Amsterdam, Plomp had almost forgotten the incident. But one day, as he was out walking, the woman greeted him on the street. She thanked him for saving her life. When he asked where she was staying, he learned that she and a few friends were camped at the village of Ruigoord on the northwestern outskirts of Amsterdam. In connection with the proposed expansion of the West Port, the village had been slated for destruction. Of the five hundred families originally living there, only a few had ignored the evacuation order and stayed on. Since Plomp had been thinking of moving somewhere out-

side Amsterdam, he decided to visit Ruigoord to see what was going on. During a conversation with the priest at Saint Gertrude's Church, he was urged to camp at the village. The priest was uncertain exactly when he would be relocated, but his forced eviction was imminent. When he left, he wanted to hand the keys to the church and the presbytery over to sympathetic souls who would commit to keeping the village alive.

Plomp immediately contacted his friend Gerben Hellinga, and together they camped at the village until they could take up residence in the presbytery. Soon after Plomp and Hellinga squatted, other artists and their families moved from Amsterdam to settle in the village, creating a thriving village life with the church as its cultural center. To this day, Hellinga maintains that it was magical validation of Hans Plomp's deep concern for the young French woman that brought Ruigoord to the squatters. (See Appendix 5 for a detailed Ruigoord timeline.)

Some of the original village residents who had stayed on were unenthusias-

The Ruigo currency used in Ruigoord (Hans Plomp Archive)

tic about the arrival of the artists (*de Volkskrant*, 09/10/1983):

> They are different, they are city people. We live during the day, they live at night. Before noon you won't meet them, because then they still lie in bed. And they don't know anything about animals. They think you milk a goat when you are thirsty!

It also seemed to sting that the "longhaired scum" had not paid for the houses abandoned by their former neighbors. The original villagers tolerated the squatters only because it was as a direct result of their actions that the authorities had allowed anyone to remain in the village. Because of the oil crisis of the early Seventies, nothing immediately came of the planned harbor expansion and the extension of the Amsterdam city limits. At Ruigoord, nature gradually reclaimed the surrounding artificially-raised land, bringing with it rare orchids, bushes and trees,

birds, rabbits, hares, and other animals. The village and its surroundings became a sanctuary for artists and non-conformists who considered themselves "an alliance of free-range people in a cultural free port." (Hellinga and Plomp, 1998)

Balloon Company Travels

In 1976, the Amsterdam Balloon Company collaborated with Radio Stad, Amsterdam's local progressive station, to organize kite festivals in the Flora Park in Amsterdam-Noord, and in 1977 the Company collaborated with the Stedelijk Museum. In 1978, they stayed a week in Almere—one of the brand new cities built on the New Land in the Flevopolder, which had been reclaimed from the sea in 1968—with theatre groups from home and abroad. For the Almere gathering, Reneman created a circular, concave, mirrored "observatorium" in which participants and visitors could upend their view of themselves and the world.

The Balloon Company was also happy to lift off from the Netherlands. In 1977, the group acquired a Magic Bus that had been used to shuttle backpackers between the Vondelpark and the Lowlands Weed Company. In their *Luchtbus* (Air Bus), which they painted over with clouds, the Balloon Company traveled to Morocco. A letter of recommendation they carried from the Amsterdam Arts Council claimed that they were traveling in the context of the Keerkring's yearly Stedelijk Museum exhibition to experience Moroccan culture. But they themselves went with the expressed intent of contributing to Moroccan culture by sharing performances, including balloon and fire-eating acts.

The account the Balloon Company kept of that trip (Margrid Stokvis, 1977) makes clear that the performances did not always go smoothly. In Marrakech, for example, things went badly wrong:

> When we started it was impossible to stay together. Huge crowds thronged around us to get a glimpse of what was going on. The square emptied toward the Air Bus, and in five minutes we had to flee because we were completely crushed. When we tried to come back, the children were almost trampled and a crowd of totally maddened men followed us, so horny that they pinched and grasped wherever they could.

Despite this incident, and the general kinds of difficulties that they faced traveling with such a large and diverse company through a complicated country like Morocco, it was a fascinating and exciting journey. On the way, inspired by the landscapes and people they encountered, the group worked on material for the next Keerkring exhibition.

Ever Wilder

the expertologistic laboratory

Within the confines of the Stedelijk Museum, the Keerkring exhibitions were growing increasingly wild. Both dissatisfied Keerkringers and some of Holland's art critics had begun to feel that the exhibitions had less and less to do with real art. On the pages of the *Algemeen Dagblad* (03/30/1974), art critic Jan Juffermans wrote that the exhibition of 1974 was almost solely an expertologists' club. Much of it was devoted to photographs of the expertologistic expedition through the Netherlands and to another expedition to the sources of the Amstel River, an account of which was later published in the *Avenue* of July 1974.

The raft Max Reneman had built for the journey to the sources of the Amstel was a platform attached to floating chunks of styrofoam. The letters OW on the sail stood for "*Onze Welvaart*" (Our Prosperity), or, read the other way around, "*Wij Onderzoeken*" (We Investigate). The comic sight of a group of adult men floating by on a homemade raft drew all kinds of attention, and when it sailed past the village of Oude Wetering the raft won third prize (for best-decorated vessel) in the village gondola festival. Reporter Willem Ellenbroek, who had joined the crew to report on this new expedition, described the voyage as "strolling through the landscape."

In 1975, under the title "Drivel," art critic Fanny Kelk wrote in *Het Parool* (12/24/1975) that de Keerking had formed the habit of filling gallery rooms with visual jokes and gags as a way of noisily kicking against well-ordered society. And filling the rooms in this way, she fulminated, made the other art works disappear. This was certainly true for the exhibition of 1975. As gags, the Amsterdam Balloon Company and the Hieronymus Bosch Society showed totem poles bearing inscriptions like Greeting, The Secret, or Time. Jasper Grootveld contributed a rubber mobile titled "Dust Nest." The World Mathematics legacy of Nicolaas Kroese was honored—Kroese had sponsored Grootveld's Anti-Smoke Temple, and at one time had sent Prince Bernhard and other celebrities long telegrams about his discovery of a mystical mathematics that would save the world from atomic war. Theo Kley placed his Fruit Organ on show. And Max Reneman displayed a newly designed flag for Amsterdam and introduced the Foundation of Public Denture (a pun on the Dutch Public Art Collection Foundation). Exhibition visitors were invited to join the Committee 2000, an organization dedicated to planning for the future commencement of the millennial centenary.

At the exhibition opening, Theo Kley's publishing company, *Volle Maan* (Full Moon), launched its book, *De Keerkring*. Members and non-members of the society had contributed to it. Henri Plaat had two pages of scribbly figures in rhythmic patterns, Jasper Grootveld submitted large photographs of himself and his rafts, and there were enigmatic prints by Pieter Hermanides, a print of a blue wave by Sjoerd Bakker, labyrinths by Pieter Holstein, images of all sorts of cacti by Karel Meijers, the *Kidnapping of the Toilet Attendant* by Guus Boissevain, and painter Jaap Hillenius' handwritten statement of his aesthetic principles:

Who shot little Redbird Peck, drawing by Peter Vos (De Keerkring, 1981)

My starting point is the harmony in nature. I note, hit-or-miss: 1. Growth rates of plants; 2. Movement of water surface; 3. Eye movements of people; 4. Color, regardless of the form. Starting from these 4 points, I work.

Next to his statement was his print of moving lines.

The book also included poetry by Henk j. Meier, Hans Plomp, and this poem by Heleen I. Hildering:

Memory
on the street I often see
friends of long time gone
when passing I think
my eyes see images
of twenty years ago
the friends became timeless
after I left I stopped them
I can never recognize them again.

The print of a squirrel girl by William D. Kuik complemented pool-playing goblins and a collection of bird people by Peter Vos, and two etchings by Theo Daamen titled "Girls Looking Back" and "Democracy" And Expertologistic matters weren't neglected: a photograph of the Amsterdam mayoral candidate Julius Vischjager was provided, as was an itinerary for a red-white-blue bicycle route, along with drawings and "Old News" by Theo Kley, and images of sculptures by René Nyssen accompanied by a realistic picture of *The Netherlands Are Almost Done*. It was the kind of charmingly chaotic book, addressing both serious and humorous subjects, that was characteristic of the Keerkring in that period.

In *de Volkskrant* Martin Ruyter described his impressions of the Keerkring as it was then constituted (05/05/1977):

It is the most peculiar artists' association in the Netherlands, whose main feature is ambiguity. Part of them—serious people like Hermanides, Peter Vos, Theo Daamen, William Kuik, Henri Plaat, Jaap Hillenius—stand out for their orthodox craftsmanship, as artists who demand the highest quality of themselves. Another part consists of a merry sort of guest, the type one can meet in certain somewhat older pubs. These are the visionaries, whose favorite activity is storytelling, describing events in which they have participated or about which they have knowledge. An important aspect of their stories is that they are based on a kernel of truth, something that *really* happened, but during the retelling that truth is enriched with new facts that the narrator creates on the spot. So a new reality originates in the faith of the listeners: A case of how imagination can take over reality. The visionary members of the Keerkring—artists like Theo Kley, Max Reneman, Gerben Hellinga, Guus Boissevain, Jasper Grootveld, naming a representative group—base their existence on an imagined reality in which the something that really happened is usually missing. They create a

new reality; they exist in a country where, for example, dozens of balloons sail through the sky; they constitute a sect searching for the last butterflies; they take part in the foundation of the science of expertologistics dealing with the production of Immune Blue.

This is an exact description of the way the Keerkring artists were regarded by the Dutch public at that time.

For the 1975 exhibition, the Amsterdam Balloon Company fabricated a two-meter-high diorama made from scavenged wood: visitors could peep through dozens of holes at various heights onto a fantastic country of mountains and valleys, lakes and pastures, people and cattle. Beneath a fabricated sky hung balloons painted in many colors, kites, an air castle, a human bird, a flying horse. Martin Ruyter thought that the term *ludic* could be applied to the diorama and to work like Cor Jaring's *Chicken Migration* images of plucked chickens flying in airplanes, or the *Rookstoel* (Smoke Chair), a discarded colonial wicker chair decorated with marijuana plants and leaves. Max Reneman disagreed (*de Volkskrant*, 05/05/1977):

> It is very important in this group, the Keerkring, that the traditional artists and the others keep each other in balance. What is displayed here should be art, or a precipitation of a clearly spiritual phenomenon in Amsterdam, or else we don't want anything to do with it. There is no question of the ludic, and also I don't want to hear the words **alternative art**. Alternative for me is a *witkar* (the electric "white car" invented by Provo Luud Schimmelpenninck in 1970), and for me a witkar is a bad car. When I hear about an alternative lamp I think: It probably won't work.

For Reneman it was important that people participate in a collective imagination, like the kind the diorama provided:

> That is a very important discovery: the collective imagination; that you are not alone. That there are other people like you staring at the sky, following the cloud wisps, and that you can discover a bond and a conversation.

Responding to the question "What is the situation in the Netherlands?" he said:

> We are the first country in the world that is almost done. That does not mean we can take our hands off the steering wheel. We have to keep maintaining ourselves. We have to be very careful with the country. It is a pity that the Dutch people are not done yet. They remain grumblers and whiners. There is still a lot to be done about that.

In January 1978, Max Reneman participated in his last Keerkring exhibition. The opening was a merry event enlivened by several musical groups and choirs, including the Gruff Men's Choir, which had been created as a counterpart to the Choir of Nicely Disturbed Women. During the opening, a new edition of the *Daily Invisible* appeared—the one-man newspaper project by journalist/editor/publisher/Amsterdam mayoral candidate Julius Vischjager, which covered important non-world news and contained the *Poezenkrant* (Cat Paper) by designer Piet Schreuders, which was full of interesting coverage about cats. The exhibit included a series of photographs showing exactly how much effort it took Max Reneman to keep his head above water by using his life raft. And beautifully composed slides of the *Hunt for the Terrible Snow Woman*, which had taken place near Ruigoord, were projected for viewing.

Hans Plomp's detailed report on the hunt had appeared in the weekly *De Nieuwe Revue* (02/17/1978), illustrated with spectacular photographs by Cor Jaring. Plomp described some unusual tracks discovered near Ruigoord that seemed to belong to a gigantic two-legged creature. He narrated the story of the decision to equip an expedition and to seek the cooperation of the residents of Ruigoord, a group of hardened artists who had become deeply attached to the wild beauty surrounding them and did not mind the hardships of primitive existence. When the creature appeared, she was running like a deer through the reeds, two red breasts dancing against her speckled fur. The sounds she uttered were recognized by one expert as a form of primitive Celtic. He began a conversation with her, from which he learned that, as a result of her diet and habits of hibernation, she was practically immortal. From time to time her biological clock woke her up so she could visit a wildness area and couple with her male spouse. She was absolutely shocked by the lack of wild country in most of the Netherlands, but near Ruigoord she hoped to hibernate quietly until early spring. Plomp reported that, after much persuasion by the expedition, she had agreed to spend part of her hibernation in a freezer in the Stedelijk Museum. Thus, for the duration of the Keerkring exhibition, the hibernating Terrible Snow Woman waiting for her Snow Man could be visited in the New Wing of the Stedelijk.

Spurred by the success of the *Hunt for the Terrible Snow Woman*, Max Reneman, Cor Jaring, and Theo Kley began planning to create fairytale books for children, using photo strips in the same way as in their earlier photo series for adults. Alas, this project was not to be.

the ending of an era

Max Reneman planned to spend Christmas 1978 with his beloved partner, Ike Cialona, in Sicily at the house of her former in-laws. His itinerary called for him to arrive in Palermo on the early evening of Friday, December 22, to overnight in the city, and to travel by train the next day to meet Cialona and her noisy Sicilian in-laws. Cialona and her daughter were awaiting Reneman's arrival when, on the night of the 22nd, a heavy storm battered Sicily. The next day Cialono's cousin phoned to report that at around midnight a plane trying to land at the Palermo airport had crashed into the sea. Cialona

Max Reneman as pilot (Chiara Reneman Archive)

wasn't anxious because Reneman couldn't possibly have been on that plane. She herself had booked his departure. Though he hadn't yet called her, she was certain that he'd either be in his Palermo hotel or roaming the city. That afternoon, she and her daughter still planned to meet him at the train station in Trapani.

Unfortunately, perhaps because the earlier plane was full, or the rows of people waiting for the check-in were too long, or he was just late and missed his original flight, Reneman *had* been on the plane. Cialona tried telephoning the airport and Alitalia, but the lines were overloaded. The radio offered bits of news. When the plane hit the sea, the impact had ejected some of the passengers, who had been rescued by a passing fishing boat. Because of the wild seas, the wreck containing the corpses of the remaining passengers could not be hauled up immediately. A few days later, Cialona received a call from the police: four of the missing bodies had been retrieved. She was taken to a hospital where she found Reneman laid out, his face resembling the self-portrait against a background of blue green water that he had painted some years earlier. A plastic bag contained his water-soaked belongings: a passport, a notebook, an eraser, a pencil, reading glasses, and a small packet of marijuana.

On Friday, January 5, 1979, Max Reneman was buried in Zorgvlied on the Amstel, a place he had passed many times on his raft the *Kleinveld*. The day was sunny but very cold. Because he had remained essentially a Catholic, though he never attended church, a priest was present at his burial. It was so cold that the aspergillum froze in the holy water. The Amsterdam Balloon Company released a white balloon with a drawing of a blue butterfly on it. High up and far away, it crossed an airplane contrail and was gone.

In 1981, Reneman's former colleague, professor Guus Flögel, published *The Future of the Denture*, a book incorporating previous publications and notes by Reneman. Flögel did his best not to affect Reneman's inimitable style, and in the first sentences of the book Reneman's attitudes towards science become clear:

> Philosophizing about the future is not science in the usual sense of the word, but a belief and a hope. But the knowledge and understanding gathered out of love for a given subject may be considered, in any case by this writer, as belonging to the realm of science.

Reneman's adagium had always been: KNOWLEDGE IS NOTHING, ATTENTION AND LOVE EVERYTHING.

The last Keerkring Exhibitions

Without Reneman's inspiring presence, a spirit that was already on the wane completely abandoned the Keerkring. Gone was the chief collaborator of the Expertologistic Laboratory, advisor to the Society of Public Denture, founding member of the Balloon Company, the Committee 2000, and the Insect Sect; shareholder in the Lowlands Weed Company, explorer of the Sources of the Amstel, and conceiver of the notion that The Netherlands Are Almost Done. Keerkring exhibitions continued to include the work of new artists and old ones like Theo Kley, Cor Jaring, Paul Hugo ten Hoopen, and Henri Plaat. But neither they nor the openings were anywhere near as outrageous, controversial, funny, or crazy as they had been when Reneman was alive.

The 1981 exhibition was special, though not sensational. At the opening, well-known poets Dick Hillenius, Judith Herzberg, Cees Buddingh, Rutger Kopland, and Hans Plomp read, and some of the poems, illustrated by various Keerkring artists, were published in an edition of one thousand copies by former Provo Rob Stolk, who had started a printing business. But the exhibitions following that one grew increasingly dull. Interest among both the public and the artists dissipated. The Keerkring became an archipelago of individual artistic islands with no collectivizing current to unite them.

The last Keerkring exhibition in the New Wing of the Stedelijk Museum took place in 1993. Like his predecessors, Willem Sandberg and Edy de Wilde, Stedelijk director Wim Beeren had consistently rejected exhibiting the work of Amsterdam's artists' societies in his museum. In 1994, he finally succeeded in forcing them all out the door.

The New Wing really had been an ideal exhibition space: because of its central location, because visitors to other Stedelijk exhibitions often detoured into it, and because the space had been free. The municipality offered the expelled societies several possible alternative locations, none of which was truly suitable. Of all the affected societies, only the Universal Moving Artists group, which had started in 1965 as an international exchange project by visual artists, undertook a protest against the expulsion. Many of them had close ties to the free village of Ruigoord, and they installed a sculpture garden inspired by the village in the New Wing. Some five thousand visitors attended the opening, and the exhibition attracted many more visitors than any comparable contemporary exhibition organized by the Stedelijk. The Keerkring eventually relocated to a building called *De Zaaier* on the Keizersgracht—an inadequate exhibition space for which they had to pay. That choice marked the society's functional end.

the ending of an era

The group did come together once more, in 1999, for an exhibition in De Zaaier in remembrance of Max Reneman. Examples of Reneman's work were on view, and some of his old collaborators offered creations made especially for the occasion. In a long speech, Robert Jasper Grootveld remembered both his reac-

Butterfly Max, drawing by Rob "Opland" Wout (1928–2001)

82 — Marjolijn van Riemsdijk

tion to Max Reneman's death and his feelings about the man himself (*Liber Amicorum deskundolog Max Reneman*, 1979):

> My first reaction was a sort of dull irritability, oh no, Max again, now he is dead . . . you know, that sort of feeling. We irritated each other immensely. Yes, for example he wore those heavy shoes and he could sometimes just stamp through things, but behind that there was so much sympathy, and so much love for so many diverse topics, that of course one image remains with me: I was close to this man: Max Reneman.

After Beeren forced out the artists' societies, the New Wing became a kind of catch-all space for the most diverse kinds of exhibitions: an overview of the development of Alfa Romeo automobiles, Scandinavian design, graduation work by Rietveld Art Academy students, works by artists from Suriname, work available from the public art depot. More often, however, the glass building on the Van Baerlestraat stood empty, a useless appendage of the Stedelijk. Sandberg's notion that it functioned interactively to link art and society when passers-by viewed the art inside, had long been passé. Rudi Fuchs, who followed Beeren as director of the Stedelijk, had no idea what to do with the New Wing, and to the great distress of the Amsterdam city council he proposed making it available to the Audi car company, which was about to become chief financial sponsor of the Stedelijk. Fuchs' proposal was rejected. After 2003, the Stedelijk was closed for renovation and rebuilding. In 2009, in a perversion of a "ludic action," Caroline Gehrels, Amsterdam's alderwoman for culture, threw a stone through the New Wing's huge windows. Soon after that it was torn down. Following the reopening of the renovated Stedelijk in September 2012, the *vox populi* quickly christened the museum's replacement appendage as "The Bathtub."

Robert Jasper Grootveld

In 1993, when the city of Amsterdam began planning to refurbish the East Port area, where shipping activities on the IJ River had ceased, the Zeeburg district showed interest in Grootveld's floating-island experiments. Proposed by a city water-management office, Amsterdam's planning department became enthusiastic about the idea of a "water square" as a recreational park for the inhabitants of the new East Port housing projects. The plan provided for a floating path of softwood logs, on both sides of which willow trees would grow six meters high. This "willow lane" would constitute a bicycle and pedestrian bridge between the

areas of Borneo Island and Sporenburg. Larger pontoons would form a floating bus bridge, and between the islands and the bridges a number of oblong floating islands would be available for all kinds of recreational purposes. One of the civil servants in the planning department fantasized (*Vrij Nederland*, 09/11/1993):

> Due to the wind and the river currents, the islands will be blown into a corner or float around more or less dispersed. Based on this principle, the park will never look the same. The oblong elements will sometimes lie against each other skewed like a gigantic mikado, at other times neatly in a row. The inhabitants of the houses along the water will sometimes find an enormous bamboo bush before their front door, other times they will see a row of mothers float by sitting on a bench watching their children in the sandbox.

It was a great project, but it was never implemented. The costs were too high—about twenty million Dutch guilders—and other practical objections interceded. The municipal transport company declared the proposed floating bus bridge "very problematic." But, on reflection, the project leader for East Port development remembered Grootveld's experiments, which would cost less than what the planning department had projected for their islands. Grootveld's projects had already proven their worth, particularly the floating gardens next to Kees Hoekert's boat in the Nieuwe Vaart, which had sprouted willows and a huge elm tree and were now overgrown with grass, wild plants, and bushes where tits, grebes, and ducks came to brood. The remnants of the *Frya* and the rafts *Kleinveld* and *Het Gooise Matras* served as the gardens' foundations, and the East Port project leader proposed having Grootveld build similar floating islands for the "water park."

Grootveld liked the idea. Employing workers from the subsidized public facility *Maatwerk* (Custom Made), which provided specific jobs and training for the chronically unemployed, he set to work in a new facility provided by the city—large sheds on the Zeeburgerkade that had originally been warehouses for the city cleaning department. It was an irony of fate that the inhabitants of the new, expensive, converted warehouses, who had fought actively against having a refuse-collection station in their neighborhood, had ensured that the cleaning-department warehouses were available. Instead of a carefully-controlled city facility, they now had Grootveld's chaotic project on their doorsteps creating artworks that the cleaning department had once considered "roaming litter." In 2000, the new islands were ready and Grootveld handed them over. But when the Zeeburg district transformed them into tidy little floating parks, he was infuriated. He had conceived each island as a "users' garden" (*gebruikstuin*) that would be modified by the people in the community according to their particular needs, but the neat little parks the city designed did not even have benches, he noted. (Interview with the author, 02/2000)

Untitled shilajit on ricepaper, 1999, Theo Kley (Theo Kley Archive)

Theo Kley

After the dissolution of the Keerkring, Theo Kley began traveling again. He journeyed with the Balloon Company through Yugoslavia as far as Greece, where they organized a kite festival near the small town of Gianitsohorion in the Peloponnesus. He later rejoined them in Goa, India, where, with help from them and a group of local craftsmen, he manufactured and placed an enormous white lime egg as a beacon on a rocky point that he called Cape Reneman. He returned repeatedly to a remote corner of India, where by sheer accident he had discovered a series of grottoes and caves containing rock paintings. The paintings reminded him of Bushman paintings he had seen years before in Africa, images that had inspired him in his earlier work. The images in India included twig-thin figures, people and symbols that looked like they had been X-rayed—representations of livestock and agriculture, hunting and martial arts, attackers on horses dressed like crusaders in chain mail and armor. In one cave there was a group of women amusing themselves with music and dance, women beautifying themselves, brushing their hair, massaging each other, or reading the palms of their hands. In another chamber he saw a royal figure surrounded by pretty women. Everything was painted in simple pigments, brown and white, very sophisticated and refined. It was not clear how old these paintings were, but they quickly began to influence all his new work. He started sending friends *Theogrammen*, fold-out postcards with images, texts, photographs, and decorations. Anyone who wanted to could subscribe to the Theogrammen list.

Midway through the Nineties, Kley abandoned his top-floor studio and roof garden in Amsterdam, where the trees had not only reached skyward but had also plunged their roots down through the roof of his studio. He settled in Ruigoord, first in a tent-house, then in a trailer that the port authority provided and made habitable. The port authority also provided him assistance on a new landscaping project, helping him construct a *Teletubbie* garden of his own design, with small round hills and a kidney-shaped pond. Work on that garden, which has become a vastly more ambitious paradise, continues today.

By 1997, the Amsterdam port authority had again grown serious about constructing a port near the village of Ruigoord and excavators began operating. In the fall of 1998, Kley joined painters Hans Gritter, Niels Hamel, and Aat Veldhoen in what they called the *Lost Landscapes* project, an attempt to capture on giant canvasses the beauty of Ruigoord's wild surroundings. The four artists wanted to draw attention to the world's increasing urbanization and the related destruction of greenscapes around big cities. Kley warned that destroying nature would provoke bad feelings among animal species. A local TV station, Rabotnic TV, filmed the painters working outside on their canvasses in all kinds of weather, accompanied by the roar of construction machinery in the background. In the spring of 2000, the finished paintings went on display in Ruigoord's Church of Saint Gertrude. That summer, a relatively small new Africa Port opened on the "coast" of Ruigoord, providing the village with a swimming beach.

Amsterdam Balloon Company at Goa (Theo Kley Archive)

TOREN VAN BABEL RUIGOORD 2000.

Tower of Babel at Ruigoord

Ruigoord and the Africa Port

After 1987, the annual kite festivals were renamed Landjuweel (country jewels) after traditional sixteenth-century Dutch theatre and storytelling contests, and became a dominant summertime feature of the rugged countryside surrounding Ruigoord. They regularly featured performers and groups that the Balloon Company had encountered during its travels throughout the world. Despite recurrent City Council threats that they would be evacuated, when the West Port area expanded the inhabitants of Ruigoord remained in place and prospered—their children have since had children of their own. Some of the oldest inhabitants, the originals who had refused to leave during the first eviction, died in their own village at well over ninety years of age.

The 1977 trip to Morocco had tweaked the Balloon Company's sense of adventure. In 1979, a new group of travelers departed Ruigoord in the Air Bus with the stated goal of reaching China. In Yugoslavia they organized a "Magic Full Moon Sabbath" in Belgrade—Hans Plomp read poetry by Paul van Ostaijen and Simon Vinkenoog, and The Ruygsisters sang accompanied by Yugoslavian musicians. In Greece, they held another kite-festival; and then, organizing performances and theatre wherever they could, they con-

SHIVA EYE 1985,
L. 95 - H. 75 CM.

René Nyssen, Shiva Eye, 1985, granite

tinued on via Turkey, Iran, Pakistan, India, and Nepal, to Goa. In 1989, the Balloon Company visited Russia, and in 1996 they reached Mongolia, accomplishing the goal they had set for themselves in 1979. Throughout it all, the home-front followed their travel accounts, and the travelers carried passport photographs of the people at home with them to "witness" their adventures.

The villagers remaining in Ruigoord did not hibernate while their ambassadors traveled. In 1985, members of the Committee 2000 (originally founded at the 1975 Keerkring exhibition to prepare for the advent of the millennium) buried "time capsules" containing representative material, texts, and photographs. Into the capsules went a map of the village and its surrounding wilderness, photographs of the Balloon Company, bottles of wine—which would be well matured by the year 2000—a piece of hashish, a horn filled with Immune Blue, and an alarm that Theo Kley wound tightly enough to ring with "old energy" when the millennium arrived. René Nyssen sculpted a rounded granite stone—the navel, or *omphalos* of Ruigoord—embossed with the sign of Shiva that covered the excavation containing the capsules. (The Shiva stone now lies next to the entrance of Saint Gertrude's Church.)

However, Ruigoord was again under siege. In 1997, it had become clear that the city of Amsterdam was bent on completing the West Port. The *Green Front* camped in the village in an attempt to prevent the destruction of the surrounding wilderness. Activists entrenched themselves in tree houses and tunnels, undermining the ground so the heavy equipment could not move in. And when those initial efforts proved unsuccessful, they built a fort on the ravaged plain and labored to plant a new forest and further delay the construction. But it was all to no avail.

In the summer of 1999, under the supervision of a talented group of builders, on the spot where the time capsules lay buried, work began on a huge Tower of Babel constructed of pallets and scavenged wood. Incorporated in the structure was a "ladder to heaven" that Theo Kley created for Max Reneman. The Tower was a magnificent creation, reminiscent of a painting by Breugel. Like a battle tower from the Middle Ages, it stood visible from afar, rising over the misty horizon of the denuded plain that was all that remained of the wilderness once surrounding the village. On the millennial New Year's Eve, at the stroke of twelve, the villagers intended to set their structure ablaze. The tower was their gesture against the Philistines controlling Amsterdam's development, a gesture so magnificent that the Philistines themselves proposed designating it a cultural monument. "No!" replied the villagers, and when the time came they burned it to the ground.

On January 6, the Shiva stone was removed and the time capsules returned to the surface. They were opened during a solemn, yet merry gathering in the church. Because its elastic band had disintegrated, the alarm con-

taining Theo Kley's "old energy" did not ring. But the wine and the hashish were fine and the other contents had been well preserved.

Under public pressure, the port authorities initiated negotiations with Ruigoord's inhabitants. The parties reached an agreement that the heart of the community would remain an artists' village. The inhabitants were allowed to choose the architect who would redesign their home, and to reorient their lives according to various artists' initiatives, with all costs paid by the port authorities. They chose Ashok Bhalotra, who was well-known for his inventive new districts in the Netherlands, and who was, coincidently, the same architect the port authorities had in mind.

To generate ideas for Bhalotra's design and the reorganization of their village, a group of Ruigoordians visited Insel Hombroich in Germany, next to the village of Neuss near Düsseldorf. In an undulating landscape, ten scattered rectangular pavilions contained the art collection of a rich industrialist. The perfect lighting in these simple pavilions displayed the art to full advantage. The place and its structures appealed to the visitors, who felt that if Ruigoord as they knew it was going to vanish, then why not build something uniquely different to replace it? But the port authorities specified that Ruigoord should become a workshop village, which meant that no one could reside there permanently; that the existing buildings would be used only as studios. And Ashok Bhalotra wanted to restore the village center as closely as possible to what it had been historically. After much work and discussion, nothing came of the plan to redesign the village.

To date, the agreement with the port authorities has worked out reasonably well. "Officially" the village is used only for artistic purposes, and the church continues to function as a lively cultural center. A foundation has been established to organize funding for cultural events and to maintain the existing buildings. The Amsterdam Balloon Company still organizes its festivals, and the village maintains its ties with other groups of artists all over the world.

The West Port surrounding Ruigoord is almost complete, and the wilderness has vanished. A coal terminal stands on the land where the annual festivals once took place—2010 was the only summer in thirty-five years without a Landjuweel. Towering modern windmills have risen into the surrounding skies, enormous ocean-going vessels sometimes moor at the end of the main street, and the sounds of progress pound and saw the once-quiet air. Yet resistance lives on, and 2013 will mark the 40th anniversary of the village.

Though Robert Jasper Grootveld and Simon Vinkenoog—whose creativity indelibly marked the Sixties and Seventies—both died in 2009, their imaginative genius lives on alongside Max Reneman's in the collective mind, and Theo Kley remains a creative dynamo. Ever embattled, yet always inspiringly resilient, under the motto *Fortuna Favet Fatuis* (Fortune Favors Fools) the magic-centered forces that conjured the Insect Sect and the Balloon Company and that brought a village commons to Amsterdam's creative community continue their assault on the impossible.

Amsterdam/New York City,
February 2013

appendix 1
robert jasper grootveld: proclaiming amsterdam magic centre of the world, white bicycles and provos

In the late Sixties and early Seventies, Amsterdam was flooded with throngs of young tourists. Together with London and San Francisco, the city grew to become one of the key youth metropolises of the world. Youngsters from all over the world, including many Americans, began visiting Amsterdam every summer. Due to the lack of sleeping places, they perched in the Vondelpark, deploying their sleeping bags on the grass and enjoying the unlimited possibilities that Amsterdam had to offer. Sleeping in the Vondelpark was an international success. KLM and PanAm advertised worldwide, offering special flights to "that cute hippie park in Amsterdam." In the summer of 1973, it is estimated that about one hundred thousand people used the park as a place to sleep. By 1975, the park increasingly began to resemble a public campground and a ban on sleeping was set to prevent a complete take-over.

The conversion of Amsterdam from a rather insignificant European town into a major capital of the new generation took place over the course of just a few years. This radical change happened fairly smoothly, without most of the turmoil and violence one would expect. The authorities more or less gave in, surrendering to the new age. Yet at the beginning of the Sixties a take-over of the city by hippies, marijuana smokers, radical students, and other representatives of the cult of love and freedom was unimaginable to the lethargic, conservative Dutch society of the time. That is, unimaginable to everybody except one man.

In the summer of 1962, Robert Jasper Grootveld was asked to introduce the opening of an exhibition of photographs from his performance in his anti-smoke temple some months before.

> It was a painful situation, because I had no idea what to talk about. So I walked forward and while I stood there I looked out over the heads of the audience and just saw a sparkle of the water in the canal. I thought, yes, now I am in Amsterdam. And then I started: "I had a dream last night"—I lied like the plague, because I had no dream, but I was trying to make a start—"that the city center had become the western asphalt jungle, the Magic Center, blah, blah, blah." And at that moment I was actually dreaming. Because I saw it, I saw thousands of American beatniks come to Amsterdam, to the Vondelpark. I saw it in my mind.

appendix 1

That, wonderful as it is, happened: that is a miracle that happened to me. (Van Gasteren, p. 52; see also Leurdijk and van der Kamp)

This nice story about the first proclamation of the Magic Center on a sunny afternoon along the canals of Amsterdam was actually a pretty accurate forecast of the events to come. But it remains a question whether Grootveld, at a time when almost nobody in the Netherlands dared to cross a lawn without the delusions of being spied on by a policeman, really predicted the eruption of freedom that Amsterdam was about to experience. It is tempting to impute prophetic gifts to him. That would mean that everything he undertook during the following few years, not least his involvement in Provo, could be interpreted as a deliberate attempt to bring closer the situation that he envisioned. Yet the only thing that is clear is that he didn't fabricate the story of his dream about the Vondelpark: a report in one of Holland's main weekly magazines of the time confirms the whole story almost word for word:

> The opening reached a depressing climax with the appearance of Robert Jasper, the man who loves to smoke to demonstrate its evil consequences. With his emaciated face, in which heavy bags hang underneath the fierce eyes, he stepped behind the bar for a statement. He had had a dream in which he ran over squares, streets, along canals, until he landed in the Vondelpark... he saw Americans in thousands, tens of thousands, hundreds of thousands come to Amsterdam, the Magic Center of the world. (*Vrij Nederland*, 06/30/1962)

With the proclamation of Amsterdam as the Magic Centre, Grootveld created an imaginative concept that would come to lead a life of its own. In the first place, he designated Amsterdam as a center. The magazine reporter describes how, immediately after the introduction of the Magic Center, Grootveld notes a conspicuous event. "With raised voice Jasper spoke about the recent party where the great people of the earth came to Amsterdam: 'Among them were Kings, Emperors, Princes; and what hung over those merry-makers? A balloon from the Roxy cigarette brand.' He spoke those words clearly and strongly," explains the reporter. Grootveld was referring to the celebration of the twenty-fifth wedding anniversary of Queen Juliana and Prince Bernhard, which had taken place a few weeks earlier. On this occasion a choice sample of high-ranking royal and imperial guests was present, which the media widely referred to as the "great people." Grootveld was inspired by the arrival of so much royalty, but at the same time made the connection with advertising and the cigarette industry, which for him was a link to the Americans he was expecting:

> I see the drugs coming like an avalanche over the western world. The ordinary cigarette is the pawn, they are the foot soldiers of the dope-army. Behind them the marijuana sticks, the hashish pipes, the pills and syringes march in. Any

94 ▬ Marjolijn van Riemsdijk

addiction is opium and opium is the religion of our people. I see the advertising pillars in the street as the totem poles of the asphalt jungle, and advertising people as the witchdoctors. However, the ordinary cigarette is now no longer of much interest, as there are other dependencies, and control must be maintained in a different way. How? By getting Americans over here, because in America you have the biggest dope-industry of the world. (*Het Parool*, 09/05/1962)

Grootveld envisions the Americans arriving in Amsterdam. But the purpose is not that they come to the Vondelpark to lie idle on the grass. Just as he attempted to do with the nicotinists in his anti-smoke temple, he wants to cure them of their many dependencies. In his conception, Magic Center Amsterdam is not simply a center for dope in the hippie sense, it is also a large rehabilitation center where awareness upends the hypnotic power of advertising and the addictiveness of cigarettes and other dope. "That's what I want: we must all become ourselves, see ourselves and piece everything together." (*Ibid.*)

Amsterdam plays an important role in Grootveld's practice as an exorcist. In his home town he can enlist the help of many others like himself: "There are at least a hundred prophets around in Amsterdam. They all have something to say and struggle against each other. Amsterdam is the city that has them all. But to attract everyone we need the continued interest of the world press—the *Time* and *Life* reporters should come here because here is where they will find it." (*Ibid.*) Publicity plays an important role in launching the rush to the Magic Center. And in the summer of 1962, Grootveld is ready to take the lead. By means of a number of astonishing performances, which generate a lot of publicity, in the years to come he will actually attract large numbers of "addicts" to the Magic Center.

Soon Grootveld will find himself at the heart of the turmoil that will change Dutch society. No other country in Europe will experience such radical change as the Netherlands in the Sixties. In ten years the Netherlands will transform economically, socially, and culturally from a conservative and backward society to the vanguard of progressive Europe, with Amsterdam as its Magic Center. Equally remarkable will be the fact that the whole process takes place almost without violence. Unlike in many other countries, the Sixties in the Netherlands are known as a "playful" (*ludiek*) time. And if anyone can be said to have had a demonstrable role in shaping that playfulness, it was Grootveld. This is shown, for instance, by the way he became involved in Provo and invented the White Bicycle Plan.

The White Bicycle Plan and the Invention of the Provo Revolution

Grootveld was upset by the provocative and rebellious rhetoric of the anti-police campaign with which Provo introduced itself. He didn't approve of it at all. In one of the first meetings he had with Roel van Duijn he raised the topic. Together they walked the narrow streets of the Jordaan in the center of Amster-

appendix 1

dam. "He talked a lot," van Duijn remembers. "He told me about his father, who was an anarchist, and about the police. He told me his grandfather was a police-officer. I remember he asked, 'What exactly is your enemy? The police? That's out of the question. . . .'" (Van Duijn and Duivenvoorden, 02/15/2007; see also van Duijn, *Diepvriesfiguur*, p. 61) Grootveld tried to convince van Duijn not to make the police a target of Provo's actions: "I told him, 'Roel, you will lose when you set up the youth against the police.' But then he responded, 'Yes, but wait till the workers join in.' I said, 'Roel, it's 1965, there are no more workers, they are

Jasper Grootveld pedaling the tricycle at the presentation of the White Bicycle Plan, Rob Stolk sits on the white bicycle above him (Hans Bruggeman photo).

all motorists now. They do not like some instigator who comes to them saying: 'Sir, you are an exploited worker.' His self-esteem lies in his car.'" (Grootveld and Duivenvoorden, 11/16/2006)

The influence of Grootveld's specific views on the Provos is immediately obvious. After successive confrontations with the authorities over the engagement of Crown Princess Beatrix to the German Claus von Amsberg, and the seizure of the first Provo magazine, Grootveld offered a whole new plan to lead the Provo movement along a different path. After his discussion with van Duijn on the worker who is only interested in his automobile, Grootveld threw the bike into the mix. Under the motto "A BICYCLE IS SOMETHING, BUT ALMOST NOTHING" (*Een fiets is iets maar bijna niets*), he succeeded in inspiring the Provos to shift their focus from provoking the police to challenging the authority of the car: the White Bicycle Plan. His basic idea advanced the general availability of this simple means of transport. In a 1966 documentary for British television, Grootveld reviewed the origin of the idea:

> I got this idea from the hunger winter in Amsterdam in 1944–1945. I was playing with kids outside Amsterdam and wanted to have a bike. But bikes weren't available anymore; they had all been stolen by the Germans. I came up with the idea of lots of people sharing a single bike for free. And it came into Provo when I saw all these traffic jams in town. It is really impossible to go with a car from one part of the center of town to another part. . . . And it is also very noisy, and it makes you nervous, because the large numbers of accidents and cars, and lots of dirty smoke, really poisonous smoke. (Apted, 11/18/1966)

In his bicycle plan, Grootveld acknowledged multiple aspects of his life. Apart from his youthful reminiscences, he emphasized two personal criticisms of automobiles: the excessive stress they caused him and air pollution. The first he clarified by insisting that he wanted: "Some silence in town, without the noise of the false images." With respect to the issue of air pollution, it should be noted that he was responding at least in part to a notion put forward by the tobacco industry and its heralds casting doubt on the causes of lung cancer. Instead of implicating cigarette smoke as the cause of cancer, the tobacco industry blamed it on air pollution caused by cars on the streets.

His favorite cultural figure, Klaas (Santa Claus), also played a part in his ideas about the distribution of the bicycles: they were to be given away for free and to be made freely available. His interest in Klaas also helps explain why white was chosen as the color for the bikes. The color would in many ways come to symbolize the sweet revolution of the Provo rebels, but, at the time it was chosen, the red and black colors of anarchism seem have been a much more obvious choice. They were indeed suggested, but Grootveld, who unlike the youngsters of Provo was himself a war child, subtly pointed out that fascism adorned itself with those same colors.

appendix 1

In an unpublished interview Grootveld elaborated on the discussions that led to the choice white, recalling in this context the Little White Bed Action. (Grootveld, unpublished interview, 07/1965) Shortly after the war, The Little White Bed Action was instituted to raise money for Santa Claus gifts for sick children, who otherwise would have been forgotten. In 1965 it was still an annual event, though very few people would have been thinking about it in the middle of summer. It is typical for Grootveld to combine his devotion for Santa Claus with The Little White Bed Action in naming the bicycle plan white. Following his logic everything fell into place, and the Provos loved the idea because it coincided perfectly with their *ludiek* conceptions of anarchistic and provocative ideas.

On Wednesday, July 28, 1965, a number of Provos accompanied Grootveld on his way to the Lieverdje, where the White Bicycle Plan would be formally presented. When he arrived at the little statue, where a year earlier he had started his weekly happenings, he began the event. Three old bikes that have been painted white were offered to the public. Pamphlets were handed out.

Provo's Bicycle Plan

People of Amsterdam!

The asphalt terror of the motorized bourgeoisie has lasted long enough. Daily human sacrifices are brought to the latest idol to which the **klootjesvolk** has delivered itself: automotive authority. Choking carbon monoxide is its incense; its image contaminates thousands of canals and streets.

Provo's bicycle plan brings liberation from the monster car. Provo launches the white bicycle, a piece of public property.

The first white bike will be offered to the public and the press on Wednesday, July 28, at 3 P.M. at the statue of the Lieverdje, the addicted consumer, on the Spui.

The white bike is never locked. The white bicycle is the first free collectivized transport. The white bicycle is a provocation against capitalist private property, because the white bike is anarchistic.

The white bicycle can be used by those who need it and must then be left unattended. There will be more and more white bikes until everybody can use white transport and the car danger has passed. The white bicycle symbolizes simplicity and hygiene in contrast to the vanity and filth of the authoritarian car. After all

a bike is something, but almost nothing.

The police department acted as spoilsport. A city bylaw prohibited leaving unattended and unlocked bikes in the streets and the white bikes were immediately confiscated. "Policemen, policemen, where's my white bike?" (*Politie, politie, waar is mijn witte fietsie*) chanted the bystanders at Grootveld's instigation. The

pamphlet announcing the White Bicycle Plan, which was published as *Provokatie number 5*, was the first Provo publication completely riddled with Grootveld's distinctive vocabulary—the asphalt terror, sacrifices, and the addicted consumer—and carefully chose not to directly confront the authorities.

The White Bicycle Plan seemed to seal the cooperation between Grootveld and Provo, although he would never play a role in organizing the movement. Nor would he ever publish anything in the Provo-magazine. It was Luud Schimmelpennink who provided, in the second issue of Provo magazine a few weeks later, the technical and theoretical justification for the White Bicycle Plan and developed it further. Grootveld hated to attend meetings and did not interfere with the Provos. The Provos, on the other hand, directly interfered with Grootveld's happenings, with his full blessing. After a year of Happenings at the Lieverdje, he was happy to have permanent allies willing to make a substantial contribution. What he did not foresee was that these new allies would quickly put such a large stamp on the events that the survival of the happenings would soon be at stake.

The cooperation between Grootveld and the Provo movement, which started with the White Bicycle Plan, roiled the Netherlands in the years to come. Grootveld's weekly happenings at the Lieverdje grew completely out of hand from the moment the Provos joined in. His direct influence on the Provo movement led to an outburst of creative thinking on the part of the activists who, while attracting a great deal of media attention by adopting his methods, vocabulary, and ways of thinking, soon learned to be provocative without being violent. And the wave of police brutality that followed resulted in the dismissal of both Amsterdam's mayor and its chief of police, because instead of blame falling on the Provos for the turmoil, it fell on the authorities themselves. The Provo revolution changed the Netherlands so completely that it would never be the same again. And significant aspects of its success can be directly attributed to the creative input of Robert Jasper Grootveld.

Eric Duivenvoorden
09/08/2012

Historian Eric Duivenwoorden has recently posted *Jasper en het rokertje* (1962) on YouTube, http://www.youtube.com/watch?v=WATRmo-g9nY. This extraordinary film footage documents Grootveld's anti-smoking Happenings and the creation and burning of the Anti-Smoke Temple.

appendix 2
theo kley: pataphysicist — fragments from the pataphysical record

In Book II: Elements of Pataphysics, Section 8: Definition, of his *Exploits and Opinions of Doctor Faustroll, Pataphysician* (Shattuck and Taylor, 1965), Alfred Jarry (1873–1907) famously defines 'pataphysics as "the science of imaginary solutions, which symbolically attributes the properties of objects, described by their virtuality, to their lineaments." He professes that 'pataphysics "will describe a universe which can be—and perhaps should be—envisaged in the place of the traditional one, since the laws that are supposed to have been discovered in the traditional universe are also correlations of exceptions . . . which, reduced to the status of unexceptional exceptions, possess no longer even the virtue of originality." In the piece that follows, Dutch pataphysicist Matthijs van Boxel proclaims Theo Kley's conceptual affinity to 'pataphysics' traditions.

Speech by Matthijs van Boxel R/OCS to a pataphysical gathering at Ruigoord, 26 merdre, 138 EP (Pataphysical Era) (June 12, 2011, vulgo)

NIP and NAP

The Dutch Institute for 'Pataphysics (NIP) was founded in deepest secrecy on the 1st Absolu 100 EP (September 8, 1972, vulgo) by morosophers from the Insect Sect.

On 130 EP (2002), the French *Collège de 'Pataphysique* commissioned the regents of the NAP (the newly founded Academy of 'Pataphysics) to track down the patriarchs, pundits, and living fossils of the NIP. After months of wandering through the Dutch polders, they washed up at Ruigoord, a Crusoe-island that protrudes like the tip of a submerged continent above the western harbor area, the industrial area of Amsterdam. (In-dus-try, one-two-three in all languages, according to arch-pataphysician Alfred Jarry.)

Under an Immune Blue sky they found Theo Kley in his garden, floating on an inflatable lotus leaf, his parrot-green moustache glowing in the sunlight, who received them with the words: "I've awaited you for three thousand years."

(Applause, for our honorary member!)

Mythology of Theo Kley
(b. 1936, vulgo)

Since 1965, world traveler and artist Theo Kley has stood at the hub of happenings that mock political dogma and expertological newspeak (*zweefkezerij*).

The standard work, lo, one of the many bibles of the Dutch pataphysicians, *Mother, what's wrong . . . with this planet? (A dozen popular science projects by Theo Kley as described to Ineke Jungschlaeger)* (Amsterdam, 1969), reports Kley's ongoing Expertological (*Deskundologisch*) research, which is supported by a team of international scientists. Kley initiates a project of dirt-glorification: he sets up a Limited Company to exploit the gas bubble (composed of hydrogen and carbon monoxide) hovering above the cities by means of enormous rubber hoses; and he develops the "Wavecoach," a painted, blue construction bearing a long pole on which a gloved hand waves when there is enough wind. (The artificial priests, including an automat filled with sacraments instead of snacks, have been tested and found wanting.)

To free people from their mother complex, Kley develops, in collaboration with the psychologist JAM Mathijsen, an eleven-meter-high electromechanical polystyrene surrogate mother with artificial hair. These motherdolls should be placed in all squares. . . . After throwing a coin in at knee-level, her pink belly opens and allows access via an escalator to the uterus, where you can find changing-rooms, from which a springboard allows naked access to an amniotic fluid composed of lemonade, stewed pears, alcohol, and dried raisins. Relaxed, one bobs in the womb—you can eat the placenta. Everything glows red; the sound of knitting needles ticks from speakers as the uterus gently rocks. An umbilical cord prevents accidents.

Demonstration Project

Especially for bad weather, and the home-bound, Kley develops a Demonstration Project: a collection of paper models of public buildings and monuments that people can use to organize demonstrations at home:

> Under the head-of-the-family's leadership the company departs on a Saturday afternoon from the kitchen, where they have gathered around The Trade-Union Man (construction 1). Armed with banners and shouting applicable slogans, the group moves slowly down the hall to the parlor, where the National Monument on the Dam has been rebuilt (construction 2). After laying a laurel wreath there, they head for the colonial Van

Heutz Monument (construction 3) in the bedroom, where a firecracker can be popped.

There is also an embassy building, the nationality of which is determined by a flag on a matchstick. One additional benefit of the project is that traffic is no longer hindered by demonstrations.

What Is the Netherlands Worth?

During past centuries we've made a mess of the Netherlands. The only permanent solution is to sell the whole thing and start again. Hence the "What Is the Netherlands Worth?" project (an idea previously suggested by Sieto Hoving and Hugo Brandt Corstius). First, we divide the country into pieces of different value, depending on what's on it.

> Of course, we leave the whole thing neatly behind us when we leave. The streets scrubbed, the windows cleaned, the trees fresh-sprayed. Every home should be ready for the buyer to move into it. We take along only a few little things. A few pedigree cows, some Delft-blue ceramics, lace curtains, cheese molds, tulip bulbs, a few windmills, and the Queen. And, of course, as pocket money each takes his share of the proceeds. On a quiet empty spot in the Sahara, for example, we could start all over again. With a political party in which all the benefits of all the splinter parties are united, with a new religion adapted to the tropical environment, a new educational system, and so on. Nobody will need to work, everyone can invest money in shares and interest. . . . But first we need to know exactly how much the Netherlands is worth.

According to calculations by the General Statistics Office, in 1968 every Dutchman can live off the country's vast revenue. In 1968, according to the Kingdom's balance sheet, the Netherlands produces:

— Enterprise (industry, construction, public utilities, trade, transport, catering, other businesses, agriculture, horticulture, fisheries), total: fl.1,376.7 billion.
— General (land, houses, schools, churches, hospitals, etc.), total: fl.219.4 billion.
— Transportation (fleet, railways, inland waterways, trams, cars, bikes, roads, airplanes, etc.), total: fl.76.5 billion.
— Private property: fl.65 billion.
— Government (state enterprises, buildings, bridges, tunnels, waterworks, sea, land and air forces, possessions of HM the Queen), total: fl.72.1 billion.
— Gold Hoard in the Dutch Central Bank: fl.6 billion.

The total amounts to 1,815 billion Dutch guilders (7 billion dollars); which yields about 13, 139,670 guilders per Dutch citizen.

Appendix: For Dutch people who also want to sell their bodies, the compensation-scheme in the State Police monthly magazine offers guidelines: in 1977, four toes were worth fl.3,000; a bruised thigh, fl.5,000; baldness, fl.15,000; totally destroyed teeth, fl.25,000.

EKK/EQF

In a Dutch café Theo Kley discovers a special barstool. A little bored, he is drumming on the imitation leather seat when the exceedingly pure, almost classic sound of the barstool strikes him. He has found the Stradivarius of barstools! With the owner's permission he takes it home, where other musicians join in with different instruments. In 1968, they found the EQF (EKK), the *Eksoties Kietsj Konservaatooriejum* (Exotic Kitsch Conservatorium). There are 83 registered kitsch sisters and brothers who "breed" kitsch—especially Oriental *exotic kitsch*, which explains the inclusion of fortune-tellers, a fakir, a sheikh, a mummy, and a man on a flying carpet. There is also a Kitsch laboratory that conducts research into the nature of kitsch:

> When is kitsch kitsch? That's a very complicated question, because today's kitsch may be art tomorrow, and vice versa. The only certainty is that, from the paradise of Adam and Eve to the tulip fields of today, throughout history kitsch has existed. Everyone possesses a **kitschdrive**.

Research determines that gold is *kitschcolor*, incense *kitschperfume*, Esperanto *kitschspeak*. *Kitschclothing* may be garments or a hairy torso. The laboratory develops a *kitschmachine* that blows soap bubbles filled with incense. There is a cursive *kitschscript*.

The EQF orchestra remains central, and appears everywhere kitsch is required. "In the provinces there is great need for exotic kitsch." Anyone anywhere can produce sound, concedes the EQF. The audition for band membership consists of rhythmic barstool drumming, whipping wet sheets on a clothesline, or shaking a package of rice.

Among the instruments: the klaas horn, consisting of a toy flute, bellows, a hose, a car horn, four nozzles, and painted funnels; piano strings wrapped on coil bed springs; a child's barrel organ and plastic balls; and a kaka phone. The orchestra doesn't strive for harmony, all sounds and rhythms, at any given time, coalesce into a unique whole.

The EQF orchestra performs *kitschmusic* in dentists' waiting rooms, at train depots, and at national disasters. But it also appears unexpectedly . . . Each performance is unique. The EKK plans to tour Dutch campgrounds, giving them a sense of being abroad, but after a few minutes at the opening of the Arnhem Town Hall the audience flees with its fingers in its ears. The EQF calls off its tour, afraid it might in-

duce mass migration by depopulating campgrounds and villages. Someone suggests using the EKK to break up traffic jams, or to disperse crowds during demonstrations.

Source: Matthijs van Boxsel, *Deskundologie, or Stupidity as Living* (*Expertological Laboratory*) (Amsterdam: Em. Querido, 2006)—in Dutch. Matthijs van Boxsel is also the author of *The Encyclopaedia of Stupidity* (London: Reaktion Books, 2004).

appendix 3
simon vinkenoog: "damn war, animate peace!" (a short biographical sketch)

Simon Vinkenoog was born on July 18, 1928, in Amsterdam, the son of a postman who divorced his wife when Simon was six years old. Despite his humble background and lack of formal education, he became a pivotal figure in the Dutch art renaissance in the Fifties and the international counterculture that peaked in the following decade. In the nation's history, it's hard to find any cultural figure with such a vast and diverse body of work. Vinkenoog was a writer, journalist, performance artist, organizer, promoter, activist, but first and foremost a poet: "A poet trapped in a journalist's body," as he was once described by writer/astrologer Jan Gerhard Toonder.

Divorce was very uncommon in the Netherlands during the Thirties, and the way his parents separated made the experience especially traumatic for little Simon. His father kidnapped the boy without warning: one night he took his wife to the cinema, and when they returned half the furniture and their son were gone, removed by members of the father's family. Simon spent a few lonely months with family he hardly knew, not knowing whether he would ever see his mother again. Eventually she was granted custody and raised her only child alone.

Simon grew up a very lonely mother's-child: bullied by other kids, pale and skinny, with more interest in books than in playing soccer or fighting. Living conditions were poor, even before the German invasion in the spring of 1940. His mother worked as a cleaning lady and depended on government handouts, like clothing and tinned food, to make ends meet. She could hardly read or write, so Simon was the man of the house from a very early age. This changed little after she remarried during the war, as his stepfather spent most of his time working in Germany.

Simon was eleven years old when World War II broke out, sixteen when Nazi Germany was defeated. These years are formative for anybody; in Simon's case they defined the core of his identity, his philosophy, and his work, which all revolve around one central theme: freedom. For Simon, the horror of war and the total absence of freedom were summed up in one dreadful image: the moment his only friend, Helmut Blumenthal, was deported. The Blumenthal family lived

right across the street from the Vinkenoogs. Helmut's father was a Jewish butcher who had fled Germany to escape the Nazi threat. In the Blumenthal household, Simon felt more at ease than in his own home. In the summer of 1942, he watched the whole family being loaded onto a truck and taken away by the Nazi police. All of them died in concentration camps.

Wartime brought more pain, anguish, and life lessons. The last winter of the war is known in Holland as the "hunger winter." A strike by the national railways prompted a food crisis in the north of the country, especially in the big cities. Over 2,500 inhabitants of Amsterdam died of starvation and cold. Vinkenoog later wrote it was the gypsy jazz of Django Reinhardt and his Quintet Hot Club de France that kept him alive during that dreadful winter. Liberation came on the fifth of May 1945. Hopes were high that a new political era would begin; an end to the Dutch "zuilen" (pillars). The zuilen system divided society along party lines: socialists, Catholics, Protestants, and liberals, each complete with its own media organizations, sports clubs, etc. It was a system of separation that had clearly proven to be inadequate in resisting the Nazi occupiers.

A festive and hopeful atmosphere lasted throughout the summer of 1945. For Simon, like so many people of his age, sex was part of the celebrations. He had experimented with gay sex during and directly after the war, before encountering a girl at a meeting of a socialist youth organization. The first time they had sex she got pregnant, and the couple had to marry—Simon was barely 18, and Jenny 19. Their only son, Robert, was born in April 1947. Simon moved in with his mother-in-law, managed to find a job at a book publisher, and hated his life and his country with growing intensity. The first elections since the war, in May of 1946, had resulted in a total restoration of the old order. The new government decided to wage war on their Indonesian colony, where Sukarno was fighting for independence. Only two years after their liberation from the Nazis, young Dutch men found themselves being drafted to go to war at the other end of the world.

Within the year, Simon managed to escape both the draft and his depressing existence as a newly-married father. A psychiatrist testified that serving in the army might revive Simon's homosexual tendencies and advised against it. And towards the end of 1947, the constraints of his life with Jenny receded when his second wife, Juc, entered his life. Juc had reasons of her own to hate her country. She was what was commonly referred to as a "*moffenhoer*" (kraut whore), having had a relationship with a German officer during the war, and had spent months suffering in prison camps after liberation. When she received a small inheritance, she and Simon decided to escape together. Their destination was Paris, the city of light, art, and the avant-garde.

The influence of Simon's Paris years, 1948–1955, can hardly be overestimated. They mark the beginning of, and remained main sources for, his artistic life. A desk job at the headquarters of UNESCO, the cultural organization of the

United Nations, gave him the opportunity to dive head first into the cultural avant-garde. The job afforded him a spacious apartment, money in his pocket, and lots of free time to devote to the arts and making new friends. He spent two months in India and two months in South America during his time at UNESCO. He and Juc became more a team than a couple. She had a job of her own and they decided not to have children; Simon had several surreptitious girlfriends on the side. Before leaving Amsterdam he had already started writing poetry and had compiled a small magazine with friends. In Paris he decided to write and publish a magazine all his own. He called it *Blurb* and sent it to around 150 people: friends, but also writers, journalists, and publishers he didn't personally know.

Blurb turned out to be Simon's ticket to literary fame back home. He published eight issues, each succeeding one increasingly filled with guest contributors, including artists and writers like Hugo Claus, Corneille, and Remco Campert, who would go on to achieve international fame. *Blurb* also led to an offer to compile an anthology of young Dutch poets, a chance Simon jumped at with characteristic enthusiasm. The anthology, *Atonaal*, was published in 1951 and launched the movement known as "*De Vijftigers*" (The Fifty-ers). The group consisted of poets, writers, and painters, some of whom were also part of CoBrA, an international collective of cultural pioneers from *C*openhagen, *B*russels, and *Am*sterdam. All these people benefitted from Simon's hospitality in his Parisian pad. Painter Karel Appel famously used paper and cardboard that Simon had stolen from UNESCO for many of his paintings during this period.

The Paris years were a *mer à boire* (sea to drink), Simon liked to say. He got to know hundreds of people, including Norman Mailer and the Scottish novelist Alexander Trocchi, who would turn out to be a vital link during the next decade. Just months after his move to Paris in the fall of 1948, he attended a speech by Jiddu Krishnamurti, the great Indian spiritual teacher. Krishnamurti's words provided a lifelong guiding principle for Simon: "the only way out is in, you can only understand the world through self-knowledge." Another crucial lesson: "accept no authority other than your own experience."

> All authority of any kind, especially in the field of thought and understanding, is the most destructive, evil thing. Leaders destroy the followers and followers destroy the leaders. You have to be your own teacher and your own disciple. You have to question everything that man has accepted as valuable, as necessary.
>
> J. Krishnamurti, *Freedom from the Known*

Being your own teacher and your own disciple is a concept that runs right through Simon's work and life. He was a voracious reader from the moment, as a toddler, he started to decipher the letters and words on the shop windows. His job title at UNESCO aptly characterized his strategy for living long after he

left Paris: Special Requests Document Officer. In his Paris apartment, he started what would become an archive of legendary contents and proportions. He typed all his correspondence and kept carbon copies. In fact, he pretty much kept every bit of paper that was relevant to any of his thousands of interests.

One of the many discoveries that came during the Paris years was his initiation into the delights of marijuana by Japanese-American sculptor Shinkichi Tajiri. Cannabis became a lifelong companion: he was still smoking about seven joints a day when he passed away at age 80. He was undoubtedly the first cannabis activist in Dutch history, never making a secret of his drug use, becoming the first celebrity to openly talk about marijuana in the media and in his own work. In 1965, he spent six weeks in prison for possession of 0.07 grams of hashish.

On a personal level, in Paris Simon got rid of most of his shyness and learned to cope with his inferiority complex. At the heart of his feeling of inadequacy was his humble working-class background—raised by a functionally illiterate single mother, bullied during his school years, and lacking a higher education. All of this lay just beneath the surface of his confident assurance as an angry young man attacking the cultural establishment and every value of mainstream society.

Simon was a human warehouse of information, stating his mission in one of his poetic slogans: "*verwerven, verwerken, verstrekken*" (acquire, process, provide). Long before "networking" became a verb, Simon was an expert at it. He read a lot in Paris and wrote about his discoveries in *Blurb* and as correspondent for a Dutch literary magazine. He introduced Jean Genet to the Netherlands and wrote passionately about Antonin Artaud, the radical French poet, playwright, actor and director who died in a psychiatric hospital a few months before Simon arrived in Paris. His heroes were the outsiders and rebels, from Rimbaud and Lautréamont to Ezra Pound and Henri Michaux.

Reading *The Outsider* by British author Colin Wilson left a profound impression on Simon. Wilson became an overnight literary sensation after publishing his analysis of the psyche of the outsider and his effect on society. He used the works and lives of artists like Kafka, Hemingway, Hesse, and Vincent Van Gogh to support his thesis. "I know I am an outsider as well," Vinkenoog once told me, "And William Burroughs calls out: remember, stay outside! The outsider has the right outlook. Within the dope scene, you are an insider, a field expert. In everything else, you are the outsider."

Bringing *De Vijftigers* together in print for the first time in the anthology *Atonaal* secured Simon's place in Dutch literary history. The group was never a true collective; it was more a group of friends hungry for recognition and radical reform. They wanted both life and art to be spontaneous and instinctive, guided not by rational thinking but by the heart. The painters of the group—Karel Appel, Corneille, Constant Nieuwenhuijs—were inspired by African art and children's drawings. Like the writers and poets, they wanted to totally disconnect

from Dutch and western cultural traditions. "Beauty has burned her face," wrote Lucebert, one of the more prominent *Vijftigers* poets, referring to the Second World War. The only earlier artistic movements *De Vijftigers* would acknowledge were Dada and surrealism. Simon's "kitchen sink" magazine *Blurb* was itself pure Dada. The link between *De Vijftigers* and Dada is obvious: both movements protest the horrors of war and reject the society that has caused, or at least failed to prevent, them. Both seek radical change and real freedom for both the artist and society at large. This attitude in turn links *De Vijftigers* to the writers and poets of the Beat Generation in the United States.

Inevitably, the *Vijftigers* and the Beats had to meet up. A few months after he moved back to Amsterdam in early 1956, it was Simon who made the connection. Leaving Paris meant a total break with his former life: he quit his job at UNESCO, cashed in his pension fund, and ended his relationship with Juc. He donated his literary archive to the National Literary Museum in The Hague, which had just been founded. In his eight years in Paris, Simon had built up the courage and experience to return home, but there were other reasons for his departure as well. Due to the French-Algerian war, Paris was a tense place in the mid-Fifties. Police and soldiers patrolled the streets. Officially they were trying to prevent bombings by Algerians supporting the struggle for independence in their native country. Unofficially, they wounded and killed Algerian demonstrators and suspected activists on a daily basis. The whole scene reminded Simon too much of his own war years.

When he arrived back in the Dutch capital in early 1956, the country was just beginning to shake off the dreariness and poverty of the post-war reconstruction years. Simon had two published novels and a string of poetry books under his belt and was ready to raise the literary revolution of *De Vijftigers* to new heights. He started working as personal assistant to the editor-in-chief of the national magazine *De Haagse Post*, bringing in his friends and colleagues as much as he could. Before long there was a new Mrs. Vinkenoog, Ilse, who would bear him his second son, Alexander. The crucial connection between *De Vijftigers* and the Beats happened on October 4, 1957, when Simon met Allen Ginsberg, Gregory Corso, and Peter Orlovsky, who were traveling through Europe. That same day the Russians launched Sputnik 1, the first artificial satellite to go into orbit, carrying the dog Laika into space. Ginsberg wrote a poem about that first meeting in the American Hotel on the Leidseplein in the heart of Amsterdam:

> O fellow travelers I write you a poem
> in Amsterdam in the Cosmos
> where Spinoza ground his magic lenses long ago.

Ginsberg showed Vinkenoog a way forward, both in his poetry and in his performance. The two forged a lifelong friendship, with Simon acting as Gins-

Assault on the Impossible ▬ 109

berg's translator and host during his subsequent visits to Amsterdam.

Another pivotal moment in Simon's life occurred in February 1959, when he took his first LSD trip. The powerful psychedelic was still legal and Simon was one of 43 people who volunteered to take the drug and be studied by a team of psychiatrists. Swallowing the five little blue pills made by the Sandoz company in Switzerland changed his life forever. It marked the end of the era of hate fueled by his miserable childhood and his terrible war experiences and opened the door to the era of love. Almost fifty years later he would write on his website:

> My first LSD experience dates from February 1959 and ever since my life has taken another direction; through the short peek around the corner of time and space you feel attracted even more by the paradigms that go a step further in the anomaly of all things. Difficult phrases, being a part of the horn of plenty that was given to me.

Inspired by Allen Ginsberg, Simon wrote and recorded his first "spoken word" poem in 1960. From this point on his performance grew into a poetic explosion that captivated any audience. He quit his job at the magazine to become a full-time writer and poet and presented several television programs, including the first-ever telethon in Dutch history, to raise money for Algerian refugees in Morocco. True to his motto "I just want everybody to meet everybody," every house he ever lived in functioned as a free youth hostel. Poets and writers, travelers and activists, drop-outs and junkies were always welcome.

The lonely boy who had been ostracized and bullied by the other kids now surrounded himself with interesting and creative people from all corners of the globe. The Sixties revolution started early in Amsterdam, and in his third novel, *Hoogseizoen (High Season)*, first published in 1962, Simon was the first writer to chronicle the new underground scene that was developing around the Leidseplein. One great passage was translated for *The Book of Grass: an anthology of Indian Hemp* (1967), which Simon put together with the British author George Andrews:

> Theun got his cigarette paper from his pocket and started making sticks. One, two, three, four went around . . . Immediately the full blast of the stuff hit me. Thousands of words and thoughts stumbled for priority and formation within me. I didn't say a thing, looked inside and listened outside, only an ear until I found that Klaas was asking for my attention. . . . Suddenly he appeared to be a new Einstein, enunciating clearly a new cosmic law, fitting in all the details. He, whom I had always considered almost an imbecile, had been thinking over a problem (I have forgotten which), and now at this exact moment he had found the precise words for it, which made his speech as correct as could be. Not one word too many.

Art and life blended into one another in 1962. Simon spent four months on the still-totally-unspoiled island of Ibiza, during which time his third wife,

Ilse, walked out, leaving him with their one-year-old son Alexander. Quite a few Dutch writers and artists hung out on the island during the summer of '62, including Jan Cremer who would go on to write the bestselling novel *I, Jan Cremer*. It was Simon who helped Cremer compose his separate pages and stories into a readable novel. Simon made a few crucial international connections on Ibiza, most notably with Mel Clay, member of the experimental theatrical company The Living Theatre. Clay would show up in Amsterdam later that year "with mescaline of the finest essence," as Simon wrote. He also befriended the French artist, poet, and activist Jean-Jacques Lebel and took part in a Happening Lebel organized in Ibiza's harbor.

On Ibiza, Simon reconnected with the international underground; it felt as if he were back in Fifties Paris. "Strange birds on strange shores, magicians at the break of dawn, swimming, tanning, fucking, smoking, listening to music, making music" is the way he summarized his experiences later. A lot of the inspiration and ideas he took home from the island would turn up in his work during the remainder of the Sixties. With Mel Clay and Frank Stern, an American film producer he met on Ibiza, Simon put together the first ever Happening in Dutch history on December 9, 1962. They called it "*Open het Graf*" (Open the Grave), a title that took on different meaning when the Dutch Queen-Mother Wilhelmina died less than two weeks before the event. Her state funeral took place the day before *Open het Graf*. Among the Happening participants was Robert Jasper Grootveld, the "anti-smoke magician" who would soon become the prophet of Magic Center Amsterdam.

As Richard Kempton notes in his book *Provo: Amsterdam's Anarchist Revolt*:

> *Open het Graf* was staged specifically to introduce the notion of the Happening to the Dutch public. It honored the dead. Though the title was a satire of a 24-hour Dutch television marathon . . . ***Open het Dorp*** (*Open the Village*), it is remarkably similar to Kaprow's *A Service for the Dead*, which was performed earlier that same year. This connection suggests a direct link between the New York and Amsterdam scenes.

This direct link was Simon Vinkenoog, who loved nothing better than bringing people and ideas together, connecting different scenes, and sharing his contacts and knowledge with as many people as possible. From the moment he started performing his poetry in public, he always included other poets' work in his performances.

Americans played a major role in Simon's artistic and personal life, from Shinkichi Tajiri, who introduced him to cannabis, to Allen Ginsberg, Mel Clay, and the other members of the Living Theatre who showed him there are no limits to self-expression. Arguably the most influential American was psychiatrist Steve Groff, who lived in Amsterdam for a few years during the Sixties. Simon met him

in the spring of 1963 and repeatedly stated that Groff came closest to what you could call a personal guru. Groff took him parachuting, introduced him to the books of Herman Hesse, and they tripped together on LSD, mescaline, and every other psychedelic they could get their hands on. "Steve could see right through me," Simon later wrote. The free fall was the crucial concept in Groff's philosophy: letting go of every prejudice and preconception, any kind of conditioned behavior.

Through Groff, Simon became very well-informed about the psychedelic counterculture developing in the United States. Groff had participated in Timothy Leary's earliest LSD sessions at Millbrook and introduced Simon to *The Psychedelic Review*. *Hoogseizoen*, Simon's portrait of the early pre-Provo Leidseplein scene, was his last more-or-less traditional novel. In 1964 he started a diary that would turn into a book of almost 500 pages, written in a stream-of-consciousness style sometimes resembling Kerouac's *On the Road*. All the leading figures of Magic Center Amsterdam pass through the pages of *Liefde* (*Love*), published in 1965. Simon called it "my most unreadable book," but no writer came closer to expressing the true spirit of those revolutionary days in Amsterdam.

In *Liefde*, Simon no longer hides behind a narrative or the mask of the omniscient narrator: the book is one hundred percent autobiographical and the writer speaks directly to his readers, urging them to liberate themselves and experiment with life, love, and psychedelics. He's doing to his writing what The Living Theatre was doing in the theater: dissolving the fourth wall between spectator and artist, reader and writer. The final paragraph of *Liefde* reads like a manifesto:

> I possess a force that tells me it is good. In the name of multitudes I speak, entirely on my own behalf. I learn to communicate daily. This is an aptitude test of communication. This is a revolution of the spirit: this is the end of the era FEAR. This I call LOVE.

Predictably, most critics rejected this extraordinary piece of literature. Simon's prosecution and imprisonment for possession of cannabis was all over the news; he actually received the first copy of *Liefde* from his publisher on the day he was released from jail. In the mainstream media his image was fixed as a spaced-out weirdo who shouldn't be taken seriously. A lot of his friends criticized the book as well, albeit for entirely different reasons. They didn't object to the sex or the drugs, but to the author's "conversion to Christianity," as they perceived it. Simon does describe an epiphany in the book, but he was never religious in any traditional sense. He took wisdom from every source that was available to him: Krishnamurti, Artaud, Allen Ginsberg, Steve Groff, Jesus, Buddha, Robert Jasper Grootveld.

One of his old Paris connections, Alexander Trocchi, invited Simon to take part in the *Wholly Communion* poetry festival at London's Royal Albert Hall in the

summer of 1965. In the introduction to the book *Wholly Communion*, published later that year, Alexis Lykiard writes:

> The Poetry Reading which packed the Albert Hall, London, on the sunny summer evening of June 11th, 1965, if not quite the hoped-for Blakean jamboree and feast of illumination, was in many ways an undoubted success—the first genuine, large-scale Happening. Seven thousand people thronged the Hall for four hours of poetry. More were turned away. These are remarkable truths.

Simon shared the stage with Allen Ginsberg, Lawrence Ferlinghetti, Gregory Corso, Adrian Mitchell, and Ernst Jandl. He was the only Dutch poet to perform. The *Wholly Communion* festival inspired Simon to organize a Dutch version at the prestigious Carré Theater in Amsterdam almost exactly a year later. The tickets for "*Poëzie in Carré*" (Poetry at Carré) sold out in days and the event lives on as "the mother of all Dutch poetry festivals," a template for future annual events like "Poetry International" in Rotterdam. Simon brought together 25 poets, including most of his old *Vijftigers* gang and lots of new talent. Jules Deelder made his first ever stage appearance and Johnny van Doorn, aka Johnny the Selfkicker, turned into an overnight celebrity. Simon himself was already a national figure by then, one of the faces of the Sixties revolution in the Netherlands. He had close connections to Provo, the anarchist group that shocked Amsterdam and the rest of the nation between 1962 and 1967. For young people he was an absolute idol, a guru.

The angry young man who unleashed his anger, cynicism, and frustration in his poems had turned into a prophet of love and self-realization. His transformation fits exactly with a quote from Colin Wilson's *The Outsider*: "The outsider is primarily a critic, and if a critic feels deeply enough about what he is criticizing, he becomes a prophet." With his fourth wife, Reineke, Simon formed the ideal Sixties couple: liberated, full of color and creativity, hip to all the new ideas and fashions. For a few years the image matched reality. Simon spent most of his time staging cultural events and running Sigma Amsterdam, a cultural center inspired by Trocchi's sigma organization in London. The concept of "sigma" was based on Trocchi's essay "A revolutionary proposal: The invisible insurrection of a million minds," published as "*Technique du coup du monde*" in the magazine *Internationale Surrealiste* in 1963. Sigma's "seizure of the world" would not be political, but cultural:

> So the cultural revolt must seize the grids of expression and the powerhouses of the mind. Intelligence must become self-conscious, realize its own power, and, on a global scale, transcending functions that are no longer appropriate, dare to exercise it. History will not overthrow national governments; it will outflank them. The cultural revolt is the necessary underpinning, the passionate substructure of a new order of things.
>
> Alexander Trocchi, *The invisible insurrection of a million minds*

Trocchi's ideas fit right into Simon's own philosophy and sharpened his view of culture and self-expression as political and social tools. In 1966, together with Olivier Boelen, the son of a wealthy wine merchant, he founded the Sigma Center in Amsterdam. The city council agreed to let them use the fabulous 19th century *Gebouw van de werkende stand* (Building of the working class) on Kloveniersburgwal. The Sigma Center only stayed open a year, but its impact should not be underestimated. It was Simon who cut the red tape and got the first subsidy for a cultural youth center. His example would later be followed by *Fantasio / Kosmos*, *Paradiso*, and *De Melkweg* (The Milky Way), the latter two still being Amsterdam's premier concert venues.

As a writer Simon switched to nonfiction in this period. He became one of the editors of *Randstad*, a quarterly magazine modeled after *The Evergreen Review*. *Randstad* came in the shape of a paperback and was published by Holland's premier literary publisher, *De Bezige Bij* (The Busy Bee). The other editors were Harry Mulisch and the two Belgian authors Hugo Claus and Karel Michiels. The bookmagazine existed between 1961 and 1969 and introduced its readers to authors like William Burroughs, Jorge Luis Borges, and Allen Ginsberg. The last issue was a double one compiled entirely by Simon and titled *Manifesten en Manifestaties 1916–1966* (*Manifests and Manifestations 1916–1966*). It's a fantastic anthology celebrating the artists and thinkers who most influenced him: the Dadaists, Artaud, Trocchi, Tuli Kupferberg, Salvador Dali, Christo, Allan Kaprow, Johnny the Selfkicker, Brancusi. . . .

The motto on the first page is a quote from Trocchi: "Now and in the future our center is everywhere, our circumference nowhere. No one is in control. No one is excluded. A man will know when he is participating without offering him a badge." Even more telling is the list of "*Sigma-Kosmonauten*" (Sigma Cosmonauts) that follows. The list is split in two categories, England and America (56) and the Netherlands (39) and shows how broad Simon's network had become. Compiling anthologies, collecting and spreading new ideas, thoughts, and art forms would increasingly become a permanent activity. His 1968 book, *Weergaloos* (*Unprecedented*), is a dazzling 500-page collection of "journeys into the truth," as the subtitle states. Any self-respecting Dutch hippie carried a copy in his or her backpack. On the cover Simon and Reineke posed as the ideal Sixties couple, and the 22 chapters corresponded to the 22 Major Arcana Tarot Cards.

1968 saw the beginning of Simon's longest-lasting freelance job, as editor of the esoteric magazine *Bres*. He would continue to write for this bimonthly until 2004, giving him the opportunity to explore the world of astrology, eastern philosophy and religion, and fringe science. Long before the term "new age" was coined, Simon was an expert in the field. Through his contacts with people like Allen Ginsberg and Barry Miles, he contributed to such now-legendary counterculture newspapers and magazines as *The International Times*, the *Berkeley Barb*,

and *The East Village Other*. He published dozens of books during the Seventies, notably a biography of his old painter friend Karel Appel, a book on Timothy Leary, and three anthologies on his favorite plant, cannabis. By the 1980s there was hardly a Dutch publisher that hadn't published one of his books or translations. He translated Aldous Huxley's classics *The Doors of Perception* and *Heaven and Hell* as well as poetry by Rabindranath Tagore, Allen Ginsberg, and Diane di Prima, and a series of nonfiction books by Colin Wilson.

The enormous number of books, translations, and magazine articles that Simon published might give the impression that he spent most of his time at home behind his typewriter. Nothing could be further from the truth. From the early Seventies to well into the Nineties, he gave over 250 lectures, readings, and performances annually. He spoke at high schools, all sorts of cultural festivals, bookstores, Lions Club dinners, youth centers, jails, demonstrations, cannabis coffeeshops, scientific conferences, funerals for the anonymously deceased, and funerals of his friends, famous and unknown. Nobody in the audience would forget his tall, energetic figure, reciting, explaining, screaming, whispering, and calling out to them—a modern day shaman and prophet, "a horrible worker" in the words of Rimbaud's famous "Letter of the Seer" (*Lettre du Voyant*).

According to a biblical saying, no prophet is accepted in his own country. In a lot of ways, Simon always remained an outsider in the Netherlands. After his marijuana conviction, the mainstream media branded him as a dope fiend. By the time marijuana had become mainstream, the image changed to that of a far-out esoteric scatter-brain. Like everywhere else in the western world, the Eighties in Holland were all about yuppies, making money, and "no-nonsense" government, including severe budget cuts. Unemployment was widespread, the squatter movement was turning violent, and "no future" was the depressing slogan for a decade of nuclear threat, environmental disaster, and AIDS. The optimistic outlook of the Sixties and Seventies seemed to have gone for good. Aggressive looking punks had taken the place of peace-loving, flower-carrying hippies. In this climate, Simon was ridiculed and cast aside as a faded icon from the past.

Things got progressively worse, both on professional and personal levels. Simon's fifth marriage became a nightmare, with his wife Barbara in the grip of a serious speed addiction and its accompanying paranoia. Ironically, one of Simon's slogans since the Sixties had warned "Speed kills!" To add to the trouble, Simon ran up a sizable tax debt in the mid-Eighties, while the sale of his books fell to a minimum. In June 1984, at his wits' end, he wrote a letter to his old friend Allen Ginsberg. "As a matter of fact, let me make clear that this is a BEGGING letter, I am very, very poor, it breaks down my family morally, and I wonder if you would be able to pull any strings in the U.S. of A. as to do something about it." The letter remained unanswered. It seemed only an angel could save him. And in the spring of 1987 that's exactly what happened.

Her name is Edith Ringnalda, the adventurous daughter of a very high ranking civil servant in the Dutch government. She was 26 years younger than Simon and gave up her job as director of the well-known theatrical company *Dogtroep* to always be by his side. Edith took over his financial administration and acted as a personal assistant, driving him to performances and supporting him in every possible way. They got married in 1989 and appeared naked in the Dutch edition of *Playboy*. At 61 Simon started a new life, with a muse that inspired him as never before. He picked up painting and drawing, arts he hadn't practiced since the Sixties, and began collaborating with a wide variety of musicians and bands. The most interesting collaboration was the work he did with Erik de Jong, better known as *Spinvis*. De Jong is widely recognized as one of the most innovative and authentic pop musicians in the Netherlands. They recorded two albums and played numerous live dates together.

It was a time of new beginnings. New generations discovered Simon, people who knew nothing of the stigma and prejudice of the past. His authenticity, passion, and knowledge of the counter culture had always attracted young people—his huge archive contains thousands of letters by young admirers and outsiders pouring their hearts out and asking for advice. Now hundreds of students, researchers, and journalists interviewed him; and he treated everyone with the same respect and patience. Every interview or conversation ends with a stack of books, magazines, and newspaper clippings on the table. After some hesitation, in 2004 he bid goodbye to his typewriters and started his own Blog, "*Kersvers*" ("Superfresh"). The internet seemed invented for people like Simon and he dove into it head first. Every day he wrote a long entry illustrated with pictures, letters, invitations, works of art. Even today it remains a fantastically inspiring resource, a work of art in itself. *Kersvers* can be seen as a sequel to the magazine *Blurb* that he started in Paris in 1950.

The last 20 years of Simon's life, which he spent together with Edith, were his happiest. "Together we inhabit the highlands of happiness," he used to say, quoting the Belgian poet Paul van Ostaijen. They traveled to India, Russia, and Africa, and Edith even managed to bring Simon's "extended family"—his four children from three different marriages and three of his ex-wives—together for regular dinner parties. Everything got better, including his poetry and live performances. In 2006, he took center stage at the reprise of the *Poetry in Carré* festival, forty years after the original event. That same year, at age 78, Simon performed with Spinvis at Holland's best known rock festival, *Lowlands Paradise*. Images of the concert appeared in a documentary on his life that showed how much his public image had changed, the voice-over rightfully calling him "a troubadour in a country full of speech impediment" and "the first poet with the allure of a rock star."

The jewel in the crown of recognition was the publication of Simon's collected poems, *Vinkenoog Verzameld* (*Vinkenoog Collected*) in 2008. The 1,228(!)

pages span six decades of poetry and contain explanatory notes by editor Joep Bremmers for almost every single poem. At the official presentation, the mayor of Amsterdam awarded Simon the medal of honor of the city. For once, he was at loss for words, tears streaming down his cheeks. Although his spirit remained young, physically he was in bad shape, suffering from terrible pain in his legs. By June 2009, his right leg had gotten so bad that the doctors decided to amputate the lower half.

Simon showed remarkable signs of recovery after the operation. On July 9th I spent a wonderful sunny afternoon with him, Edith, and two friends who brought sparkling Prosecco wine, tapas, and great hashish to the nursing home. The next day, while playing Scrabble with Edith, Simon suffered a massive brain hemorrhage. He passed away in the early morning hours of July 12th, six days before his 81st birthday. Hundreds of people attended his funeral on July 18, 2009, at St. Barbara Cemetery in Amsterdam. Simon lay in an open coffin, decorated by children and admirers with colored crayons. He wore a white T-shirt with one of his best known slogans printed in big letters across his chest: "Simon says: *verdoem de oorlog, beziel de vrede*!" (Damn the war, animate the peace!).

> Derrick Bergman is a Dutch journalist, photographer, and cannabis activist currently working on Simon Vinkenoog's authorized biography.

appendix 4
cor jaring:
photographer of amsterdam, magic centre of the world

The birth of Provo, the first European happenings, the playful performances of the Insect Sect, Yoko Ono and John Lennon's bed-in for peace at the Amsterdam Hilton, Cor Jaring (b. 1936) attended them all and his photographs of the events went all over the world. Who doesn't remember Jaring's photographs of Jasper Grootveld performing as the Anti-Smoke Magician? The famous photo of Jasper Grootveld as Zwarte Piet? Without Jaring, the period when Amsterdam became the Magic Centre of the world would not be so widely known. He wasn't a detached photojournalist taking pictures: he helped define the whole scene. He befriended Jasper Grootveld and participated in Anti-Smoke Temple and Insect Sect activities. During the Provo riots, he wore a custom-made Magic Press Helmet with an automatic object finder, 100-meter flash, built-in walky-talky-like communications system, and escape mechanism. If the police attacked, he could activate a red, white, and blue smoke screen. It was funny, a kind of joke, but also very serious, demonstrating that he wasn't an ordinary press photographer, that he could be playful and at the same time do a serious job.

Jaring is a self-taught photographer with an eye that immediately finds the right point of view, the essence of a scene or a person. He is unafraid of novel situations and settings, an indispensable feature for a photographer who wants to be at the happening core of things. This fearlessness developed early in his life, when to survive during the war he was forced to take all kinds of odd jobs, and competition to get them was fierce. Born next to the harbor in Wittenburg, one of the poorest sections of Amsterdam, as a young boy he cleaned storehouses, cargo spaces, and took whatever work was available. During his military service, one of his fellow soldiers lent him a small Kodak box camera, and so began his lifelong passion. After he left the service, he bought a camera of his own and went door to door offering to take pictures in neighborhoods with young families. "I took ten pictures of each kid, and when the mothers bought one I said that I would destroy the other nine, so they thought this was a pity and they bought the other nine pictures too; at a discount, though." Jaring likes to tell this story, along with a thousand others from his more-than-fifty-year photographic career. But photographing children didn't

generate enough income to maintain his young family, so he returned to working in the harbor, where he eventually became a fireman. Of that he says, "That was the best job I had. Five o'clock in the afternoon to two o'clock in the morning. Because I could sleep from three o'clock to half past nine, and then the rest of the day I could take photographs." He was taking pictures of his colleagues—portraits of rugged dock workers that were unique in their time and have become even more so since most harbor activities have ceased.

His breakthrough came when he began frequenting artist cafés, where he took pictures of the young Simon Vinkenoog, Ramses Shaffy, Karel Appel, and many others. He became a recognized photographer of the art scene, and in that sense became an artist himself. When he befriended Jasper Grootveld, he photographed Grootveld's happenings and met the boys who founded Provo. During Provo his work became world famous, especially the pictures of the turbulent events surrounding the royal marriage of Beatrix and Claus in 1966—the international press eagerly sought his photos of smoke bombs and desperate policemen.

His favorite citation is from his friend Jasper Grootveld: "He who looks makes pictures, he who sees makes photographs." About himself and the role he played he says:

> You have to remember that as a press photographer I had access to all the newspapers. I had access to the mainstream. And it was important to Jasper Grootveld, Theo Kley, and Max Reneman of the Insect Sect, as artists, to get their work and ideas out. My photos were a way of doing that. So I attended the happenings and the galleries and got involved with things like the Insect Sect and the visit to John and Yoko. It was fun, but it was important, too. When my pictures appeared in the newspapers, ordinary people could begin to see what was going on. They showed our scene, helped build the scene. They drew people in.

<div align="right">Marjolijn van Riemsdijk,
08/21/2012</div>

Autonomedia is a not-for-profit volunteer collective. The price Cor Jaring set for the original group of photos we selected would have been more than it cost to print this book. Readers interested in viewing his work can visit (http://www.corjaring.nl) or buy the Dutch edition of this book (*De Bestorming Van Het Onmogelijke*, Amsterdam: Bres BV, 2001).

appendix 5
ruigood cultural free zone, a timeline history to the millennium

This story was created in the living; it's a trip through time; a journey as a work of art in many dimensions. It's a process, the art of living, a spectrum of emotions, impressions, stories, and images. The subject is Ruigoord (rough place), a flower blooming from the seeds of the Sixties. At its core is the Amsterdam Balloon Company (ABC), wandering over the planet, cross-fertilizing cultures everywhere, always returning to the center from which the journeys start. Ruigoord: one of the freest places on Earth, an autonomous cultural zone where Nature recreates herself. Welcome to the adventure, a voyage of discovery with the ABC. The *Luchtbus* (Air Bus) will carry us far off trodden paths, to mysterious destinations, full of magic and mosquitoes, madness and minstrels.

Timeline

1973
Squatting Utopianists occupy Ruigoord. The artists who squat Ruigoord in 1973 are enthusiastic supporters of Robert Jasper Grootveld's conception of Amsterdam as the Magic Center and incorporate magical thinking into their daily lives.

1974—The Amsterdam Balloon Company (ABC)
Theo Kley and Rudolph Stokvis collaborate to organize kiting parties. The kite parties evolve into the Amsterdam Balloon Company, which is founded to stimulate "Soft Aviation." One of the first Balloon Company events is a midsummer solstice gathering at Ruigoord, which enrolls most Ruigoordians and many of their friends and acquaintances as Balloonies. Ruigoord begins sponsoring an annual midsummer feast/kite festival that soon attracts hundreds of enthusiasts from far and wide. The ABC develops from groups like Provo, Insect Sect, Exotic Kitsch Conservatory, and Bohemian Mystery School, evolving into a flexible free-floating movement that welcomes anyone who loves balloons, birds, kites, and other gentle heavenly bodies. Under the guise of kiting, thousands of people gather and camp in abandoned places to communicate, perform, and celebrate life.

1974–1975
With no real awareness of the value of a natural and healthy environment, Amsterdam's "rulers" conceive a plan to expand the city's industrial fringes. Residents are evicted from the surrounding villages and green polders, which are destroyed to benefit multinational corporations. To defend themselves, the citizens of Ruigoord and their friends ally with the newly-appointed mayor of Haarlemmerliede, Amsterdam's neighboring rural municipality. As author Harry Mulisch notes: "Religion gives way to advancing technology, but art lies in wait to jump into the gap between the two." Thus we Ruigoordians begin to practice country life: we mow, reap, prune, plant, and harvest—we write, sculpt, and paint, struggling to widen the gap between the onslaught of industrialization and wild nature.

1975
The ABC and members of the Keerkring artists' society found The Comité-2000. Its aim is to survive the 20th century, to ensure that the ambitious festivities we have planned for the turn of the millennium actually take place.

1977—A Post-Apocalyptic Oasis
A century ago a village appeared at Ruigoord—then an island in an estuary called IJ, now a reclaimed polder. The first inhabitants built a church, a school, shops, and bars, but remained an isolated community. In 1973, when we modern Ruigoordians arrived, only twenty houses and the church remained. The old priest of Saint Gertrude's Church, heartbroken by the manipulations and destruction, sided with us. After a short physical and long juridical battle, Amsterdam withdrew from the ruins of Ruigoord and its surrounding land. We squatted and restored the deserted houses and built new dwellings. The church became our cultural center where creative groups and individuals from all over could cooperate on artistic projects. In the years since our arrival many children have been born on our island, nature is abundant, and the surroundings have turned into an oasis for rare and threatened species of plants, animals, and humans. The original families learned to get along with us, and a very special atmosphere developed, a unique combination of environmental awareness, self-government, and creativity. We've become a truly post-apocalyptic oasis.

1977—Riddles of Ruigoord
A wondrous creature arrives at Ruigoord. For thousands of years the Snow Woman's ancestors have visited this rough place to mate, and now this is the last natural area in the West of the Netherlands. With nowhere else for her to go, she agrees to hibernate in a deep-freeze until her mate arrives; her freezer goes on display at Amsterdam's Stedelijk Museum.

Gertrude, patron saint of the Ruigoord church, is a fascinating protectoress, a Christianized version of the ancient Germanic goddesses Freya and Hella. Among her many qualities, she is psychopomp to the souls of the deceased; as a symbol of this power, mice climb up the staff she carries. These small animals symbolize the souls of mortals like us.

1978—Beginning the Paradiso Shows
The *Volksopera* (folk opera) is the ABC's first large theatrical spectacle at Paradiso, Amsterdam's foremost alternative theater and music hall. That first spectacle initiates an annual tradition of presenting a topical theatrical happening at Paradiso around Christmas. (Over the years, countless artists have worked together on these events to celebrate and renew the magic power of Amsterdam.)

1979–1980—Journey around the World.
The ABC obtains an old Magic Bus and decides to tour around the world. The bus heads for China, with friends joining the journey for longer or shorter periods. Along the way we present performances of all kinds, from poetry to theater, art exhibitions to children's circus. The Air Bus, our mobile oasis, eventually reaches the Tibetan frontier, where the so-called People's Army refuses to let us pass. So India becomes our destiny; the beginning of an extended love affair.

1981—Anti-Doom Production
This manifestation welcomes the millionth labor-free Dutch(wo)man! The Industrial Revolution was intended to free humanity from dull labor. We consider the so-called unemployed as liberated slaves, able now to enjoy their favorite occupations. During the Anti-Doom Production, a well-known medium contacts the spirit of John Lennon, who predicts that money will be abolished by the year 2000.

1982—Hollanditis
Cruise missiles in Western Europe pointing at Moscow! The warlords have situated the nuclear battlefield here! The people of Holland reject the placement of these weapons on their soil. Half a million people take to the streets to demonstrate. The US government considers it a dangerous sickness, which they call "Hollanditis." The ABC organizes a huge happening to infect Europe with the disease.

1983—The Psilist (Symbol of Ruigoord)
This is the sign of the coming time / the symbol of the androgyne. / The male and female will unite / to put an end to the old fight. / Look, so you may recognize / the old spirits in a new disguise. / The three teeth on top form a Yoni perfect, /

the stick and balls are a penis erect. / Together they make up the Greek letter Psi, / in honor of grandmother psi-locybe, / the dear little mushroom that helps us see / the lemniscate of eternity / beyond the veil of reality. / The trident of Shiva, the Devil, Neptune / resting on the reclining Moon. / And all the while that Cosmic smile! (Poem by Hans Plomp)

1984—Why Not Theater?
As I cross a hill between two beaches, I spot a Dutch bus gaily painted with skies and clouds. The ABC has arrived in Goa! They bring poetry, stories, acrobats, music, and magic to enraptured audiences. They prove that being high and creative can be a surprisingly heady cocktail. The traveling wing of the ABC has transformed itself into the Why Not Theater? troupe, presenting shows on stages and in public places from Belgrade to Bombay, from Berlin to Budapest, from Bergen to Baikal. (Ruigoordian Montje Joling subsequently creates the Why Not Circus? to facilitate the ABC's outreach to children.)

1985—Art and Change
An exhibition of paintings, photos, and sculptures by Balloonies is organized at Bombay's most prestigious modern art venue, the Jehangir Art Gallery. A grand scandal erupts when the Action Paan Spitting Painting is destroyed by an enraged Indian sculptor, who mistakes our Dadaist statement for an insult.

1986—Landjuweel
In the 15th and 16th centuries, Landjuweel (country jewel) was the name given to open-air festivals organized by artists from different towns in order to share their latest creative works. The ABC adopts this name for its yearly festival in Ruigoord, which takes place around the August Full Moon. Thousands of people from all over the planet visit our Landjuweel to show their creations and exchange information.

1987—The Street University
ABC creates a public chair of Crazy Wisdom, where streetwise whizpersons spread incredible snatches of knowledge to passers-by and other interested creatures.
1987—Documenta 8, Kassel
The ABC takes part in the famous Documenta arts festival, with a project called Freiraum. (See Appendix 6 for our manifesto.) Balloonies establish a Temporary Autonomous Zone wherever we pitch our mobile oasis.

1988—Tannhauser
In 1988, Berlin is the cultural capital of Europe. The UFA-Fabrik, an avant-gardist theater community housed in the former film studios of the (in)famous movie

company of the same name, invites the ABC to perform at their theater. A full-fledged ABC show is staged non-stop for a fortnight, and a ritual in front of the Reichstag honors Marinus van der Lubbe, the Dutch anarchist who supposedly set fire to the building during the time of the Nazis.

1989—Next Stop Soviet
Perestroika begins to sweep across Eastern Europe. In 1989, the ABC joins a caravan of artists from Scandinavia heading for Moscow. We call our show *Prometheus*. Although nobody gives us permission, we put it up in Gorky Park near the spot where Bulgakov's novel *The Master and Margarita* begins.

1990—The Baikal Cultural Express
After a number of extremely successful Landjuweel festivals, the gathering has grown so huge and noisy that we must make a change. Beginning in 1990, the Landjuweel becomes acoustic and totally non-commercial. Electricity is banned, which greatly stimulates the inventivity of the participants.
The Baikal Cultural Express is organized for a tour to Siberia and Mongolia. The following year, a large group of artists from Buriat and Mongolia visits Ruigoord, initiating an intensive cultural exchange. Baikal Cultural Express becomes the core of an organization that collects funds to send young Chernobyl victims on a holiday into healthy surroundings.

1991—Rosenwinkel
In the beautiful East German countryside, the ABC collaborates with a group of East Berlin artists to organize an open-air festival unlike anything ever before experienced behind the Iron Curtain.

1992—The Stomping Ground Manifest
America was inhabited by Native Americans; Australia by Aboriginals; New Zealand by Maoris. European invaders have tried to destroy the original indigenous cultures. The robbers are celebrating their 500th year of occupation. Ruigoord declares its surrounding lands to be a Stomping Ground for positive energies. We value native cultures and express our respect for and solidarity with all truly indigenous cultures.

1993
A *berceau* is a lane of trees. Hundreds of friends of Nature plant their trees around Ruigoord, creating a natural work of art amidst the unDutch luxuriance surrounding our village.
The Word in Ruigoord—many prominent poets and writers speak and read from their works at monthly poetry readings in St. Gertrude's church. An overwhelm-

ing number of artists respond to our call for solidarity with our besieged village. Dreamtime Awakening—the Australian Aboriginal culture emanates from the concept of connected natural energy centers. Ruigoord in the Netherlands and Arnhemland on the opposite side of the globe are two such centers. During the full moon of August 1993, these two poles connect in a ritual dance simultaneously performed at both places.

1994—Lisbon Cultural Capital
The Clowns School of Lisbon invites the ABC to create a show in the famous Castle of Saint George, towering above the center of this splendid city. We bring Old George down a peg or two in favor of the Dragon. (Every period of our 25-year existence has been characterized by a hexagram from the ancient Chinese I Ching oracle.)

1995
Potsdam lies on the dividing line between Eastern and Western Europe. The ABC's Potsdam camp, environment, and art route is dedicated to the Gypsies, who never demarcated borders, settled a native country, or made war.

1996—Mongolia Again
A group of Balloonies travels to Ulan Bator to install a sculpture of the Ulzii, national symbol of the newly independent state of Mongolia. An identical symbolic sculpture graces the village of Ruigoord.

1997—The Green Front
In July 1997, Green Front activists set up camp in the fields surrounding Ruigoord to prevent the destruction of our Nature preserve which, after a 25-year legal battle, Amsterdam has finally gotten permission to destroy. People from all over Europe build tree huts and dig tunnels. They succeed in drawing international attention to the wanton rape of our fields, which teem with birds, orchids, and endangered plants supposedly protected by laws now demonstrated to be futile.

In October, a special police force of 850 men evicts the activists and protects the laborers undertaking the gory task of felling thousands of our trees. Our resistance fighters return to build a castle in the new wastelands.
On December 1, the cops storm the castle and burn it to the ground. The activists retreat to the village and merge with the Ruigoorders. A great impulse for the future!

1998—The Threat
In the heart of the most overpopulated and regulated country in Europe lies a lovely place, a remnant of what was once beautiful about Holland. Horses run

in the meadows, orchids flower abundantly, and rare birds breed here. But its future is hazy. With tricks and lies, the industrial lobby (with the help of its political allies) has almost succeeded in turning this unspoiled area into a dump for poisoned soil. Ruigoord fights on, supported by countless sympathizers and environmentalists. Our slogan is and remains: *Fortuna Favet Fatuis*—Fortune Favors Fools.

1999

The horoscope for Ruigoord's 25th birthday clearly delineated the problems we face. Neptune opposite Sun: plans for Amsterdam's new harbor prick our creative heart. Saturn in Taurus square Sun from the 8th house: the authorities want to destroy us. Uranus opposite Moon: the domestic situation in the village is tense and may change radically.

However, there is Hope. Pluto in Sagittarius trine the Sun: we have powerful allies. Jupiter trine the Sun: we'll get strong support from environmental movements and volunteers. A Uranus-Jupiter aspect: we can expect a sudden and unexpected windfall, possibly on the juridical front. And, last but not least, the position of Venus—ruler of this birthday horoscope—high in the Mid-Heaven indicates that Ruigoord is in full creative swing, emphasizing that our ability to draw media attention to our struggle is unimpaired.

Compiled by Aja Waalwijk and Ted Doorgeest

appendix 6
an amsterdam balloon company manifesto

Documenta 8, Kassel—1987
Freiraum

Amsterdam Balloon Company
(*Amsterdams Ballon Gezelschap*)

Free Space = Freiraum = Espace Libre
Always Different than One Expects

The Amsterdam Balloon Company is rooted in a long tradition of happenings by various groups from the magical center of Amsterdam. From the tumultuous days of the Provo movement onward, a liberation of the mind and nature has been spread in words and deeds by movements like Deskundologisch Laboritorium, Insektensekte, Committee 2000, Bohemian Mystery School, and Royal Dutch Eclipse Club (to name just a few), working together occasionally under the name Amsterdam Balloon Company.

Thus the Balloon Company is a collective of artists and congenials of different disciplines. It is based on friendship and a common sympathy for the fantastic and revolutionary arts. The Company organizes regular manifestations and festivals all over the world, providing a platform for the free spirit. In fact, everybody in the world possessing a free spirit is considered a member of the Balloon Company. Only after a written request will this membership be cancelled, and never longer than for one week.

The Origin of the Festival

Long ago there were not so many people. They all lived in families on their own land and they never had any contact with other families, except when stealing each other's daughters.

One day a young hunter was walking in the wilderness when he met an old woman. She had a large nose and he looked at her with great fear. "I am the Old Eagle Mother," she said. "Why do you look so scared?"

"Because all strangers are enemies of my people," he answered. "Whenever

we meet other people we fight them."

The Old Eagle Mother said, "People are lonely and scared of each other because they don't have the gift of the festival. They cannot make songs, they have no music, and they cannot dance together. That's why they mistrust each other and fight." She put her ear to the Earth and told him to do the same.

"Listen," she whispered. From deep inside the Earth he could hear a heavy beat, like a giant heartbeat. "That is the great drum," said the Old Eagle Mother. Then they listened to the sound of the wind in the trees. "That is the great flute," she said.

She taught him to make a drum and a flute, she taught him the words of songs, and she taught him to dance and play the instruments.

"Now you must go home and collect the best food and drinks. And you must think of presents for all the people of the land. Then you must invite everybody you can to your house and offer them your food and drinks. When they have dined to their satisfaction, make music for them and sing the songs and dance. They will also learn how to dance and they will want to make songs and music too. And as they go home give them the presents. Soon the families will start inviting each other for festivals. The young daughters will dance with the young men, the people will get to know one another and the fighting will stop. Peace and joy and friendship will be in the land as long as you keep the festivals."

The young hunter went home. His family was delighted by his new gifts, and he taught them to dance, sing, and make music. Then they went to all the other families, dancing and singing. The other families were so surprised to see them and to hear the music that they forgot to attack them and decided to come to the festival. Even the children and old people wanted to come. Everything went as the Old Eagle Mother had predicted, and from that day on people greeted each other on the roads.

Vrijplaats

At the beginning of the No Future Era, in 1975, we decided to create our own future. So we set a goal that would keep us busy for the next 25 years, a reason to live and to work for the survival of the planet: our goal is to celebrate the birth of the new millennium in the year 2000 with a worldwide festival! Through the years the Balloon Company has kept on trucking to festivals in many countries, showing our work and getting to know the ideas of our allies. We organize a yearly festival in the beautiful wild prairies around the village of Ruigoord. This festival, Landjuweel 2000, has now become a link in an international network of avant-gardist groups. From all over the world people involved in art, environment, and new (or ancient) ways of creative cooperation, come to the Landjuweel 2000. They add their own nomadic shelter to the large camp, so everyone can stay

for several days and nights. For three days a program is presented on stages and in nature. This program includes concerts, dance, poetry, theater, circus, rituals, video, kite-flying, ingenious objects, totems, live radio, happenings, sculptures, exhibition. All this is freely accessible for all, although we encourage participants more than people who just want to be entertained. All artists work for free. Landjuweel 2000 is not a commercial undertaking, but an informal and magical gathering of free spirits.

With our festival we promote the idea of Free Spaces all over the world where cultural, experimental, and ecstatic happenings can take place. Every town should have a Free Space where the witches and shamans can dance around the fire and drums can sound all night long, without interference from anybody. A network of such Free Spaces all over the world will be the setting for the Global Festival 2000.

Art and Change

Humanity has been striving for renewal since the beginning of history. Renewal is a necessity to escape from the problems every society breeds. From the past we know political, religious, scientific, and cultural revolutionary movements. Often these movements are based on criticism of the established order. Sometimes alternatives are presented, but hardly ever is a new free way of seeing, thinking, and acting stimulated. Yet this is basic for renewal. New ways are often shown by unfettered original spirits, artists, and other eccentrics. The performing of an opera is known to have started a revolution. In the first half of the past century, as the world was torn apart by wars and confusion, artists began to work together to manifest themselves in international movements like expressionism and Dadaism, which had a great influence on society.

Although the problem seems more tremendous and insoluble than ever, we have only witnessed fruitless and marginal revivals of a political or religious nature during the past decades.

More culturally oriented movements, like the beats, provo, and punk, have been restricted to relatively small groups and have mostly been suppressed or ignored by the establishment and its media. The more traditional artists feel safe in a web of cultural manipulation and subsidies, and they echo the establishment views.

Now the ignored artists are going back to the streets, to open-air festivals, to small theatres, to reach their audience. In Amsterdam a strong movement has been growing among people who find their visions boycotted by the official media. Many artists are working together against abuses like racism, exploitation, and war. They are no longer using their talents to create successful individual careers in the rat-race, but have joined forces to work on a change of awareness that will lead to a change in society.

There is a direct connection from expressionism to Dadaism to surrealism to the beat generation to provo to punk to psilism: they are all cultural movements having nothing to do with accepted politics or religion, but everything to do with revolution on all levels—power to the imagination. "Dada wants to destroy rationalist lies, to retrieve the irrational natural order," Hans Arp said. In a document from the surrealist movement from 1925, we read:

> The immediate aim of surrealism is not to change the physical reality, but to establish a movement of spirits. This revolution has to do with the mystery schools and alchemy and wants to create a new imagination. We are on the side of the heretics because the system considers us heretics. We reject all dogmas. We are on the side of the lunatics, the ecstatics, children, tramps, gypsies, and the suppressed people of the world. We are for love, wisdom, freedom, humor, and generosity. A surrealist will kneel to no god.

The surrealist movement found a continuation in the psychedelic revolution, the renewal of spontaneous laments over Utopia caused by ecological worries, criticisms of the established culture, the use of hallucinogenic drugs, and the recognition of the feminine. The most effective way to rebel against a society that boycotts the arts is to live an artistic life.
As Shelley famously said: "I live my life in a fantastic way to show the people there is no reason to conform."

Homo Ludens

Before the last world war, the historian Johan Huizinga wrote about the coming of a new specimen of humanity: Homo Ludens, the playful human. In the same years, the aging Herman Hesse wrote his novel *The Glass Bead Game*, in which the main character is named Ludo (I play). The concept of Homo Ludens is completely different from the Ubermensch of the fascists. Huizinga predicted that Homo Sapiens would soon be replaced by machines and robots. Then there would be nothing left for humans but their feeling, their imagination, and their creativity. All the rest would be better done by robots.

Paul Lafargue, son-in-law of Karl Marx, was thinking along the same lines when he wrote his *Right to Laziness*. He attacked Marx's idealization of labor and production and recommended a pleasant and creative life instead, with as little labor as necessary. Of course, this situation can only exist in a mechanized and rich society, or in abundant nature, where food and shelter are freely available. Twenty years after the war, the industrial countries had reached a peak in their economic development, and large groups of young people began to "drop out" of the system voluntarily, to search for new ways to live.

In the Sixties the former Situationist, Constant, defined Homo Ludens as

the successor of Homo Faber, the working man. He saw the beatniks, hipsters, rockers, stijlagi, etc., as an avant-garde of the new creative human. He predicted a revolt against the existing structures if they frustrated the drop-outs into truly using their creative potentials. Around the same time a playful revolution began on the streets of Amsterdam. This revolution was started by Robert Jasper Grootveld, who cursed the addicted consumers' society in his spectacular street happenings. His war cries attracted thousands of young people, and so the Provo movement was born in the streets. The struggle for the freedom of Homo Ludens had begun.

The joy became even greater when the police began to interfere. The "Revolution for Fun" became more violent, but the playful (ludic) attitude of the Provos drove the authorities mad. They lost their minds and soon the mayor and chief of police in Amsterdam lost their jobs, too. The revolution for the liberation of the imagination that failed in France and most other places somehow succeeded in Amsterdam. An enormous subculture is flowering in an atmosphere of extraordinary freedom. New generations carry on the struggles of their Provo parents and beatnik grandparents.

The last decades of the twentieth century demonstrated the inherent failings of an automated society. Unemployment rose rapidly in technologically advanced countries. In Holland there are now hundreds of thousands of people who have never slaved for money, but receive a basic income from the state. They can spend their time as they like. They are free to create a meaningful existence or to perish in the jungle. The system has nothing to offer them but money—no philosophy, vision, or ideal. In many cases this leads to apathy and pessimism, but there is also a large movement of people trying to use their energy to create a new future. We are part of this movement, exploring the possibilities of Homo Ludens, creating joyful adventures for free spirits.

<center>HOMO LUDENS IS ALIVE AND WELL. HUIZINGA PREDICTED IT.
CONSTANT DEFINED IT. PROVO PREACHED IT.
WE LIVE IT.</center>

"The Origin of the Festival," "Art and Change," and "Homo Ludens" are by Hans Plomp.

appendix 7
burning the anti-smoke temple and the birth of the amsterdam balloon company, an interview with gerben hellinga

Gerben Hellinga is one of the Netherlands' most prominent mystery writers. He was a co-founder of the Ruigoord Cultural Free Zone and the Amsterdam Balloon Company, and his first-hand recollection of the fire at Jasper Grootveld's Anti-Smoke Temple is unique.

Q: I'd like you to talk to me about the Leidseplein scene, whoever they were, and to hear your story about the burning of the Anti-Smoke Temple.

GH: I was only someone from the outside. I was very, very young and was not really involved in all that. I just happened to be where it happened all the time. I knew, for example, Grootveld before he became Grootveld. He was a window cleaner in the Leidseplein opposite—in the old days they were warehouses; warehouses, but very high fashion, expensive stuff; and very nice really, inside, very 19th century; nowadays, Apple is there. And Grootveld was a window cleaner on that building.

I didn't know what he did, actually—but he knew a person in Amsterdam who died a long time ago, unfortunately, but [who] was one of the people who was most influential in forming intellectual Amsterdam. Hans Rooduin—later he worked in theater, and then I knew him. (I met him in Berlin on the street for the first time.)

When I was fifteen, sixteen, Rudolf [Stokvis] and I were friends, and Rooduin had a place in Amsterdam, and from there he organized parties, music—intellectual stuff. Nobody did that. There was nothing. It was a dead village, totally, totally, totally. And I knew this and went there, as a visitor. The first time, we walked into a jazz concert; everybody was sitting on the floor. And this was still the time

when we were still listening to French chansons, you know. Paris, we were orientated towards Paris at that time; everyone in black. And when Grootveld was a window cleaner, he was in contact with Hans Rooduin.

Hans Rooduin started out as a bookseller, maybe, or a gallery owner, and later went into the theater. Hans Rooduin was involved with Grootveld for a long time. In the sense that he was taking care of him—he was giving him intellectual shape, you know, giving him all sorts of feedback. And later Rooduin had to drop him because the guy was totally over the top all the time and he started to turn against him.

Q: Grootveld?

GH: Grootveld. You can take him in any context you want. And he was great maybe—he probably was—but he was also as mad as a hatter. He really was, but brilliant, in that sense.

Anyway, Hans Rooduin is an interesting person: I *loved* him. We were very good friends. I was lots and lots younger. I used to go and visit him all the time in his place. I was always welcome, and we would sit down and talk; like Simon Vinkenoog later became. And then he became involved in the theater, became a dramaturge, and I was a writer and we started to work together. Well, anyway, he had a strong influence on Jasper Grootveld. I know that. And then, this was during my first marriage. I was married to a model, and we had a big house, and through Hans Rooduin, or someone, I found out about this Smoking Temple.

I don't know who owned the building.

Q: It was the man who owned the Five Flies. Nicolaas . . .

GH: Nicolaas Kroese. Yeah.

Q: It was his building.

GH: Okay. It was a tiny little building that used to be a bicycle shop, a tiny little thing. Very run down. And so there were, for a while, there were things going on and meetings and whatever. I wasn't often there. Then one day, one evening, I was walking on the Leidseplein and I saw there was something happening there in the Smoking Temple, so I went there because I knew Jasper. He had been to my house. We had drinks together and long talks, but we weren't friends. I was sort of curious about him. And so I saw there was smoke coming out of the Smoking Temple. I went in, and he was in there.

Q: And it was burning?

GH: And it was burning! After a while, I said: "Well, we have to get out." Because there was so much smoke. There were other people there too, but it was so silly because he was walking around. He wasn't scared. He was . . .

Q: Performing?

Assault on the Impossible ▬ 133

GH: I don't know. Yeah! I didn't know what was going on, you see? I just went in.

Q: [Pointing to the cover photo of Eric Duivenwoorden's *Magier van een nieuwe tijd* showing Grootveld in pink leotards and silver shoes, gloves, and lapels, with a clown mouth and a grey, brimmed hat.] Is that a photo from the Anti-Smoke Temple? Is that a performance he did in the Anti-Smoke Temple?

GH: It appears to me that this is much later. It's much more um . . .

Q: Provo-y?

GH: Acting, you know? Silver shoes and so on. I think that's later. But at that time, you see, you must imagine Amsterdam as a village.

Q: The photo is by Ab Pruis.

GH: Ab Pruis, the photographer; a great guy. We had him out at Ruigoord many times.

Q: Is he still alive?

GH: No! He died a long time ago.

Q: That's the same costume Grootveld has on at one of the Lievertje Happenings.

GH: Yeah.

Q: So I guess the Smoking Temple must have burned down by then.

GH: Oh yes! The Smoking Temple was 1964. And then later Provo came. But he did that before: All on his own. He was this crazy guy all by himself. Then Provo came into being and he joined them, or rather, they went together. But they were rather different, because really he wasn't a Provo. But he was into all sorts of things. I mean he was against smoking, but he would smoke himself, of course.

Q: Let me to ask you about the founding of the Balloon Company.

GH: Alright.

Q: The story that I heard was that Theo Kley had decided one night—I guess you were over there a lot, weren't you?

GH: Yeah. We were friends.

Q: And he had decided to send some balloons up with aluminum streamers on them, and the air traffic controllers at Schipol Airport had these things suddenly appear on their radar.

GH: Something like that.

Q: He thought, "Okay. This is something I can work with." And he took it from there. I'd love to hear more. I'd love to hear your impressions.

GH: Well, I guess that happened, which I'm not so sure about. But it was part of

a process you see, because Theo, as an artist he was going into all sorts of experiments and directions. Before that he had this *Kietsj Konservaatooriejum* together with other people, and later they did archaeological research right in the center of Amsterdam. So he . . . he discovered the idea of the soft airship. The *sachterluchtvart*—there were the real airplanes and then you had the soft ones with balloons and kites, and so he discovered kite flying.

And when we had squatted Ruigoord we didn't see him as often because we were involved in Ruigoord. And this went for all my friends who remained in Amsterdam. I was in Ruigoord and had met some new people there and we were in the middle of something together, so we didn't go to Amsterdam much at that time. But I stayed in contact with Theo, and so I brought Theo and Ruigoord together, and this led to the idea of doing the kite flying festival. So we started out with the . . . festival in Ruigoord, the first time. And this was immediately a great success. People loved it. And the whole kite-flying thing, which was at that time totally dead in Amsterdam and in Holland, suddenly it became a hip thing. Even the Stedelijk did a kite-flying exhibition, and a shop appeared where you could buy stuff for kites, and the whole thing started from there. But the first one we did was in Ruigoord.

We did four—one each year. But we did them outside Ruigoord on places where there was going to be building and that were deserted and were going to be reused soon as a freeway and stuff. And we did one outside Amsterdam, which was very, very interesting. And it became bigger and bigger and bigger—like huge. We were just a few amateurs, and even though it was very nice, it became too big. And so we stopped and withdrew into ourselves, into Ruigoord. And then we started doing Landjuweel in Ruigoord, but I don't think we had the name Landjuweel, we used another name, and then it became Landjuweel. I can't remember the exact sequence.

But anyway, it started small, it started to grow, and then it grew and became explosive. It became huge. And then we stopped that, and secretly went on small in the middle of nowhere—they couldn't find us; and next year bigger, and bigger, and bigger. And again it started to grow, grow, grow. But then we had to stop because we could only do it in the village. And in the village it can only be on a certain scale, which is small. And it's great. It's very good to do small things. And now, you see, there's a whole new tendency in the party world: small parties. I'm not saying that we introduced it, but we are very much on the good wave.

Q: You were a member of the Keerkring for a while, weren't you?

GH: Me? No!

Q: Weren't you?

GH: Well, we all went there. But I'm not a visual artist.

Q: And they were only visual artists?

GH: Yeah. It was a group of visual artists, who, I think, normally couldn't get into the Stedelijk Museum, because the Stedelijk Museum was a place that was very much orientated towards the avant-garde. And the Keerkring was not against that. It was not anti-modernism at all, but it wasn't like the superstars.

And so, anyway, Theo—you have to really give him the credit for inspiring the Balloon Company. Where did the Balloon Company name come from? We started going to places where a balloon went up, a real hot-air balloon. And then we were—I think it was in Hoorn, and we were sitting in a grass field, and there was the Haig Balloon Company: they had a banner. A well-known man and lady went up in a balloon, and we were watching it. And we saw that they drank champagne before they left, which was exactly to our liking. So someone said, "Let's become the Amsterdam Balloon Company."

Q: And drink champagne, too! The reasons that things get done! But you were in a couple of Keerkring shows, too.

GH: Well, the group, Ruigoord. We were all together. We did an exposition in that place. We had great success with the Ruigoord exposition. Yeah, we were all involved.

Q: Do you remember years for the establishment of the Balloon Company and . . .

GH: Very badly. For that you have to be Rudolf Stokvis. He has an iron memory. And he knows exactly the day when we went into . . . he knows it all. Very strange! Mine is totally diffuse, always has been, but I do clearly remember things. I see them and I remember how people talked or how they looked, but I don't really know when it was. [Laughs.]

Q: You attended the Happenings at the Lievertje, didn't you?

GH: Some. But no way as a Provo! I wasn't. I was a young writer just starting out to write my books at that time, living with a young actress, and these Provo guys were beginning and they were friends; no, they were in the cellar of one of my friends, Pieter Schatz [the composer, at 123 Oudezijds Acterburgwal].

Q: The Provo basement?

GH: The Provo basement. Well, as it was in his house. I didn't go there so much, because it was really in his house. It was strange. And later on they got into trouble. So I wasn't so much involved. I was more amused. But then it became a thing with these ridiculous Happenings at the Lievertje. I mean ridiculous in the sense of her [Koosje Koster] handing out raisins and the police getting upset about that.

So it all comes together later. I really started to realize then that the captain of the ship makes the whole atmosphere, apparently. If the captain is a lunatic,

then the ship will be in a crazy way. We had this Burgermaster of Amsterdam, Van Hall at that time, and he couldn't cope with it. So the city couldn't cope with it. And the authorities couldn't cope with it. And the police couldn't cope with it. Nobody understood it, but the guy couldn't cope with it. Very interesting! You know, like these things happen nowadays, too, I think, that people in power don't really know what to do when they are confronted with "how it is." And instead of going with it, you know, and looking for a solution, they go voooom, against it, and it becomes a big huge thing. Crazy! Stupid!

Q: Well, how did Simon Vinkenoog get involved, then? Was he just always involved in everything?

GH: No! No, Simon was later also. You see, all my life I've admired Simon. And when I was a young kid, fifteen or sixteen—at that troubled age—we started out reading poetry. And Simon had brought out his book [the *Atonaal* anthology] which was an influential hit on Dutch literature. He was living in Paris at that time, and had assembled the poetry of some ten poets and brought that out, and it was an immediate big, sure hit.

And so we were also writing poetry of that kind and all that. And I wrote a newspaper at school about Simon Vinkenoog and his literary influence. And shortly after that Simon became a giant, and so he and these other guys were like the untouchables. But I knew his lady, Reineche. I knew her well, because we were in the Leidseplein scene together, at The Lucky Star, and so through Reineche I knew Simon. But he was far away, a giant.

Then much later we were in Ruigoord and Simon had a new girlfriend, Barbara. I knew her even better because Barbara was my good friend when we were at school and we used to read Simon's book together. And through Barbara we got really involved with Simon. And we started to visit him at his house on the Amstel, and we started to perform together and invite him to Ruigoord and things like that. And meanwhile we had become friends. And Simon would visit Ruigoord every now and then and do things. Then Edith became his wife and they became good friends. Yeah, Simon! I miss him a lot. He and Guus are two guys that I miss.

Q: Guus? I don't know Guus?

GH: Guus Boissevain, he was Margaret's guy. And Guus was my friend, for a long, long time. Way before Ruigoord. On Theo's roof, way before Ruiggord, we started to meet, and not only for the *sachterluchtvart*, but as friends. Talking and doing things together. Theo organized marvelous parties—he can do that now, still. But then there was this very together group of friends on that roof. And there were all sorts of well-known people—people who became well-known later, but we were all young. And Guus and Margaret were very involved in that.

Q: In the rooftop parties?

GH: Yeah. Guus had met her not very long before that, and they were young and outgoing. So Guus, from the beginning of the Balloon Company, played a very active part. But he was a gentleman type, he was not the type who wanted to be in front, but he was always there. And he contributed marvelous ideas. That banner above the entrance to the church: that's from Guus.

Q: Fortune Favors Fools?

GH: The text is from Guus, and the cartoon. And then my wife Jinny came up with the idea of putting it over the door of the church in Ruigoord. So you see that's how it is.

Q: A process. It's all a process.

GH: It's a process. Guus was very much in the process.

Q: Did Kees Hoekert fit into . . . ?

GH: No! Not at all! He stayed on his boat and he was a rather inaccessible person, but I visited him a few times.

Q: How about Leo van der Zaalm?

GH: Well, Leo, yeah. Leo recognized Ruigoord immediately as a place for him. And the Balloon Company—he loved the Balloon Company and the Balloon Company loved Leo. He was a great guy, in his own way—terribly difficult, because he was so much himself. A sweet man. And some of the stuff that he wrote was good.

<div style="text-align:right">
Gerben Hellinga and

Jordan Zinovich

Amsterdam

05/19/2012
</div>

appendix 8
kees hoekert: recipe for one kilo of hashish

Let's go back to the 9th of March 1966. The following day Princess Beatrix will marry Claus von Amsberg. On Hoekert's houseboat, future abode of the Lowland Weed Company, a party is going on. He reminisces: "It was a romantic time. The world was smoldering: Russia, revolution, a charged atmosphere. I was no adherent of Provo. Politics do not interest me. But many of my friends were Provos. That night we drank cheap wine and made wild plans to upset the royal marriage. Our slogan was: *Provo, da's lachen* (Provo, for a good laugh). Do something crazy, just because it's not allowed."

At 11:45 the following morning, Hoekert stands on the Raadhuisstraat bridge at the Herengracht, white chicken in hand. As the royal bridal party's enormous Golden Coach crosses the bridge, he tosses his white chicken into the horses' path, spooking them. Moments later he finds himself swimming in the Herengracht (where an angry monarchist has tossed him), and as the Waterways Police fish him out, Provo smoke bombs envelop the Golden Coach in the clouds of white smoke that will appear on newscasts throughout the world. Amsterdam's Provo Revolution has begun.

In 1963, Hoekert had discovered that "fine quality" marijuana could be grown in Holland. Armed with that knowledge he somehow convinced farmers on a government experimental farm to seed and harvest a four-acre plot for him. "We were planting pot with a tractor. . . . They were working for the state and harvesting the marijuana without ever knowing what it was." Soon he was drying tons of the stuff in a hayloft and dealing it to friends throughout the Netherlands.

But life as an entrepreneurial capitalist wasn't his ultimate goal, and when he learned that Dutch marijuana law focused only on "the dried tops of female plants" he turned to selling the whole live thing. And so, in the playful context that drove the art and politics of the time, began the Dutch move towards comprehensive decriminalization of "soft drugs." Searching for a basic stock, he shopped mail order. "Soon, I received a 15-kilo package of seeds from Nepal, and we were in business — legally, for a change."

appendix 8

When, in 1969, Hoekert and Robert Jasper Grootveld co-founded the Lowlands Weed Company, they had absolutely no intention of keeping their enterprise underground. "UNDERGROUND!" Jasper Grootveld once exploded. "WHAT IS UNDERGROUND? We do not believe in underground. We cannot afford an underground in Holland. Already we are beneath sea level! Underground is water and we drown. We open up the underground. . . . We are fools! Village idiots! Very important to the community! Everybody likes the village idiot!" And to emphasize his points, he and Hoekert set up shop less than 50 feet from a police station, notably above the water table.

Significant credit for the permissive freedoms that Holland's pot smokers enjoy today rightly lies with Hoekert, Grootveld, and adventurous fellow travellers like Simon Vinkenoog and Gerben Hellinga. Though Kees Hoekert didn't do much more than throw a white chicken beneath the feet of some horses and establish a prominent marijuana plantation in front of a police station, his playful cantankerousness had real impact, as is illustrated by his article "The Recipe for One Kilo of Hashish," which originally appeared in *Aloha*, no. 7, 1972–73. (*Aloha* was a popular magazine that was published between 1969 and 1974 and combined a cheeky, quirky, layout with ironical articles about sex, drugs, and music.)

In a few months thousands of hippies will again settle in the Vondelpark. Most of them are youthful Americans and Germans from the upper and middle classes, furnished with a well-filled purse. They come here to smoke hashish. If they couldn't safely smoke hashish here, they'd go elsewhere. Whoever thinks Amsterdam is Europe's most beautiful city must have a hole in his head.

Let's sensibly exploit this summer's economic boom. Here's the recipe for the preparation of 1 kilo of Nepalese hashish, the so-called "Black Nepal":

8 parts of fresh cow dung
1 part finely crushed split peas
1 part wheat flour
2 finely grated mushrooms
2 teaspoons pepper
Mix well and let dry in the open air.
In wet weather watch out for mold.

One kilogram will sell in three days for about 3,000 guilders. Because this trade isn't illegal, one can hand it all out in grams. For amounts up to 25 guilders, be careful to hide behind a tree, bush, or wall every time you appear, otherwise you won't be trusted. Above 25 guilders, do your selling in a bar like The Pool

on the Damstraat. Between each kilo, take a month off, because by then the last batch will have practically disappeared. Each summer you can save a good 10,000 guilders. This is a considerable amount of money, especially when one realizes that the trade is perfectly fit for boys and girls as young as fourteen years old.

Very good marketable varieties of hashish are being produced in *Artis* [the Amsterdam Zoo]. The alpaca (*Auchenia pacos*), a goat species originating from the Andes, furnishes a variety that, after having dried in the open air, does not need any further processing.

In the manufacture of pills one should only use reliable raw materials like flour, sugar, dyes from Albert Heijn [a popular supermarket] etc., because if serious mental or physical injury occurs one can be prosecuted if caught. Last year, many were far too careless in this regard. Don't take any risks.

An eminently useful substance, which is also good for the market, is mescaline. One fills a capsule (gelatin Lily No. 2), which can be found in every pharmacy, with a mixture of 8 parts flour, 1 part salt, and 1 part almond powder. A capsule filled with this powder is called a "cap" and will sell for 10 guilders. In quantities of several tens, the price can be lowered to a minimum of 8 guilders per cap.

Some people have asked me if trading fake opium ensures a reasonable living. This is certainly not the case here because Amsterdam has no market for heroin or opium.

I discourage everybody from trading hashish or pills of unknown origin. In some cases they contain potentially dangerous substances prohibited by law (like tetrahydrocannabinol and lysergic acid diethylamide), the trading of which might incur prison sentences that make your enterprise utterly unrewarding. Do not sell glass powder cocaine since this causes nose bleeds in the consumer, again exposing the seller to prosecution. Such is also the case if one adds traces of strychnine to fake LSD in order to delude the customer into believing he bought real LSD.

For the most part, the success of your enterprise depends on the sales act. You should, for example, explain patiently that the use of LSD is more heavily penalized than marijuana. You tell them something they already know, which makes a favorable impression. Explain that you can't sell less than 10 pills at 10 guilders apiece because of the risk. Look around somewhat skittishly from time to time (not too obviously) and delay the transaction for a day if you suspect it will be a major deal. This inspires confidence.

Last summer, sales were unexpectedly easy. I once read that a salesman succeeded in selling an American farmer a milking machine by installments and taking from him his only cow as down payment. Americans inherently possess a deep impulse toward spending, which is at a low ebb here because of their hippy status. But spending a lot of money for drugs isn't heresy for these believers, so this trade becomes rewarding in every way.

Assault on the Impossible—141

This summer the Vondelpark will produce gold again.

Let us, as readers of *Aloha*, exchange information about the preparation of fake hashish and fake pills. This will certainly pay off, since the trade in these substances will increase steadily as long as they remain illegal. So there is a reasonable future in it. Some of you might object that this will spoil the market because of the many disappointed customers. This is not at all a dangerous prospect because the frequent open sales of hashish and pills raise the reputation of Amsterdam sufficiently to more than compensate for the loss of this group of disappointed buyers.

Others will object that many readers of *Aloha*, whose wellbeing my article addresses, might themselves come into possession of fake hashish. I can reassure everybody: Only use marijuana for which the seller has a certified report provided by the Lowlands Weed Company. If not, let an expert from the L.W.C. test the product before any payments are made. A seller who refuses to allow this usually sells trash.

Except for selling them drugs, there is not much to gain from hippies. Owing to their counter-cultural status, they don't buy a bottle of milk, they steal it. So even milkmen should sell a few kilos of fake hashish in the park—there is nothing wrong with that.

<div style="text-align: right">Translation Marjolijn van Riemsdijk
and Jordan Zinovich, 2013</div>

an annotated general bibliography

Aloha. (1969–1974) A popular magazine that combined a quirky layout with ironic and parodic articles about sex, drugs, and music.

Apted, Michael (producer). *It's a happening*. Granada Television, 11/18/1966. A British television documentary about Provo; broadcast in the UK.

Avenue. (1965–1996) A prestigious, glossy, monthly magazine originally meant for highbrow women, with articles on fashion, food, cosmetics, as well as stories by well-known writers, pictures by well-known photographers, and poems. It attracted the best writers and artists.

Buikhuizen, Wouter. *Achtergrond van Nozemgedrag (Background to Nozem Behavior)*. Assen: Van Gorcum, 1965. A definitive study of the Dutch delinquents who rallied to the Provo movement.

Carmiggelt, Simon, "Plannen," *Het Parool*, 02/28/1968. Holland's most popular newspaper columnist expresses his admiration for Theo Kley's work.

"Dag in Dag uit" (Day in Day out), *de Volkskrant*, 03/05/1968. A column reporting on Stedelijk director Edy de Wilde and the presentation of the *Sycle Woeps* (Cycle Whoops).

De Realist. Periodical of the Amsterdam artists' group, the Realists.

De Rotterdammer. 04/06/1973. A critic describes the experience that awaits visitors to an exhibition dedicated to expertologistology, which ran from March 18 through April 24, 1973 at *Het Lijnbaancentrum* in Rotterdam.

De Volkskrant. 02/22/1972. A prominent Dutch newspaper reviews a 1972 Keerkring exhibition.

———. 09/10/1983. Some of the original residents of Ruigoord comment on the squatters who moved in.

Dubuffet, Jean. "*Place à l'incivisme*" (Make way for Incivism). *Art and Text*, no. 27 (December 1987 – February 1988). Explores notions of art brut, outsider art.

Duivenwoorden, Eric. *Magier van een nieuwe tijd: Het leven van Robert Jasper Grootveld*. Amsterdam: Uitgeverij de Arbeiderspers, 2009. A magisterial biography of Grootveld.

Ellenbroek, Willem. "Volgens de Echoput is Nederland klaar" (According to the Echo-Well the Netherlands is nearly done), *de Volkskrant*, 06/30/1973. About the ten-day expedition to the Heart of the Netherlands.

———. "De meesterkraak in de polder" (the Mastersquat in de Polder), *de Volkskrant*, 09/10/1983. About the founding of Ruigoord.

Expertologistic Magazine. No date, no publisher. The magazine of the Expertologistic Laboratory.

Frascina, F. *Pollock and After: The Critical Debate*. London: Harper & Row, 1985. Investigates the collusion between the CIA and the Abstract Expressionists.

Goudriaan, Huub. *De Rotterdammer*, 04/06/1973. A vote for the critical acuity displayed by expertologistology.

Grootveld, Robert Jasper. *Het Parool*, 03/19/1962. An early article about Grootveld's anti-smoking campaign.

———. "Sektestichter Jasper." *Het Parool*, 09/05/1962. Grootveld comments on the dope syndicates.

———. Unpublished interview made at the end of July 1965 (07/1965); typescript in the International Institute for Social History, Provo-archive, box 50, folder 9.

———. Interviewed with Max Reneman on VARA TV, *Achter het Nieuws* (Behind the News), 07/18/1977.

———. Interview with Marjolijn Van Riemstijk, 02/2000.

———. *Jasper en het rokertje* (1962). http://www.youtube.com/watch?v=WATRmo-g9nY Extraordinary film footage that portrays Grootveld's anti-smoking Happenings and the creation and burning of the Anti-Smoke Temple.

Grootveld, Robert Jasper, and Eric Duivenvoorden. Interview, 11/16/2006. Available from Eric Duivenvoorden.

Hellinga, Gerben. Interview with Jordan Zinovich, 05/19/2012. An edited version appears as Appendix 6.

Hellinga, Gerben, and Hans Plomp (eds.). *Honderd seizoenen Ruigoord* (*One Hundred Seasons at Ruigoord*). Amsterdam: Amsterdam Balloon Company, 1998. Explores the founding and importance of Ruigoord.

Het Parool. Editorial, 07/19/1977. Information concerning Mayor Polak's attack on Grootveld's rafts.

———. 03/19/1962. Story about one of Grootveld's earliest Anti-Smoke Temple Happenings.

Hoekert, Kees. "The Recipe for One Kilo of Hashish." *Aloha*, no. 7, 1972–73. This article appears as Appendix 8 in this book.

Hofland, Henk. "Peilloos melancholiek" (Unfathomable Melancholy), *NRC Handelsblad*, 01/23/1998. A journalist remembers the sound of Huub Mathijsen's violophoon and recalls performances by the Insect Sect.

Holstein, Pieter. *NRC Handelsblad*, 04/11/1975. A Keerkring artist describes the texts that accompany some of his drawings.

Huizinga, Johan. *Homo Ludens: A Study of the Play Element in Culture*. Boston: Beacon Press, 1955. (First published in Dutch in the Netherlands in 1938.) Huizinga discusses the importance of playfulness to culture and society, with his term *Play Theory* defining the conceptual space in which play occurs. He views play as a primary and necessary (though not sufficient) condition of cultural generation.

Illés, Vera. "Ik geloof in wondertjes" (I believe in small wonders), *NRC* (*Nieuwe Rotterdamse Courant*), 01/09/1976. An interview with Max Reneman.

Imaginarymuseum.org/Grootveld. A source for information about Grootveld and the strange fetish case he found in Africa.

Jarring, Cor. *Cor Jaring*. Amsterdam: NieuwAmsterdam, 2009. An oversize photo book chronicling Jaring's life as a photographer, including remarkable coverage of the Insect Sect and the Provo years.

Juffermans, Jan (ed.). *Expertologistic Manual, Part I*. No place, no publisher, 1972.

Juffermans, Jan. "Deskundologen," *Algemeen Dagblad*, 03/30/1974. About a particularly wild Keerkring exhibition.

Kaprow, Allan. "Something to take place: A Happening." *The Anthologist*, 1959. The first published Happening script.

Kelk, Fanny. "Drivel," *Het Parool*, 12/24/1975. About a later Keerkring exhibition.

Kempton, Richard. *Provo: Amsterdam's Anarchist Revolt*. New York: Autonomedia, 2007. The most comprehensive English-language treatment of the Provo movement.

Kley, Theo. *Mother, what is wrong... with this Planet?* (*Moeder, wat is er mis... met deze planeet, een dozijn wetenschappelijke projecten van Theo Kley*). Amsterdam: Volle Maan, 1969. Realized and unrealized projects conceived by Theo Kley.

———. *de Volkskrant*, 03/13/1969. Theo Kley suggests that the Insect Sect environmental emergency flags appear every time Prince Bernhard goes to Africa on an elephant hunt.

———. "Interview with Theo Kley," *Het Parool*, 08/31/1974. About the founding

of the Amsterdam Balloon Company.

———. *De Keerkring*. Amsterdam: Volle Maan, 1975. Contains a representative sample of work by Keerkring artists.

———. Personal communication with Marjolijn Van Riemstijk.

Lebel, Jean-Jacques. *Le Happening*. Paris: Ed. Denoël, 1966. An article by the artist who introduced Happenings to Europe.

Liber Amicorum deskundolog Max Reneman. Amsterdam: Volle Maan, 1979. A memorial to Max Reneman.

Leurdijk, Dick, and Manus van der Kamp. *Omzien in verwondering*. A film documentary about the Provo movement, broadcast on NOS-television 10/01/1972.

Pas, Niek. "In Pursuit of the Invisible Revolution: Sigma in the Netherlands, 1966–1968." In Timothy Brown and Lorena Anton (eds.), *Between the Avant-Garde and the Everyday: Subversive Politics in Europe from 1957 to the Present*. New York: Berghahn Books, 2011, pp. 31–43. An insightful, wide-ranging analysis of the avant-garde sigma movement, concluding with a detailed examination of the founding and impact of the Amsterdam Sigma Center.

Plomp, Hans. "Jacht op de Verschrikkelijke Sneeuwvrouw" (The Hunt for the Terrible Snow Woman), *De Nieuwe Revue*, 02/17/1978.

Plomp, Hans, and Coen Tasman. "De les van de kabouterbeweging," *Bres*, juni/juli, 1997. A piece about the Kabouter (Gnome) movement—Coen Tasman wrote the definitive book on that particular Provo offshoot.

Polak, Wim. *Het Parool*, 07/19/1977. The Mayor of Amsterdam demands that Grootveld dismantle his raft the *Tand des tijds*, threatening police action if he doesn't.

Prange, Vincent. *The God Haj Haj and Rhubarb, with the Chopping-Knife through the Jungle of Modern Art* (pamphlet), 1959. A raving tirade against experimentalism and a passionate plea for "beauty in art."

Reneman, Chiara. Interview with Marjolijn Van Riemstijk.

Reneman, Max. "Max Reneman maakt kunst en gebitten," *De Telegraaf*, 01/01/1962. An early interview with Max Reneman.

———. "De stoel van Claus," *De Nieuwe Linie*, 08/31/1968. Reneman discovers Grootveld's Klaas Chair.

———. Interview in *de Volkskrant*, 05/05/1977.

———. *The Future of the Denture* (Guus Flögel, ed.). Brussels: Stafleu & Tholen B.V., Alphen a.d. Rijn, 1981.

Rosenberg, Harold. "American Action Painters," *Art News* 51/8, 1952. An American critic talks about Abstract Expressionism.

Roskam Abbing, M. "Een waarheid als een hond" (A Truth like a Dog), *NRC Handelsblad*, 04/11/1975.

Ruyter, Martin. "Kunst is alleen Kunst als er Kunst op staat" (Art is only Art if it is designated Art), *de Volkskrant*, 05/05/1977. A description of the membership of the Keerkring at the height of the society's popularity.

Shattuck, Roger, and Simon Watson Taylor. *Selected Works of Alfred Jarry*. New York: Grove Press, 1965.

Smits, Hans. "De profeet van het piepschium" (The Prophet of Polystyrene). *Vrij Nederland*, 09/11/1993. An article exploring Grootveld's use of materials and the plans for the Zeeburg water park.

Sontag, Susan. *Against Interpretation and Other Essays*. New York: Dell Publishing, 1966.

Stansill, Peter, and David Mairowitz (eds.), *BAMN (By Any Means Necessary): Outlaw Manifestos and Ephemera 1965–1970*. New York: Autonomedia, 1998. A collection of ephemera produced by radical movements from the Sixties.

Stokvis, Margrid. *Morocco, Travel Account of 17 Big Ones, 4 Little Ones, and 1 Dog*. Amsterdam: Amsterdam Balloon Company, 1977. The Amsterdam Balloon Company goes to Morocco.

Stokvis, Willemijn. *CoBrA, de weg naar spontaniteit (CoBrA, the Road to Spontaneity)*. Blaricum: V + K Publishing B.V., 2001. The most authoritative published study of the CoBrA movement.

Tegenbosch, Lambert. "Fodor," *de Volkskrant*, 02/22/1972. A critic deplores the most recent Keerkring exhibition.

———. "De Keerkring," *de Volkskrant*, 04/15/1972. An enthusiastic vote for Theo Kley's aesthetic sensibility.

Trocchi, Alexander. "A Revolutionary Proposal: Invisible Insurrection of a Million Minds," originally published in 1962 in *New Saltire Review*; republished as "Technique du coupe du monde," *Internationale Situationniste* #8 (January 1963). This is Trocchi's reassessment of the internationalist project, which functioned as a call for the foundation of the counter-culture.

———. "sigma: A Tactical Blueprint," originally published in *New Saltire Review* (1962). Trocchi's sigma manifesto.

Trouw. 08/10/1964. Police comments on Provo Happenings at het Lievertje.

Van Beek, Marius. "De Keerkring," *De Tijd*, 12/17/1957. An early article sympa-

thetic to the Keerkring.

Van der Zalm, Leo. Interviewed by Marjolijn van Riemsdijk (d.d.), 09/2001.

Van Doorne, J. "Aansporingen tot krankzinnigheid" (Incitements to Insanity) *Trouw*, 06/11/1967. A critic rejects Simon Vinkenoog's enthusiastic support for Happenings.

Van Duijn, Roel. *Diepvriesfiguur*. Amsterdam: Praag, 2012, p. 61. Van Duijn has changed the spelling of his surname by the time this book is published.

Van Duijn, Roel, and Eric Duivenvoorden. Interview, 02/15/2007.

Van Duyn, Roel. *Het witte gevaar: een vademekum voor Provos* (*The White Danger: A Handbook for Provos*). Amsterdam: Meulenhoff, 1967. A study of the Provos written by one of the founders of the movement—published under the original spelling of his surname.

———. Quoted by Willem Ellenbroek in *De Volkskrant*, 09/08/1973.

Van Galen, John Jansen, and Huib Schreurs. *Het huis van nu, waar de toekomst is* (The House of Today, where the Future Lies). Amsterdam: V & K Publishing, Blaricum, 1995. Reviews the history of the Stedelijk Museum.

Van Gasteren, Louis. *Allemaal rebellen*. Amsterdam: Tabula, 1984.

Van Reeuwijk, P. J. *Damsterdamse Extremisten*. Amsterdam: De Bezige Bij, 1965. Contains information about Grootveld's more extreme beliefs, particularly those related to his experiences in South Africa.

Vinkenoog, Simon. "Manifests and Manifestations," *Randstad 11–12*, 1966. Vinkenoog's reports on Happenings in Amsterdam.

Vrij Nederland. 06/30/1962. Jasper Grootveld prophesizes the arrival of countercultural tourists in Amsterdam.

———. 09/11/1993. A planning-department civil servant fantasizes about a "water square" in Amsterdam's Zeeburg neighborhood.

Welling, Dolf. *Rotterdams Nieuwsblad*, 04/06/1973. A critic hails Grootveld as an authentic genius.

Wiekart, K. "Mooi zwembad" (Beautiful Swimming Pool), *Vrij Nederland*, 10/31/1970. An architectural critic admires Max Reneman's sense of architectural style.

Wingen, Ed. "The Cycle that Wants to Turn the Tide," *De Telegraaf*, 11/07/1964. A supportive article on the Keerkring.